HIGHER

Graphic
Communication

course notes

Peter Linton ✕ Richard Smith ✕ Scott Urquhart

Contents

Introduction

Communicating and interpreting information is an essential part of contemporary society. Graphic communication – using graphics to communicate ideas and information – is the shared medium of global markets in industry and commerce. It enables the effective exchange of ideas and information between two parties without confusion. This makes the ability to communicate information graphically a vitally important and relevant skill to possess.

The Higher Graphic Communication course is intended to make students aware of the role of graphics in society and to help students develop essential graphic skills and techniques employed in their creation. The course reflects the use of graphics in business and industry, while embracing changes brought about by advances in technology.

What this textbook covers

These Course Notes will support you through the Higher Graphic Communication course, using worked examples, sample materials and a Thematic Presentation case study.

Graphic Communication is a practical course, and the practical drawing skills and computer skills require practice through repetition. This book can be used alongside the classroom teaching which takes you through the course. Your teacher should provide you with the drawing practice required to give you the skills and confidence that you will need to pass the internal and external assessments.

Required prior knowledge

Ideally, you should have passed Standard Grade at grade 1 or 2 or Intermediate 2 Graphic Communication. However, the Higher course is also suitable for students in S5 or S6 with an aptitude for graphic work.

Topic order

The topics in this book have not been grouped according to unit specification. Instead, topics have been grouped with other related topics and these topic groups have been placed in an order of logical progression. Your teacher will know which topics are relevant to each unit.

The order here will not be the order that you will tackle the course in. However, this book is designed so you can 'dip into' the topic you are working on in class.

Course content

You must pass all the internal unit assessments as well as the external assessment.

Internal assessment

The **Technical Graphics 1** unit covers:
- manual graphic techniques (sketching and drawing) for pictorial representation and geometric construction
- manual illustration and presentation techniques to give emphasis and realism to graphic presentations.

Assessment: A portfolio of manual drawings.

The **Technical Graphics 2** unit covers:
- manual techniques (sketching and drawing) of orthographic projection for components, assemblies, sectional views and locations
- principles of dimensioning orthographic production drawings
- knowledge and demonstration of the use of graphic communication within consumer, engineering and construction industries (written pass/fail **Graphics in industry** test).

Assessment: A portfolio of manual drawings and a written test.

The **Computer Graphics** unit covers:
- orthographic and pictorial drawings produced using computer-aided draughting software
- computer rendered drawings produced using illustration software
- production of single and double page layouts using desktop publishing software
- terminology and hardware associated with computer graphics (written pass/fail **Computer graphics** test).

Assessment: A portfolio of computer graphics and a written test.

External Assessment

Thematic presentation: a presentation portfolio incorporating manual and computer aided graphics, assessed at **30%** of the course mark. This is internally assessed and externally verified.

External examination: a 3-hour single paper covering Graphic Knowledge and Drawing Ability, assessed at **70%** of the course mark.

Studying and preparation

Start your preparation in good time – there is no sense in trying to do it all in the few weeks before the exam. Your preparation should include:
• learning each topic as it occurs in your class work
• completing any homework that is given to you
• trying additional drawings for topics that you are not comfortable with
• using past papers.

When you use past papers, you will find that similar question types appear from year to year. Prepare yourself for these by looking over this book, and revise homework questions and drawings you have already completed. Tackle the past papers and check your answers. If there are any aspects of the solutions that you do not understand, use this book or ask your teacher for guidance.

Exam technique

Be well prepared! It does seem an obvious thing to say but you will not pass the exam if you do not know the topics. Take time beforehand to discuss any weak areas you may have with your teacher. In the exam you can tackle the questions in any order, so do the ones that you are most comfortable with first. Once you have completed these, go back and spend time on the ones that you find more difficult.

Look at the marks given for each question. These are a good indicator for the length of answer you should give. For example, a 3 mark written question probably needs you to make 3 points, while a 1 mark question may only require a short answer.

Graphic Knowledge section

The Graphic Knowledge section should take 45 minutes to complete and is worth 40 marks. Allocate 1 minute per mark to answer each question, plus 5 minutes total reading time. Read the question carefully, make sure you understand what they are asking and ensure you express your answers clearly.

Drawing ability section

The Drawing section should take 2 hours and 15 minutes to complete and is worth 100 marks. There are four questions. Allocate 1 minute per mark to answer each question, plus 5 minutes reading time for each question. This should leave you 15 minutes to check your work and tidy up any unfinished answers.

Factors that determine your success in the course

Success factor	Why it counts	How to improve your ability in each success factor
Knowledge	When you are asked to tackle a topic such as isometric drawing, you need to know what an isometric drawing is and how to construct and complete one.	Watch and listen carefully to demonstrations and lessons. Revise at home what you have learned in class. Use this book to support your study and revision.
Drawing accuracy	Your drawings require a degree of accuracy before they are deemed correct.	Take care measuring and setting out your construction. Keep pencils and compasses sharp and your drawing instruments clean.
Drawing speed	The final exam lasts 3 hours. You must work quickly enough to complete the entire question paper in that time.	Your speed will improve with practice. The more drawings you complete the quicker you will become. Learn to 'think-ahead' while you are drawing
Problem-solving ability	Your ability to decode a drawing question so that you understand what you are being asked to do and then planning your answer, step-by-step, will carry you through even the most difficult questions.	Your teacher will give you problem solving tips and this book also provides problem solving advice. This is another skill that will improve with practice.
Thematic Presentation	At 30% of the course marks, this project is vital in helping you achieve a final mark that reflects your ability.	Get your project off to a good start as early in the course as you can. Be thorough in each part of the TP and use the case study in this book as a guide – gaining full marks is always achievable.

Graphics in industry

The increasingly international nature of all types of industry is making graphic communication more important. Increased use of graphical information around the world has led to the development of international standards in all fields, from engineering and construction, to electronics, retail and the chemical industries.

In most manufacturing industries the design and manufacture of any product follows a cyclic path from design though manufacture and marketing to its use by the consumer. If the product is successful, further market research will identify additional consumer needs and the product will be updated and modified before being manufactured and marketed all over again.

This process is known as the **design cycle**. The design cycle involves people with a broad range of skills and knowledge. Graphic skills are also important right through the design cycle and it's these specialised graphic skills that you will learn about and demonstrate in your Thematic Presentation (pages 189–217).

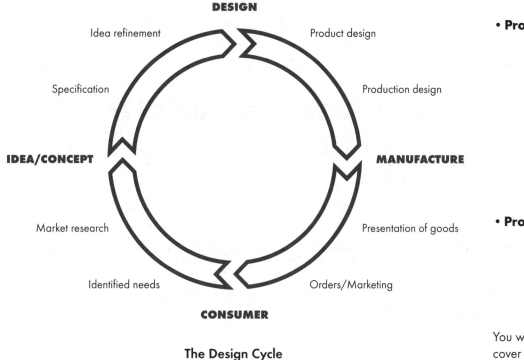

The Design Cycle

During the design cycle the type of graphics used fall into three main categories known as the **3Ps**:

• **Preliminary graphics**

• **Production graphics**

• **Promotional graphics**

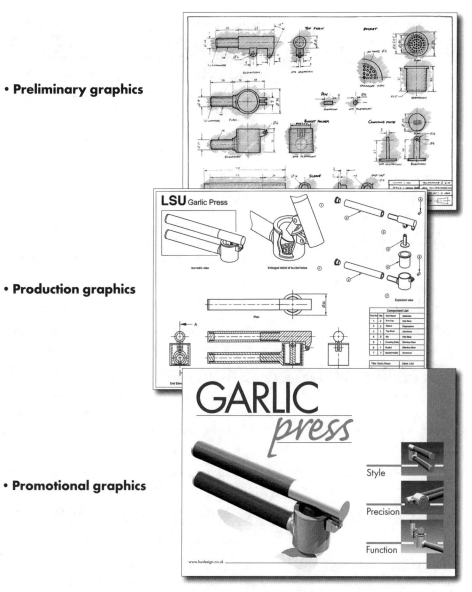

You will follow a similar path in your Thematic Presentation by creating graphics that cover all three types.

GRAPHICS IN INDUSTRY

The 3Ps can be further separated into more specialised types. Each type of graphic performs a specific role in the design cycle and each may require specialised skill and knowledge to produce. The table lists the most important types of graphic and explains their purpose, how they are produced and who is likely to produce them.

Type of graphic	Purpose and production	Who produces them
Preliminary graphics		
Freehand sketching	Design and concept sketches (2D and pictorial) and manual illustrations are produced early in a design project to create and record ideas quickly. They will be produced manually and freehand (without the use of drawing instruments).	Designers and architects
Manual illustration	Quick pencil, coloured pencil and marker pen illustrations bring colour, texture and realism to a concept. These illustrations help communicate initial ideas to a client.	Designers and architects
Modelling	Product design and building design often make use of 3D models to develop and present the design before manufacture or construction begins. 3D models are now usually computer generated.	Designers, architects and model makers
Planning charts (flow charts, Gantt charts and story boards)	These are charts to plan the design and manufacture of a product or construction project from start to finish. The charts break the project down into smaller tasks and plan the sequence of tasks against time. Planning charts are developed at the start of a project so that time and resources are used effectively.	Project management teams
Market research charts	Tables and graphs display information gathered through product tests and consumer questionnaires. Relevant information is collated for the design team.	Marketing and sales team
DTP thumbnails, roughs and visuals	Design sketches and drawings are used for promotional publications and documents such as sales brochures, instruction manuals, assembly guides, advertising leaflets, posters and videos.	Graphic designers create layouts for promotional publications
Production graphics		
Orthographic drawings (sectional views, exploded views, assembly drawings and surface developments)	Scaled and fully dimensioned CAD drawings are used in the manufacture and production of a product. The dimensions are toleranced so that components can be assembled correctly. Planning charts (schedules and Gantt charts) are also used to plan the production.	Design engineers and design draughtsmen and women
Location plans, site plans, floor plans and sections	Scaled and fully dimensioned and toleranced building drawings give builders, joiners and construction engineers the information they need to construct a new building.	Architects and architectural technicians
Promotional graphics		
DTP proofs	In publishing, camera-ready or plotter proofs are needed before a publication goes to print.	Graphic designers and printers
Illustrations, 3D models, animations, graphs and charts, and photographs	These are used in promotional material such as sales brochures, instruction manuals, assembly guides, advertising leaflets, posters and videos to promote and advertise a product or a company.	Graphic illustrators and graphic designers

British Standards

The British Standards Institution (BSI) is the body responsible for determining British Standards for products, materials, systems and services at European and international level.

In the Higher Graphic Communication course it is expected that you will familiarise yourself with the guide **British Standard for Technical Product Specification (TPS)**, **BS 8888**. In the guide a Technical Product Specification is defined as a **working drawing of the proposed design of the whole product**.

Familiarising yourself with BS 8888 will give you the theoretical knowledge needed for the Higher exam and assist in the completion of production drawings for the Thematic Presentation.

The main purpose of the guide is to establish a common standard for communicating product and drawing details between designers and manufacturers, with clear understanding and consistency worldwide.

British Standards are universally understood by everyone involved in producing or using production drawings. Using British Standards has a number of advantages:
• drawings are easier and quicker to draw because products are simplified
• drawings are easier to understand due to their concise nature
• drawings can impart lots of information efficiently.

This section of the book gives a brief overview of the requirements of producing production drawings which conform to BS 8888. There are four main areas to consider:
• setting up production drawings
• projection methods
• making drawings easier to understand
• representing standard components.

This section is intended as reference only. For more detailed information on each of these topics, refer to BS 8888 itself.

Setting up a production drawing

Ensuring that all production drawings are set out in a consistent way helps reduce errors which might inadvertently be introduced by the use of an unusual or non-standard presentation.

Title Blocks

Title blocks should be at the bottom of the sheet and extend to the lower right-hand corner of the page. The following information should be contained within:
• name
• projection symbol
• title
• date
• original scale
• drawing number
• dimensional tolerances.

Drawing Scales

Every technical drawing needs to be drawn in accurate proportion, i.e. to a uniform scale. This scale should be given in the title block as a ratio, e.g. ORIGINAL SCALE 1:2.

In the Higher course you should be aware of the following recommended scales within BS 8888:

Full size	Reduction scales (drawings less than full size)	Enlargement scales (drawings larger than full size)
1:1	1:2, 1:5, 1:10, 1:20, 1:50, 1:100, 1:200, 1:500, 1:1000	2:1, 5:1, 10:1, 20:1, 50:1

Lines and line work

On working drawings the line work should be the appropriate type, thickness and density. The type and thickness of a drawn line conveys specific information to the reader. Failure to do this could lead to the intentions of the designer being misunderstood by the user. A selection of lines that may be encountered in the Higher course is shown in the table on the following page.

BRITISH STANDARDS

Line	Description	Application
A ————————	Continuous thick	Visible outlines and edges
B ————————	Continuous thin	Dimension, projection and leader lines, hatching, outlines of revolved sections, short centre lines, imaginary intersections
C ∼∼∼∼∼∼	Continuous thin irregular	Limits of partial or interrupted views and sections if the limit is not an axis
D ╱╲╱╲───	Continuous thin with straight zigzags	Limits of partial or interrupted views and sections if the limit is not an axis
E – – – – – –	Dashed thin	Hidden outlines and edges
F —·—·—·—	Chain thin	Centre lines, lines of symmetry, trajectories, loci, pitch lines and pitch circles
G	Chain thin thick at ends and changes of direction	Cutting planes
H —··—··—··	Double dashed chain thin	Outlines and edges of adjacent parts, outlines and edges of alternative and extreme positions of movable parts, initial outlines prior to forming, bend lines on developed blanks or patterns

Projection methods

BS 8888 identifies two main methods of projection, **orthographic** projection and **axonometric** projection, that are relevant to students of Higher Graphic Communication.

Orthographic projection

Standards for orthographic projection include the two types of orthographic projection in use, **first angle** orthographic projection and **third angle** orthographic projection. These are the most commonly used methods of representing technical objects and are considered to be the accepted technical language. Of the two methods the most widely used is third angle orthographic projection.

The third angle projection symbol indicates the method of projection used on orthographic drawings. This is the method used in this course.

Axonometric projection

Standards for axonometric projection include the most commonly used methods of pictorial representation: **oblique** projection, **isometric** projection and **planometric** projection. These methods do not usually provide all the information required to define a product, but may be used to provide general information without requiring special skills or knowledge to be able to interpret drawings.

Making drawings easier to understand

One of the most important features of good drawings is that they should be easy to understand. With complex components, there are occasions when orthographic drawing may have limitations and it is sometimes necessary to provide further information in the form of additional or partial views of the component parts of a product. The main methods to consider are:

- auxiliary views
- partial views
- sectional views
- interrupted views.

Auxiliary views

An auxiliary view is a view added to the main view to impart more information about the product. These views are completely new elevations of the product used to give true representations of features where this cannot be achieved by orthographic projections (see pages 38–47).

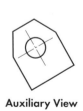

Auxiliary View

Sectional views

There are many types of sectional view (other than a section along one plane) that can be employed to aid the clarity and understanding of production drawings. The following types of sectional views are useful for showing detail in more complex engineered objects:

• local or part sectional view

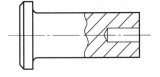

• revolved sections

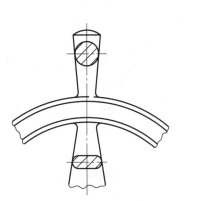

• half sectional view

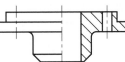

• removed sections

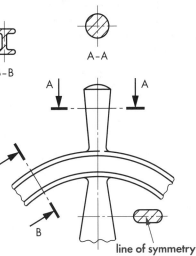

line of symmetry

Partial views

It is not always necessary or desirable to enlarge a full view. There are occasions when a partial view can be used to enlarge a detail and improve clarity.

Enlarged Partial View

Interrupted views

Drawings can be made to fit a sheet or screen more easily using interrupted views. These views only show the portions of a long or large object that are necessary to define it. They are drawn close to each other and break lines are used to define the edges of the section that has been removed.

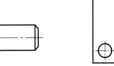

Type C lines used for solid shaft

Type D break lines

Conventional break lines for solid shaft

Conventional break lines for hollow shaft

General break lines (type C lines)

Representing standard components

Modern engineering makes use of an extensive range of standard components. It's important that these standard components are all represented properly to allow products to be assembled correctly.

Screws and nuts

The simplified representations of a range of screws and nuts are shown below. Although you may not need to use many of the representations shown here, learning them builds your theoretical knowledge and enables you to read engineering drawings more accurately. Note that these are not actual representations, but are drawn to conventions. A convention is an agreed method that is accepted as common usage.

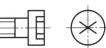

Hexagon head screw

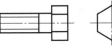

Hexagon socket screw

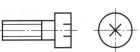

Cylinder screw cross set

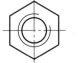

Countersunk screw

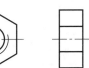

Hexagon nut

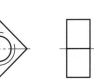

Square nut

BRITISH STANDARDS

Bolt construction

The figure below gives recommended sizes and construction details of an assembled hexagon head bolt, nut and washer. Familiarise yourself with the parts of the bolt that are labelled – you may be asked to draw them.

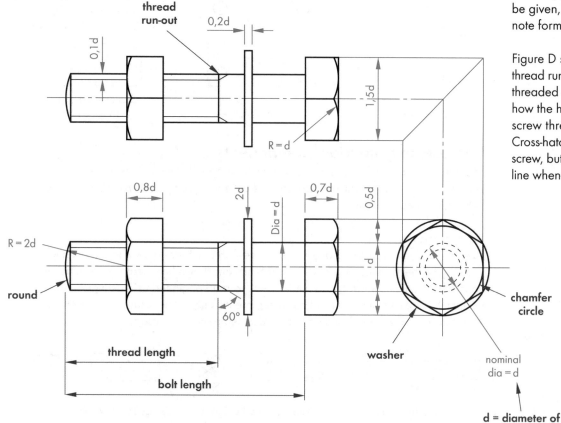

Screw threads

Figures A, B and C show the main conventions and details of how orthographic and sectional views of threaded parts are drawn. These conventions are used irrespective of thread type. However, if the thread type and size needs to be given, this is usually done in note form.

Figure D shows details of the thread run-out and how assembled threaded parts are drawn. Note how the hatching is affected when screw threads are assembled. Cross-hatching lines stop at the screw, but continue to the inside line when a screw is not present.

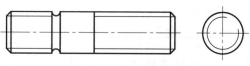

A External screw threads

B Internal threads (blind hole)

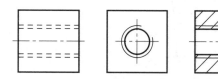

C Internal threads (through hole)

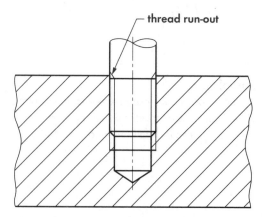

D Assembled screw thread

Helical springs

The figures below give the conventional representations of a cylindrical helical spring made of wire with a circular cross section. If necessary the cross section of the spring material can be indicated in words or by a symbol.

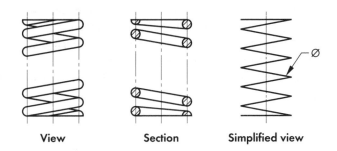

| View | Section | Simplified view |

Knurling is represented by showing only part of the surface it is applied to. For diamond knurling the lines should be drawn at 30° to the centre line.

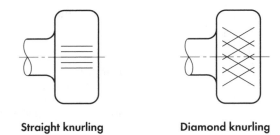

| Straight knurling | Diamond knurling |

Symbols and abbreviations

Symbols and abbreviations are used to save time and space on engineering drawings. Consistent use of symbols and abbreviations aids clarity. Use the following list as a reference – you will come across several examples during this course and they may be used in your thematic presentation.

AF	Across flats
ASSY	Assembly
CRS	Centres
CL	Centre line

CHAM	Chamfer
CH HD	Cheese head
CSK	Countersunk
CSK HD	Countersunk head

CBORE	Counter bore
CYL	Cylinder or cylindrical
20°	Degree symbol
DIA	Diameter (in a note)
Ø	Diameter (preceding a dim)
DRG	Drawing
EQUI SP	Equally spaced
EXT	External
FIG.	Figure
HEX	Hexagon
HEX HD	Hexagon head
I/D	Inside diameter
O/D	Outside diameter
INT	Internal
LH	Left hand
LG	Long
∀	Machining symbol
M	Metric screw thread
MATL	Material
MAX	Maximum
MIN	Minimum
mm	Millimetre

NO.	Number
NTS	Not to scale
PCD	Pitch circle diameter
R	Radius (preceding a dim)
RAD	Radius (in a note)
RH	Right hand
RD HD	Round head
SCR	Screw or screwed
SPHERE	Spherical
SØ	Spherical diameter (only preceding a dimension)
SR	Spherical radius (only preceding a dimension)
SFACE	Spotface
SQ	Square (in a note)
□	Square (preceding a dim)
STD	Standard
THD	Thread
THK	Thick
TYP	Typical or typically
UCT	Undercut
VOL	Volume
WT	Weight

DIMENSIONING

Dimensioning

Dimensioning is the process of stating measurements on technical drawings. Dimensions are a key element of communication between the design engineer and the manufacturer of the product. The system of dimensioning currently used in the UK is set by the British Standards Institution in their document BS 8888.

General principles

- There should be no more dimensions than are necessary to completely define the object.
- Linear dimensions should be expressed in millimetres (mm). If this is stated in the title block then the unit symbol **mm** should be omitted from the individual dimensions.
- All measurements should be in millimetres unless instructed otherwise. If other units are used the symbols should be shown with their respective values.
- Dimensions should be expressed to the least number of significant figures, e.g. 22 not 22,0.
- Crossing of projection/leader lines should be avoided if possible.
- Dimensions should not, where possible, be crossed by other lines in the drawing.

Dimensioning standard practice

Radii

Always show the radius on arcs, curves and rounded corners. The letter symbol **R** is always shown in front of the figure. Radii should be dimensioned by a line that passes through or inline with the centre of the arc. The dimension line should have only one arrowhead, which should touch the arc.

Diameters

Where a complete circle is shown in a drawing, the diameter is shown by placing the symbol **Ø** in front of the figure. The radius should never be used to dimension a complete circle. When holes or circles are dimensioned, the diameter is shown as well as the location of the centre.

Figures on linear dimension lines

Figures on dimension lines should be placed so that they can be read from either the bottom or the right-hand side (above and along the line). Figures should not touch outlines, dimension lines or centre lines. Figures that require a decimal marker should use a comma, e.g. 22,1.

Dimensioning small features

Where space is limited for dimensioning small features, the figure can be placed centrally, above or in line with one of the dimension lines.

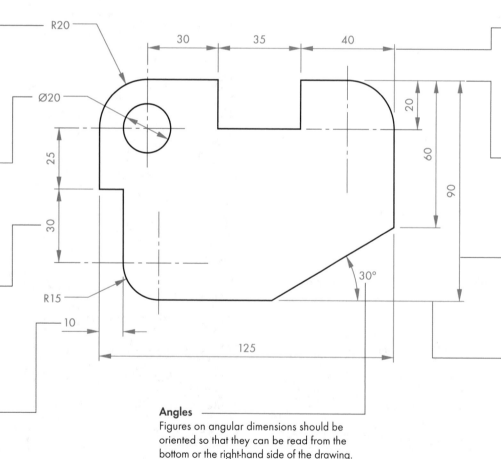

Intermediate dimensions

Intermediate dimensions give sizes for individual parts of the drawing which appear in line with each other. In this example the arrangement of these dimensions shown is known as **chain dimensioning** (one after the other).

Datum line

Multiple dimensions can be taken from a datum line (as in this example) and set out parallel to each other, using **parallel dimensioning**.

Overall dimension lines

Overall dimensions give the maximum sizes of objects (total length and total height). They should be placed outside all other dimensions.

Projection/leader lines

Projection, or leader, lines are used to allow the dimension line to be placed outside the outline of the drawing to aid clarity. A small gap should be left between the outline of the drawing and the projection line. Projection lines should be drawn at right angles to the dimension line and extend past it slightly.

Angles

Figures on angular dimensions should be oriented so that they can be read from the bottom or the right-hand side of the drawing.

Examples of dimensioning methods

Parallel dimensioning

Parallel dimensioning consists of a number of dimensions that originate from a common reference feature (a datum edge).

Combined dimensioning

Combined dimensioning is a combination of parallel dimensioning and chain dimensioning that can be used when space is limited or the drawing is very complex.

Dimensioning screw heads

When dimensioning screw threads, the thread system and size should be given. The letter **M** indicates ISO metric threads and is followed by the nominal diameter.

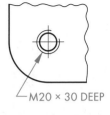

M20 × 30 DEEP

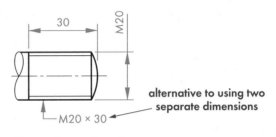

alternative to using two separate dimensions

External screw thread

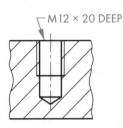

M12 × 20 DEEP

Internal screw threads

Chain dimensioning

Chain dimensioning consists of a chain of dimensions. This method can lead to an accumulation of tolerances that will affect affect the function of the part.

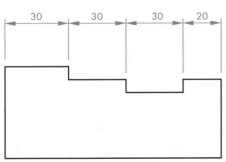

Running dimensioning

Running dimensioning is a simplified form of parallel dimensioning that can be used when space is limited. It has a common origin as shown below. Dimension values may be either above and clear of the dimension line (as in this example), or along the corresponding projection line.

Chamfers

Chamfers at 45° should be dimensioned as shown. Chamfers at an angle other than 45° should dimension the angle separately.

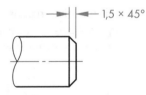

1,5 × 45°

45° chamfer

Countersinks

Two examples of dimensioning countersunk holes are shown. The diameters of the countersink and the hole and the angle of the countersink should be given.

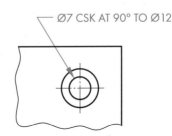

Ø7 CSK AT 90° TO Ø12

Plan view of countersink

90°
Ø12
Ø7

Sectional view of countersink

Dimensioning diameters
Circles dimensioned in a variety of acceptable methods:

Dimensions of diameters indicated by leader lines:

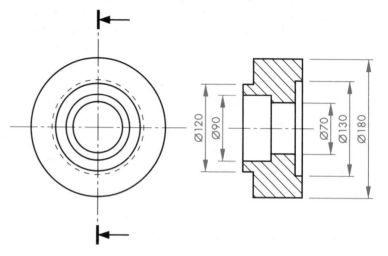

Dimensions of diameters should be placed on the view providing the greatest clarity:

Orientation of dimensions
This diagram shows where linear dimensions should be placed on sloping edges:

Angular dimensions can be positioned using either of the methods shown below:

Tolerances

When products are manufactured in industry, because of inaccuracy in manufacturing processes it is very difficult to achieve absolute accuracy in the size of the finished item. This creates problems when manufactured items have to fit accurately with other parts. When individual component parts are manufactured in batches of thousands or more, it is not economic to accept parts that do not fit and so cannot be assembled. To overcome this problem, items are manufactured with an acceptable margin of dimensional error called the **tolerance**.

Tolerances that affect the size of an item or features contained within an item are known as **dimensional tolerances**. Tolerances can also be applied to the dimensions of location features on the item, e.g. the position of holes and slots to ensure that one part can be assembled with the next part.

For example, the height of a pin of an electrical plug, as shown below, is 10mm. The company has determined that this size could vary between 9,75mm and 10,25mm and still be able to fit in the slot provided for it in the wall socket. In this case a tolerance of 0,5mm could be applied to this dimension without affecting the function of the part. This 0,5mm tolerance band is normally stated as ± 0,25mm.

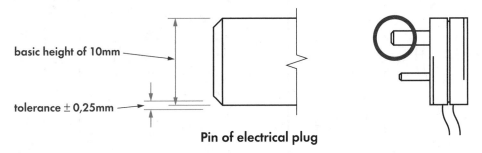

basic height of 10mm

tolerance ± 0,25mm

Pin of electrical plug

Functional and non-functional dimensions

In practice, all dimensions in manufacturing drawings are subject to tolerances. There are however two distinct types to consider: **functional** and **non-functional** dimensions.

Functional dimensions are dimensions that directly affect the function and fit of parts. An example is the diameter of a sink plug which must fit into a plug hole in a sink. **Non-functional dimensions** are dimensions that do not directly affect the function or fit of a part, but may allow the product to meet other criteria such as final appearance or strength. An example is the height of a sink plug, which could vary without affecting its function.

There are two ways to represent tolerances in manufacturing drawings. **Non-functional dimensions** are generally represented in note form in the title block and are often referred to as general tolerances. For example:

TOLERANCES UNLESS OTHERWISE STATED
LINEAR ±0,25 ANGULAR ±0°30'

Tolerances on **functional dimensions** are represented by attaching information to individual dimensions on the drawing. The methods used to indicate tolerances on individual dimensions are shown below.

Linear dimensions

- The **common method** shows the upper limit of size placed above the lower limit.

- **Symmetrical tolerance** shows the nominal size and the symmetrical tolerance band.

- **Asymmetrical tolerance** shows the nominal size plus the upper and lower limits of the tolerance band.

```
 31,25
 30,55                42 ± 0,15              + 0,35
                                           55 - 0,55
```

Angular dimensions

Tolerances of angular functional dimensions are indicated in much the same way as linear dimensions by giving information on individual dimensions, as shown.

- **Common method**

- **Symmetrical tolerance**

- **Asymmetrical tolerance**

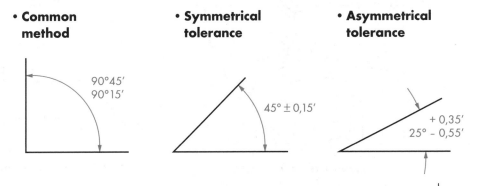

90°45'
90°15'

45° ± 0,15'

+ 0,35'
25° - 0,55'

DIMENSIONING AND TOLERANCING EXAMPLE

Dimensioning and tolerancing example

Component drawings of a cast aluminium soap dish have been produced by a manufacturing company. To ensure that the lid locates with the legs on the base, slots 1, 2, 3 and 4 must be accurately machined (cut).

The functional dimensions and relevant tolerances are:

Functional dimension	Tolerance
Dimension between slots 2 and 4 (A)	−0,1 −0,2
Dimension between slots 1 and 3 (B)	−0,1 −0,2
Width of each slot (C)	+0,55 +0,35
Slot locations (D)	−0,2 −0,3
Depth of slots 1 and 2 from corner X	+0,15 0
All other (non-functional) dimensions	±0,25

For you to do

- Draw the plan view of the lid to a scale of 1:1.
- Add all the functional dimensions to the drawing and show the tolerances.
- Find the maximum and minimum depths of slots 3 and 4.

The solution is given on page 221.

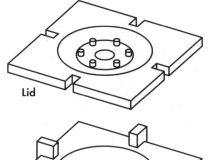

Lid

Base

Exploded view

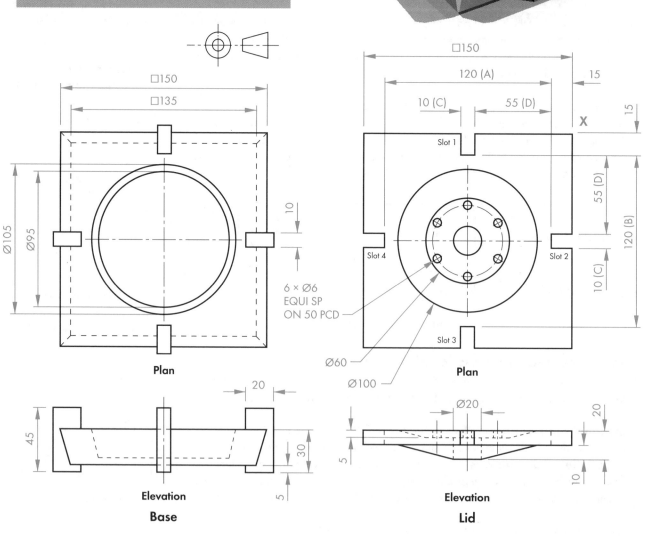

□150
□135
Ø105
Ø95
10

Plan

Base

Elevation

6 × Ø6
EQUI SP
ON 50 PCD

20
45
30
5

□150
120 (A)
15
10 (C)
55 (D)
X
15
Slot 1
55 (D)
120 (B)
10 (C)
Slot 4
Slot 2
Slot 3
Ø60
Ø100

Plan

Lid

Elevation

Ø20
20
5
10

Orthographic assembly drawing

Many everyday products are assembled from a number of individual component parts. The components are manufactured separately and assembled later. A drawing that shows the product with all the components in place is known as an assembly drawing. This type of drawing is often used in instruction manuals to show how the individual components are assembled.

You will be asked to create assembly drawings from a number of individual components. There will be detailed drawings of each component which need to be assembled correctly.

Worked example

The seven component parts of a set of bicycle aerobars are shown. The product will be assembled by the cyclist and a drawing is required for the instruction manual.

To a scale of 2:1, with all parts assembled, draw:
• the elevation
• the plan.

Show all hidden detail.

Problem-solving tips

Study all the information you are given, including the small pictorial views. These may show the assembled parts in position. Select and draw the main component. You may be given a starting point on the question paper. Look for clues to assembling the next part:
• holes that line up
• shafts that fit in holes
• other interlocking features.

Add one component after another until the assembly is complete.

Parts List		
Part	Title	No. of
A	Top bracket	1
B	Bottom bracket	1
C	Arm	1
D	Grip	1
E	Allen cap screw	2
F	Countersunk Allen screw	1

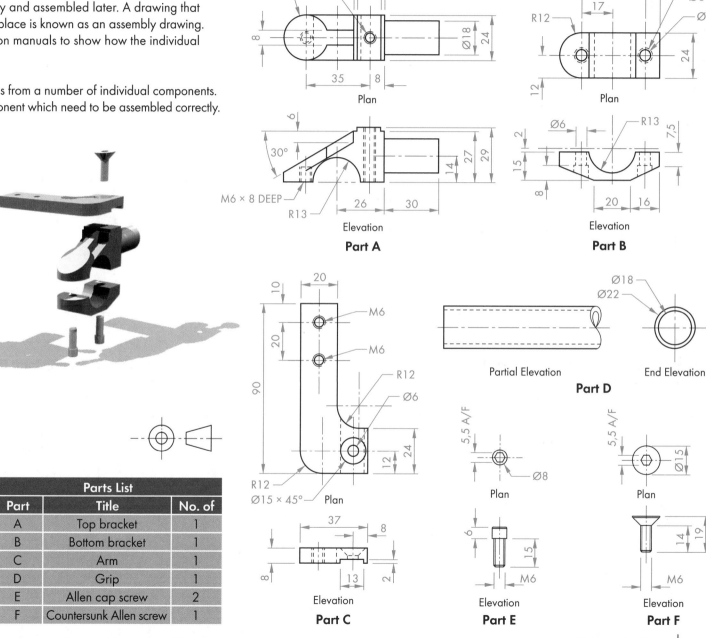

Part A

Part B

Part C

Part D

Part E

Part F

ORTHOGRAPHIC ASSEMBLY DRAWING

1 Draw the plan and elevation of the top bracket (part A)

- Draw the plan of the top bracket.
- Project down from the plan and draw the elevation.
- Use your compass to construct the shaft on the end of the bracket.
- Add the centre lines for the two threaded holes.

2 Draw the elevation of the bottom bracket (part B)

- Draw the elevation of the bottom bracket.
- Start the semi-circular hole on the same centre as part A.
- Add the centre lines for the two counter-bored clearance holes.

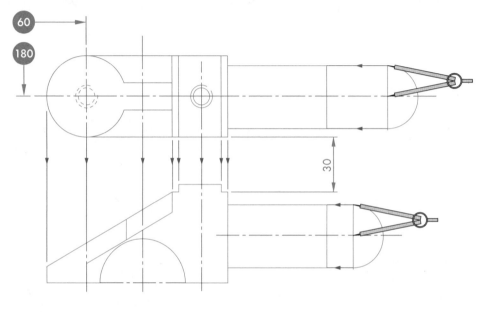

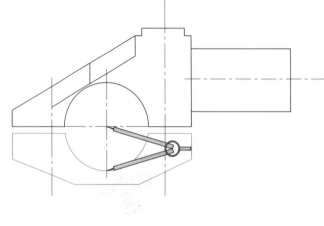

3 Draw the elevation of the arm (part C)

- Draw the elevation of the arm.
- Add the centre lines for the counter-sunk and clearance holes.

4 Draw the elevation of the grip (part D)

- Draw the partial elevation of the grip.
- Use your compass to ensure the diameter is centred.

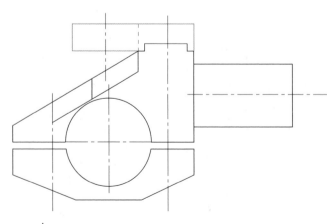

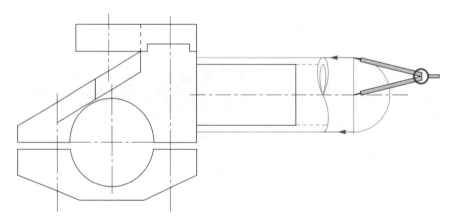

5 Draw the plan of the arm (part C)
- Project from the elevation to draw the plan of the arm.
- Add the centre lines for the counter-sunk and screw threads.
- Draw all holes on the plan.
- Project the diameters down on to the elevation.
- Complete the elevation of part C.

6 Complete the plan and elevation of the top bracket (part A)
- Project the diameters down onto the elevation.
- Project the large diameter up to the plan.
- Complete the elevation and plan of part A and finish in accordance with BS 8888.

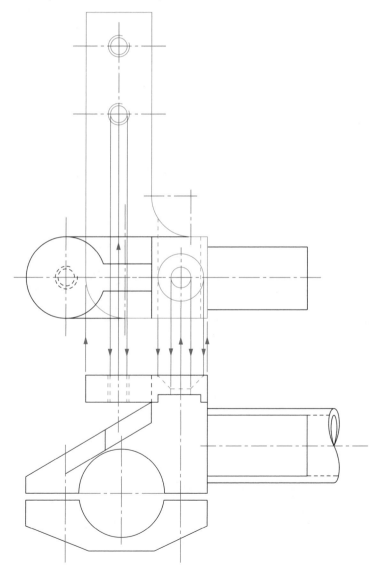

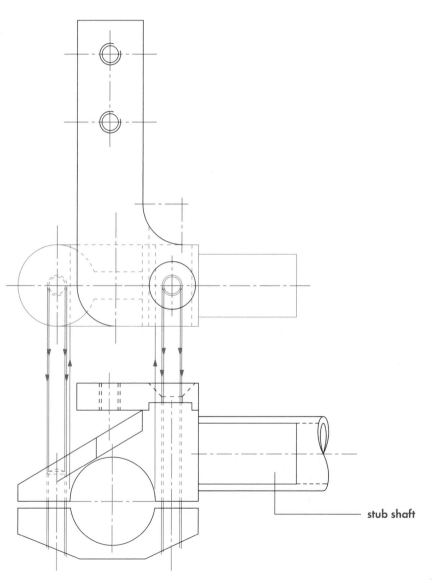

stub shaft

ORTHOGRAPHIC ASSEMBLY DRAWING

7 Draw the plan of the bottom bracket (part B)
- Project the bottom bracket including the two counter-bored holes.
- Construct the circles for the counter-bores and through holes on the underside of the bracket.
- Project the diameters down to the elevation.
- Add the counter–bores to the elevation.

8 Draw the plan of the grip (part D)
- Draw the partial plan of the grip on the stub shaft.
- Use your compass to ensure the diameter is centred.
- Add the break line.

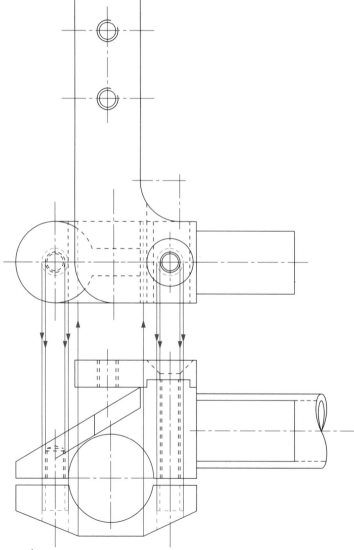

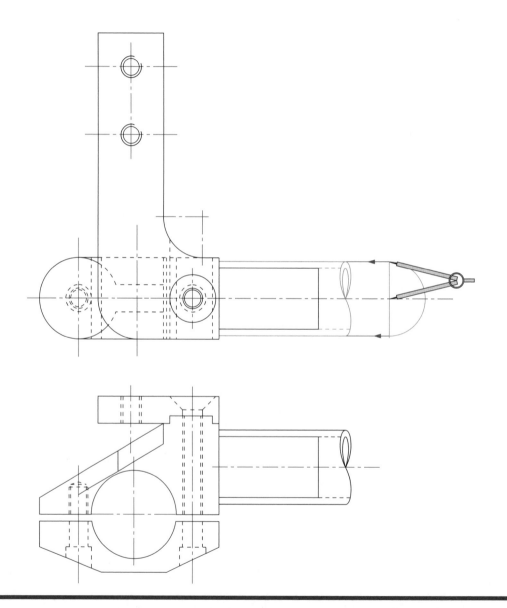

9 Add the screws (parts E and F) to the elevation and plan

- Add the hex detail to the CSK screw on the plan.
- Project down from the plan to draw the hex detail on the elevation.
- Use this construction to draw the hex detail on the elevation of the Allen cap screws. (Do not show this detail on the plan – it is too small to be of benefit.)
- Complete the ends of the three screws in accordance with BS 8888.

10 Firm in

- Firm in the outline of the assembly.
- Title the views.

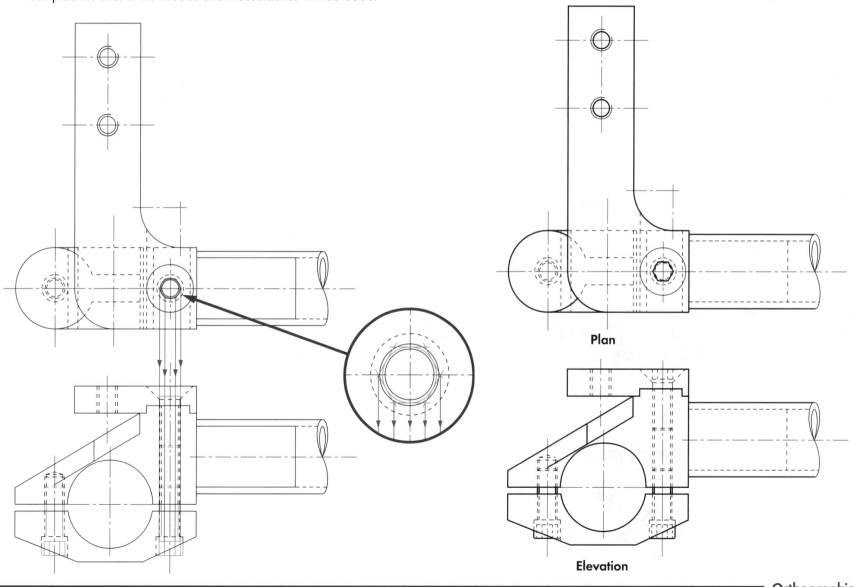

Plan

Elevation

Orthographic full section

Sectional orthographic drawings of assembled parts are used to show internal details of the product and how individual parts connect to form the assembly. Sectional drawings are vital in both the engineering and construction industries for adding clarity to very complex drawings. In this example, a full section is used to show details of the screw fixings and web design of the assembly.

Rules of sectional drawing

- A cutting plane on an adjacent view indicates where the assembly is sectioned.
- Cross-hatching lines are drawn at 45° and are spaced approximately 5mm apart.
- Cross-hatching on adjacent parts must be staggered and run in the opposite directions.
- Cross-hatch to the **inside line** of a threaded hole when a screw is **not in place**.
- Cross-hatch to the **outside line** of a threaded hole when a screw is **in place**.
- Do not cross-hatch webs when they are cut along their length.
- Do not cross-hatch screw or bolt fixings or spindles.

Worked example

A pictorial view of a set of bicycle aerobars are shown. See page 17 for details of the individual component parts. The product will be assembled by the cyclist, but a small sample will be assembled and tested by the manufacturer prior to sale. A drawing is required to show internal details of the product for testing purposes.

Draw the sectional elevation on A–A with all parts assembled to a scale of 2:1. Do not show hidden detail.

This example uses the **Orthographic full section** worksheet, which can be downloaded from the Leckie & Leckie website. If you do not have access to this worksheet you will have to draw the plan view of the assembled parts prior to completing the sectional elevation.

1 Project and draw the elevation of the arm (part C)
- Project the outline of the arm from the plan.
- Use the size from the detail drawing to step out the height.
- Project the countersunk hole detail from the plan.
- Use your 45° set square to finish off the CSK.

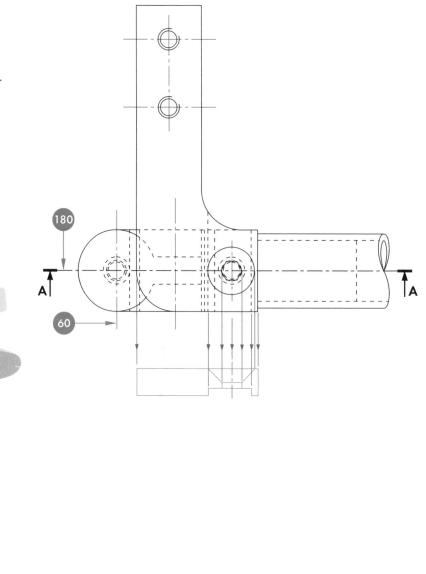

2 Draw the elevation of the top bracket (part A)
- Project from the plan to draw the outline of the top bracket.
- Use your compass to draw the stub shaft on the right of the bracket. This will ensure the shaft is centred.
- Use your compass to draw the semi-circular hole on the bottom of the bracket. (Draw the full circle here as the bottom half will be used to form the top of the bottom bracket.)

3 Draw the elevation of the bottom bracket (part B)
- Project from the plan to draw the outline of the bottom bracket.
- Use the construction from the previous step to construct the semi-circular hole on the top of the bottom bracket.

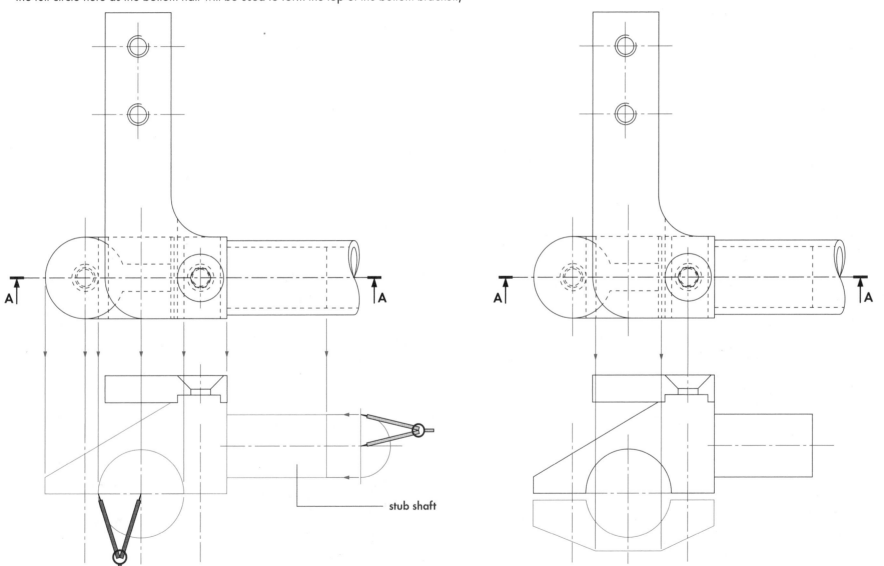

stub shaft

ORTHOGRAPHIC FULL SECTION

4 Draw the hole detail on the elevation of the top and bottom brackets
- Project the diameter of the counterbores from the plan view onto the bottom bracket.
- Project the diameter of the threaded and clearance holes from the plan view onto the top and bottom brackets.
- Use sizes from the detail drawings to finish off the counter bores and the blind screw thread.

5 Draw the partial view of the grip (part D) on the top bracket
- Use your compass to draw the outer diameter of the grip on the stub shaft. This will ensure the grip is centred.
- Project along from the shaft to form the inside diameter of the grip.

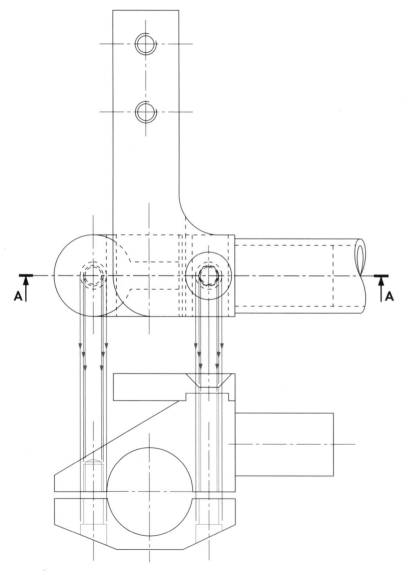

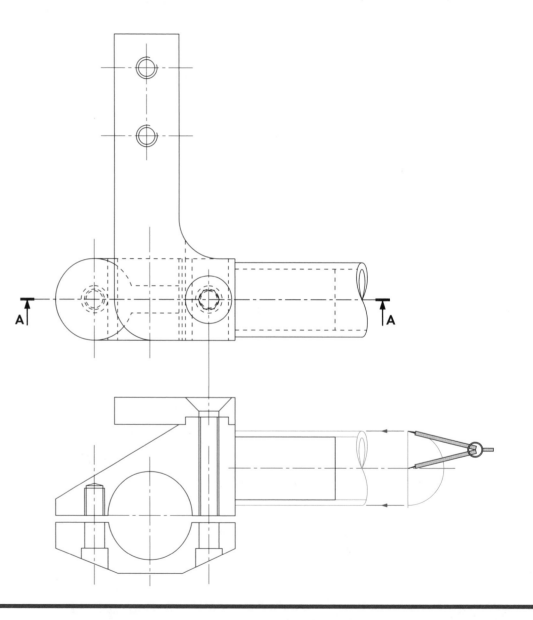

6 Add the screw and web details

- Check the screw lengths on the detail drawings and draw the three screw fixings.
- Project from the plan to form the web detail on the top bracket.

7 Add cross-hatching and firm in

- Add cross-hatching lines to all three cut parts, following the rules for sectional drawing on page 22.
- Complete the outline of the assembly.
- Title the views.

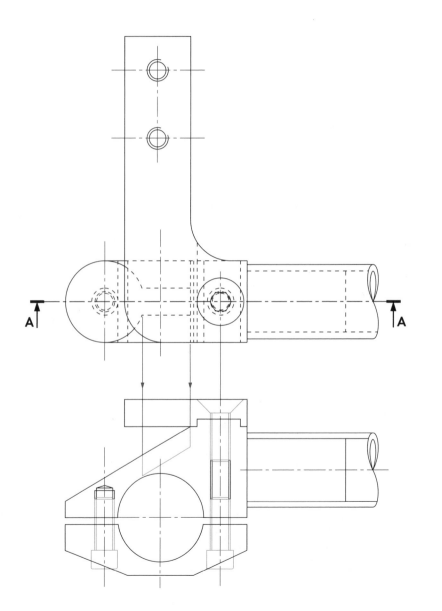

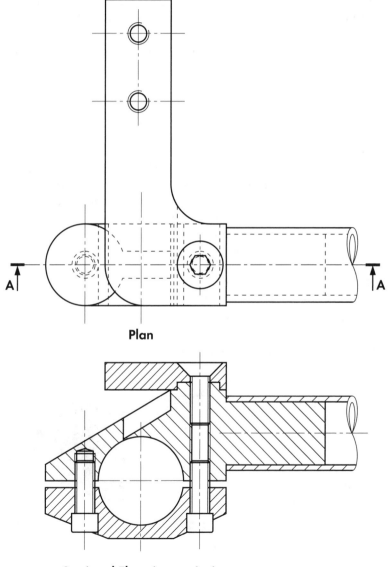

Plan

Sectional Elevation on A–A

ORTHOGRAPHIC STEPPED SECTION

Orthographic stepped section

Stepped sectional views are similar to part sectional views (pages 28–29). They are used when a full sectional view is not needed, but where there is value in showing details of the product through one or more planes.

In stepped sectional views, the cutting plane shown on an adjacent view changes direction. This change in direction usually takes place through the centre of a hole, shaft or feature.

In this example, a stepped section is used to show only the details of the fixings that hold the bracket together.

Rules of stepped sectional drawing

- A cutting plane on an adjacent view indicates where the assembly is sectioned. Where the cutting plane changes direction the line will be thicker at the corner.
- Cross-hatching lines are drawn at 45° and are spaced approximately 5mm apart.
- Cross-hatching on adjacent parts must be staggered and run in the opposite directions.
- Cross-hatch to the **inside line** of a threaded hole when a screw is **not in place**.
- Cross-hatch to the **outside line** of a threaded hole when a screw is **in place**.
- Do not cross-hatch webs when they are cut along their lengths.
- Do not cross-hatch screw or bolt fixings or spindles.
- Do not show hidden detail on sectional views.

Worked example

The seven component parts of a set of bicycle aerobars are shown. An assembly drawing is required to show details of the threaded holes during production.

Draw the stepped sectional elevation on A–A with all parts assembled, to a scale of 2:1. Do not show hidden detail.

This example uses the **Orthographic stepped section** worksheet, which can be downloaded from the Leckie & Leckie website. If you do not have access to this worksheet, you will have to complete the plan view of the assembled parts prior to completing the stepped sectional elevation.

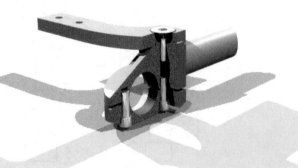

1–6 Construct the evelation of the assembled parts

- Follow steps 1 to 6 of the orthographic full section drawing on pages 22–25.

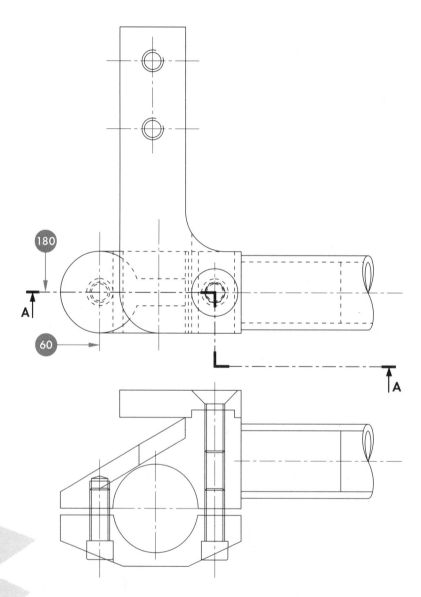

7 Add cross-hatching lines

The shaded area is to be removed. The cut surface will be cross-hatched on the elevation, with the exception of the web, screw fixings and voids.

- Add cross hatching lines to all three cut parts, following the rules for stepped sectional drawing.
- Complete the end of the grip in accordance with BS 8888.

8 Firm in

- Complete the outline of the assembly.
- Title the views.

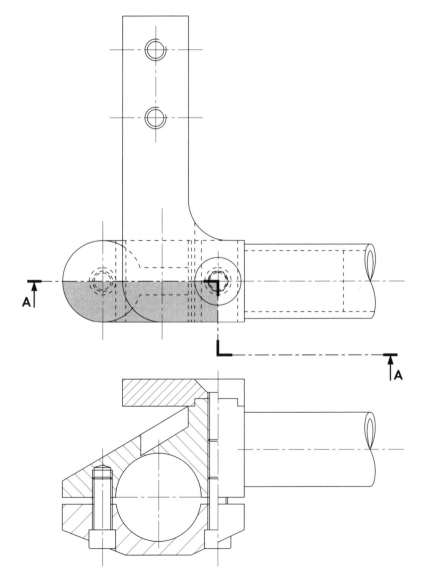

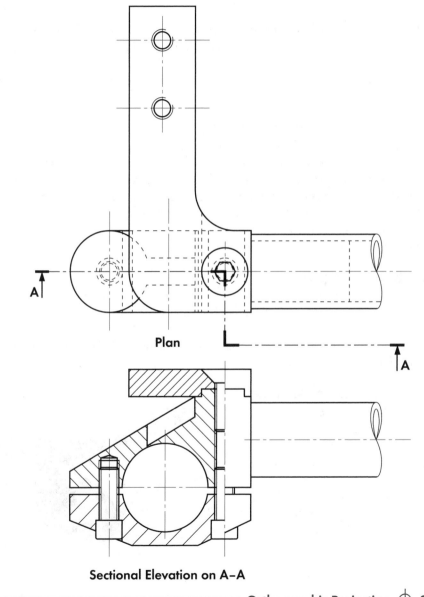

Plan

Sectional Elevation on A–A

ORTHOGRAPHIC PART SECTION

Orthographic part section

When draughtsmen only need to show the internal details of a small part of an assembly, they use a **part sectional orthographic drawing**. This type of view is used when a full sectional view is not needed, but there is value in showing one part of the assembly as a sectional view.

Part sectional views do not always have a cutting plane shown on the given views. Instead, a note will explain which part of the assembly has to be shown as a sectional view.

In the following example, a part section is used to show only the details of the blind threaded hole on the end of the bracket.

Rules of part sectional drawing

- Cross-hatching lines are drawn at 45° and are placed approximately 5mm apart.
- Cross-hatching on adjacent parts must be staggered and run in the opposite directions.
- Cross-hatch to the **inside line** of a threaded hole when a screw is **not in place**.
- Cross-hatch to the **outside line** of a threaded hole when a screw is **in place**.
- Do not cross-hatch webs when they are cut along their length.
- Do not show hidden detail on sectional views.
- Do not cross-hatch screw or bolt fixings or spindles.

Worked example

The seven component parts of a set of bicycle aerobars are shown. An assembly drawing is required to show details of the threaded blind hole during production.

Draw to a scale of 2:1 a part sectional elevation of the assembled aerobars, showing details of the blind screw fixing.

This example uses the **Orthographic part section** worksheet, which can be downloaded from the Leckie & Leckie website. If you do not have access to this worksheet you will have to draw the plan view of the assembled parts prior to completing the part sectional elevation.

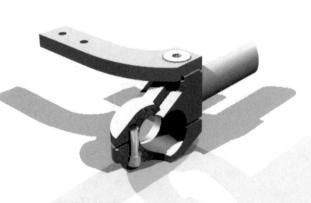

1–6 Construct the elevation of the assembled parts
- Follow steps 1 to 6 of the orthographic full section drawing on pages 22–25.

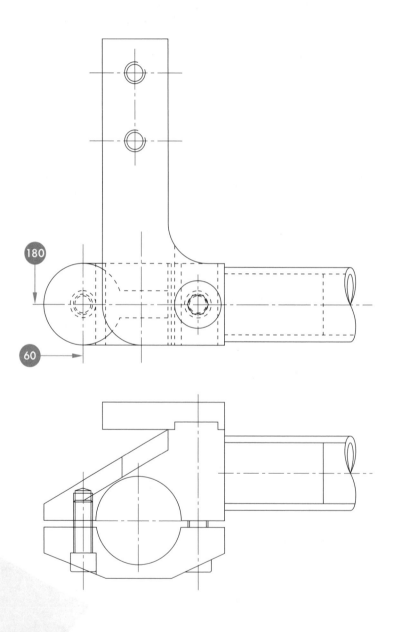

7 Add cross-hatching lines

- Position the freehand break line beside the detail to be exposed, in this case the blind screw fixing.
- Add cross hatching lines to both cut parts, following the rules for part sectional drawing.

8 Firm in

- Complete the outline of the assembly.
- Title the views.

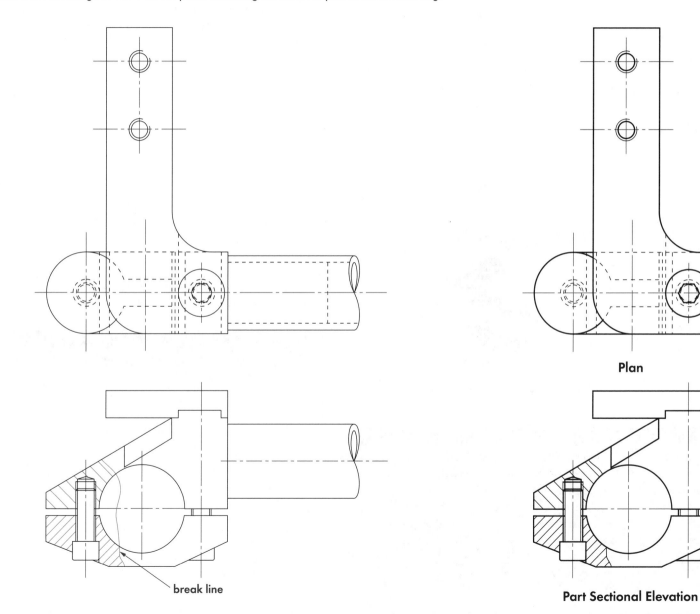

Plan

break line

Part Sectional Elevation

EXPLODED ORTHOGRAPHIC DRAWING

Exploded orthographic drawing

Instruction manuals and catalogues often need exploded views of complete products. These types of drawings give more detail than assembly drawings and are used to show how individual components align or fit together.

At Higher level you will be given a pictorial view and a number of detail drawings from which you will produce exploded orthographic drawings.

Rules of exploded orthographic drawing

• Parts should be exploded along the axis or plane that connects them when they are assembled.
• There must be clear space between each component part.

Worked example

The pictorial view of a set of bicycle aerobars is shown. The product will be assembled by the cyclist and a drawing is required to accompany the parts list in the instruction manual.

Draw to a scale of 2:1 an exploded orthographic elevation of the component parts, showing the top bracket (part A) as a sectional view. Show all hidden detail. Refer to page 17 for details of the individual component parts.

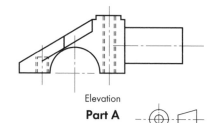

Plan

Elevation

Part A

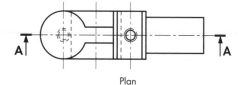

1 Draw the elevation of the top bracket (part A)

• Construct the elevation of the top bracket.
• Construct a half plan of the left end and project up to locate the web detail.
• Draw the stub shaft on the right of the bracket using your compass. This will ensure the shaft is centred.

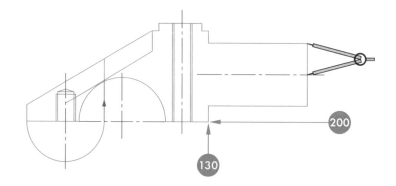

2 Add hatching lines to the top bracket

• Add hatching lines to the elevation.

> **Remember**
> Pay close attention to sectioning through webs – refer to BS 8888.

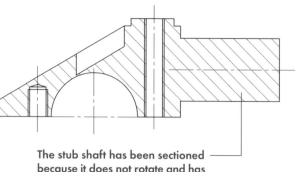

The stub shaft has been sectioned because it does not rotate and has been cast as one part.

> **Problem-solving tips**
>
> This topic involves a great deal of problem solving. You should:
> • Use the pictorial view and detail drawing to visualise how the product will look when exploded along the axis.
> • Look for similar sizes or mating features on the component drawings and establish which axes or planes the object can be exploded along.
>
> • Study all the information you are given, including pictorial views. These will show the assembled parts in position.
> • Select and draw the main component. You may be given a starting point on the question paper.
> • Remember to tackle the drawing in a methodical manner, adding one component after another until the drawing is complete.

3 Draw the elevation of the bottom bracket (part B)
- Project down 20mm from the underside of the top bracket for the top surface of the bottom bracket.
- Project down from the elevation to form the outline of the bottom bracket.

4 Draw the outline of the arm (part C)
- Project up 20mm from the top bracket and draw the outline of the arm.

5 Draw the outline of the screws (parts E and F)
- Project and space the screws 20mm from their components.
- Draw the screws, taking care to add screw threads correctly (BS 8888).

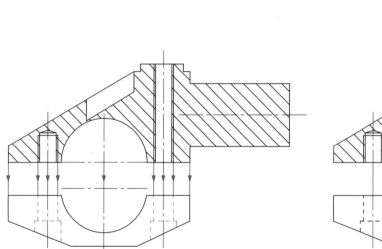

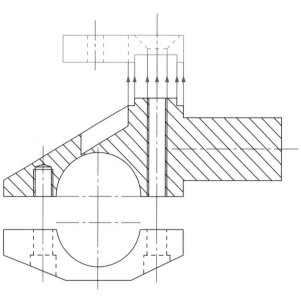

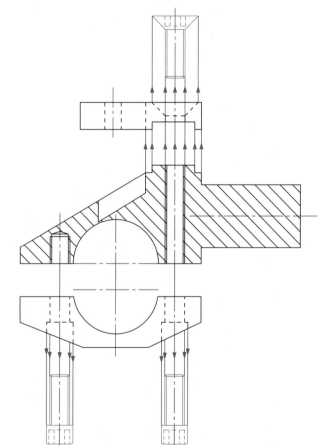

EXPLODED ORTHOGRAPHIC DRAWING

6 Draw the partial elevation of the grip (part D)
- Project 20mm to the right of the stub shaft.
- Project across the centre line and outside diameter of the stub shaft – this is the inside diameter of part D.

7 Firm in
- Firm in the outline of the view.
- Title the view.

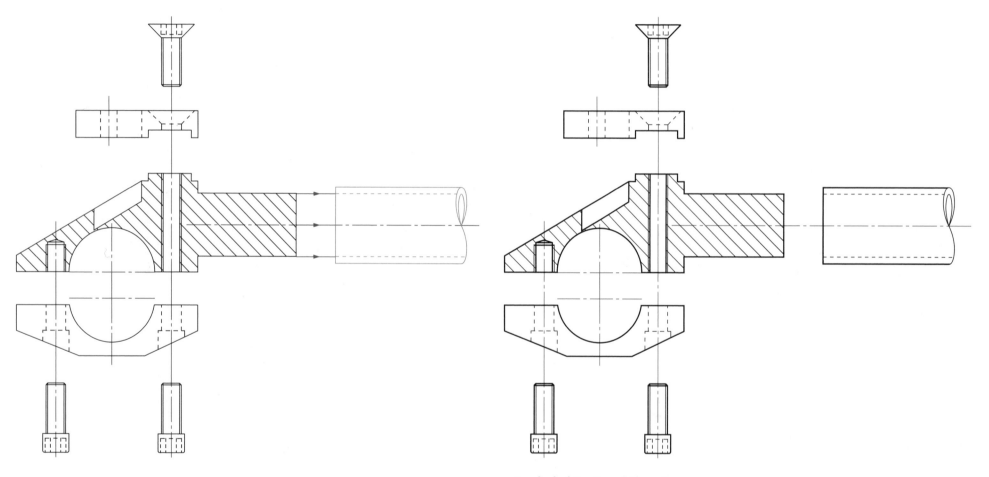

Exploded Sectional Elevation

Half section assembly

Components and assemblies that are symmetrical about an axis can be shown in **half section**. This means that one half of the object is shown as a sectional view while the other half shows an external view. It saves drawing time and space on the sheet and enables the user to view the inside and outside of the assembly at the same time.

Worked example

A compact sports pump for inflating balls is being designed. The manufacturer needs drawings to show how the components are to be assembled.

Draw:
- the plan view of the pump showing all hidden detail and a stepped cutting plane
- an elevation of the pump in half section. (Position the plunger mid-way down the cylinder, and shorten the shaft to fit the elevation on the sheet.)

Problem-solving tips

Study all the information given. In this case the component drawings show the dimensions you need and the exploded view gives an idea of how the components are assembled. The pictorial view gives you a clear picture of the exterior when the pump is assembled.

The pump comprises seven components. In order to simplify the half section assembly drawing, tackle the drawings in two parts. Do a full assembly first, then remove the half-section.
- Draw one component at a time in plan and elevation.
- Draw the plan view of the component first and project the elevation.
- Draw the complete assembly in construction lines before you remove the half section.

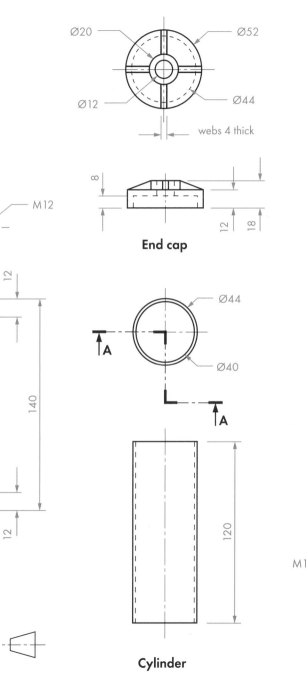

Shaft

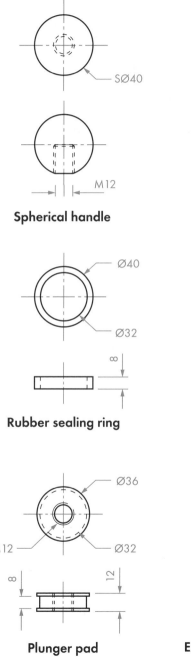

End cap

Spherical handle

Cylinder

Rubber sealing ring

Plunger pad

Exploded view

1 Draw the cylinder
- Draw two centre lines on the plan, no lower than 35mm from the top of your sheet.
- Draw the two circles of the cylinder.
- Project down and draw the elevation of the cylinder.

2 Draw the end caps
- Draw the end caps on the plan view (three additional circles).
- Draw the webs.
- Project down to the elevation and add the end caps to both ends of the cylinder.
- Draw the webs to the left, right and centre.

3 Draw the plunger
- Draw four circles, including the screw thread, on the plan.
- Project down and add the plunger to the elevation. (Place it mid-way down the cylinder.)

4 Draw the rubber seal ring

The seal ring stretches over the rim and fits into the groove in the plunger.

- Project the seal ring from the plan and draw it in place on the elevation.

5 Draw the shaft

- Both circles, including the screw thread, are already on the plan (from step 3).
- Project down to the elevation.
- Include break lines to shorten the shaft from 140mm to 110mm.
- Remember to add the M12 screw threads at each end.

6 Draw the handle

- Use the 40mm circle already on the plan.
- The handle has a screw hole in the lower half. To find the centre of the handle on the elevation, set your compass to 20 and scribe an arc across the centre line from the bottom of the screw thread.
- Draw the centre line and complete the circle.
- Add the threaded hole.

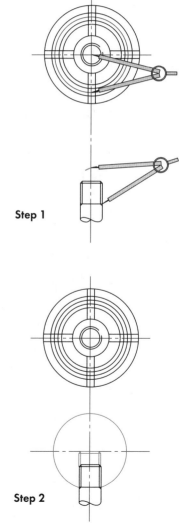

Step 1

Step 2

7 Draw the cutting plane and section the end caps
- Draw the stepped cutting plane A–A on the plan. (Thicken the ends and the corners of the cutting plane.)
- Project from where the cutting plane slices through the end cap.
- Section the end caps on the elevation.
- Add cross-hatching at 45°. (Remember, you do not section a web when it is cut along its length.)

8 Section the cylinder
- Project from the intersection of the cutting plane and the wall of the cylinder.
- Section the cylinder on the elevation.
- Cross-hatch in the opposite direction to the end caps.

9 Section the plunger and rubber seal
- Project from the intersection of the cutting plane and the plunger and rubber seal.
- Section both parts on the elevation.
- Take care to alternate and stagger the cross-hatching.

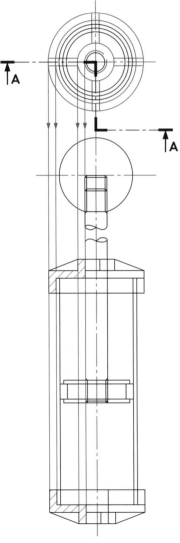

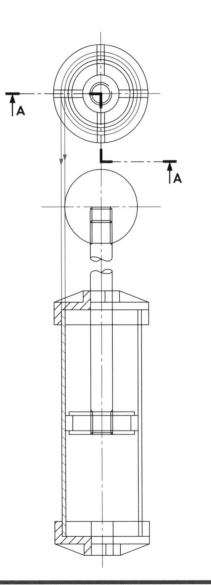

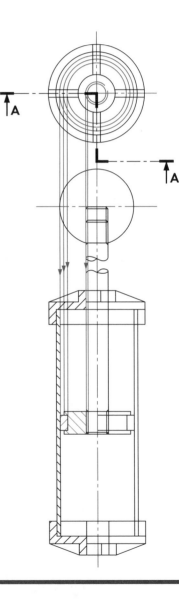

10 Section the handle
- Project from the intersection of the cutting plane and the handle.
- Cross-hatch the handle. (Note: the cross-hatching around the screw thread meets the thread on the shaft, but travels further into the hole above it.)
- Firm in the shaft – this is **not** sectioned (BS 8888).

11 Firm in the right side of the pump assembly
- Carefully check your projection is accurate and line in the exterior of the pump assembly.
- Do not show hidden detail (BS 8888).

12 Firm in the drawing
- Firm in each line on both views.
- Add titles.

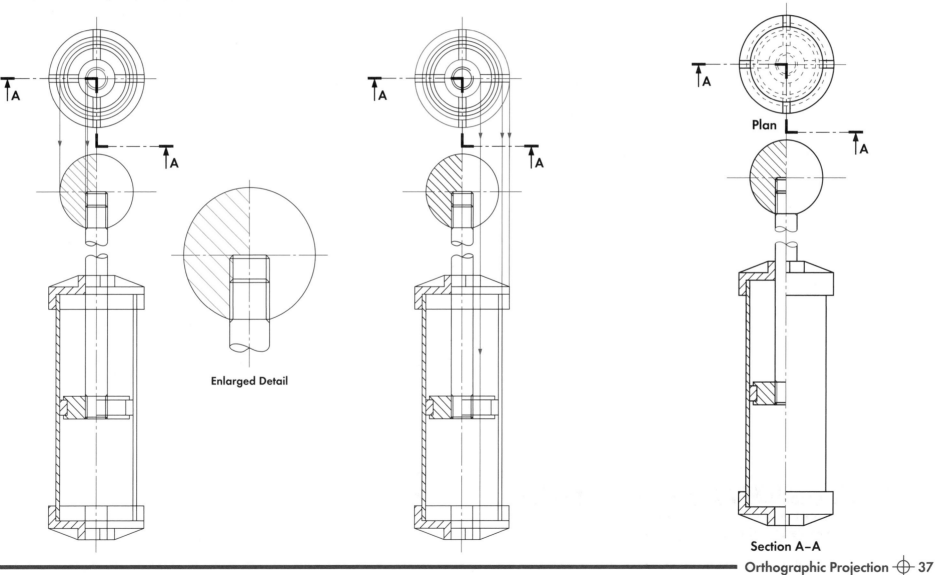

Enlarged Detail

Plan

Section A–A

Auxiliary plan

The term **auxiliary** means **extra** or **additional**. Projecting an auxiliary plan is very much like projecting the true shape of a surface. However, an auxiliary view is the projection of the whole object rather than just a surface. Auxiliary plans are used to show an object or building from a different angle.

Worked example

A new air freshener is being designed. The body is a hexagonal prism with a 60° slice that creates a sloping surface. The slope is intersected by the replaceable cartridge. Drawings are needed to plan colour schemes and graphics. Additional views are required of the air freshener.

Draw:
• the plan view including the line of intersection
• the elevation
• the end elevation
• the auxiliary plan to show the true shape of the sloping surface.

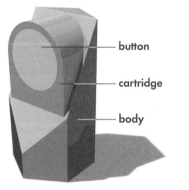

button
cartridge
body

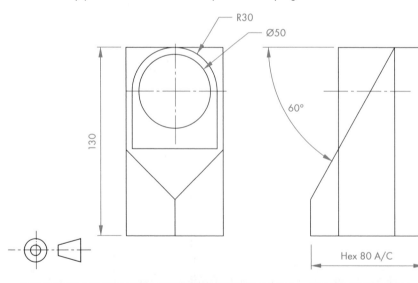

R30
Ø50
60°
130
Hex 80 A/C

1 Draw the plan and elevation
• Draw the hexagon for the plan.
• Project the elevation.
• Label the edges of both views **a** to **f** as shown.

2 Project the end elevation
• Position a 45° bounce line.
• Project the end elevation.
• Label the edges on the end elevation **a** to **f** as shown.

Note

Note that you can see the line of intersection on both views. This will enable you to project the intersection line onto the plan.

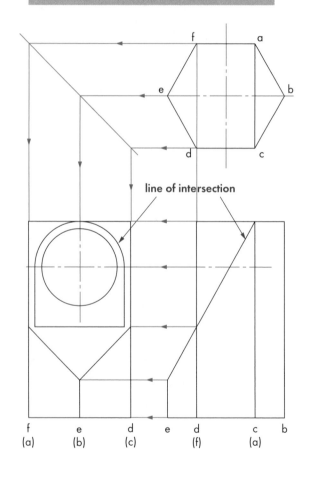

70
60
40

f a
e b
d c

e d c b
(f) (a)

f e d
(a) (b) (c)

line of intersection

f a
e b
d c

e d c b
(f) (a)

Problem-solving tips

• Don't try to picture what the auxiliary view will look like.
• Follow the procedure methodically and you will arrive at the correct solution.

3 Draw the line of intersection

- Construct a semi-circle on the plan. Divide it into six and project generators across the cartridge.
- Construct a quarter circle on the elevation. Divide it into three and project generators across to the line of intersection. Number each generator.
- Project up from the line of intersection to the plan.
- Plot the line of intersection where generators meet on the plan.

4 Project the true shape of the sloping surface

- Project from the elevation at 90° to the sloping surface.
- Draw in a datum line (in this case the centre line) at 90°.
- Identify and label the same datum line on the end elevation.
- Step the breadths from the end elevation onto the auxiliary plan and draw the true shape.

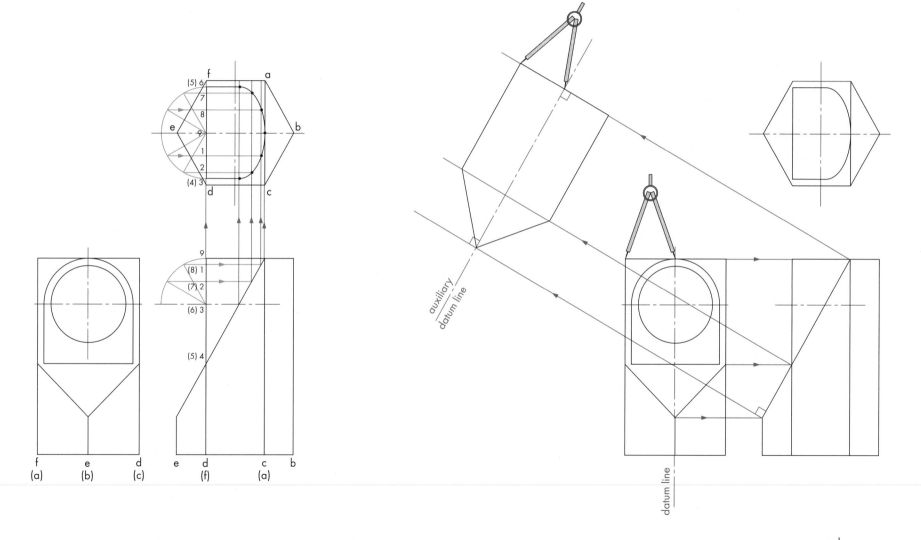

5 Draw the line of intersection on the auxiliary view

- Divide the cartridge on the end elevation into six and number each point.
- Project these points across to the elevation and up to the auxiliary plan.
- Step the breadths from the end elevation onto the auxiliary plan.
- Draw in the line of intersection.

6 Project the base and top surface

- Project the base from the elevation and transfer the breadths from the end elevation.
- Project the top surface using the same method.
- Draw in the base and top surface.

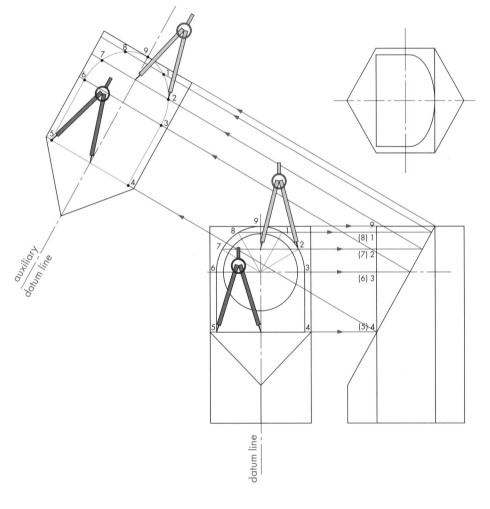

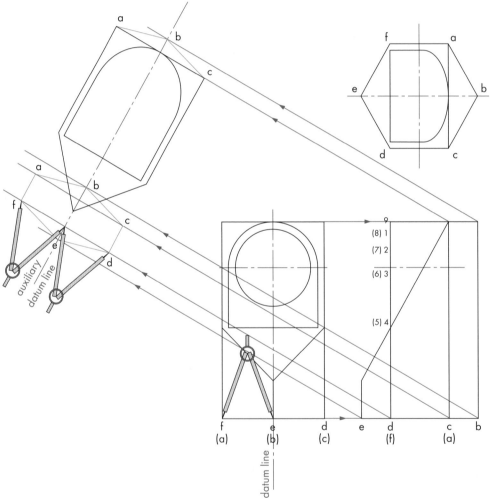

7 Project each surface in turn

- Project from the two lower surfaces.
- Transfer the breadths from the end elevation.
- Draw the edges.

8 Project the front of the cartridge

- Project the front of the cartridge from the end elevation to the elevation and up to the auxiliary plan.
- Transfer the breadths from the end elevation.
- Sketch in the curve.

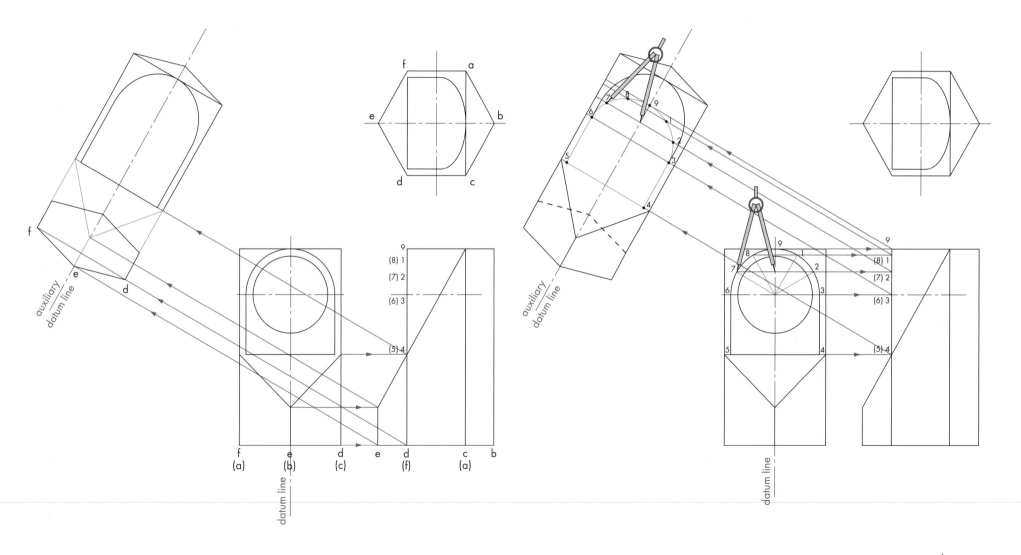

AUXILIARY PLAN

9 Project the activator button
- On the end elevation, divide the button into twelve and number it.
- Project each point to the elevation and up to the auxiliary plan.
- Transfer breadths from the end elevation to the auxiliary plan.
- Sketch in the button.

10 Firm in the auxiliary plan
- Add hidden detail.
- Firm in the completed auxiliary plan.
- Title each view.

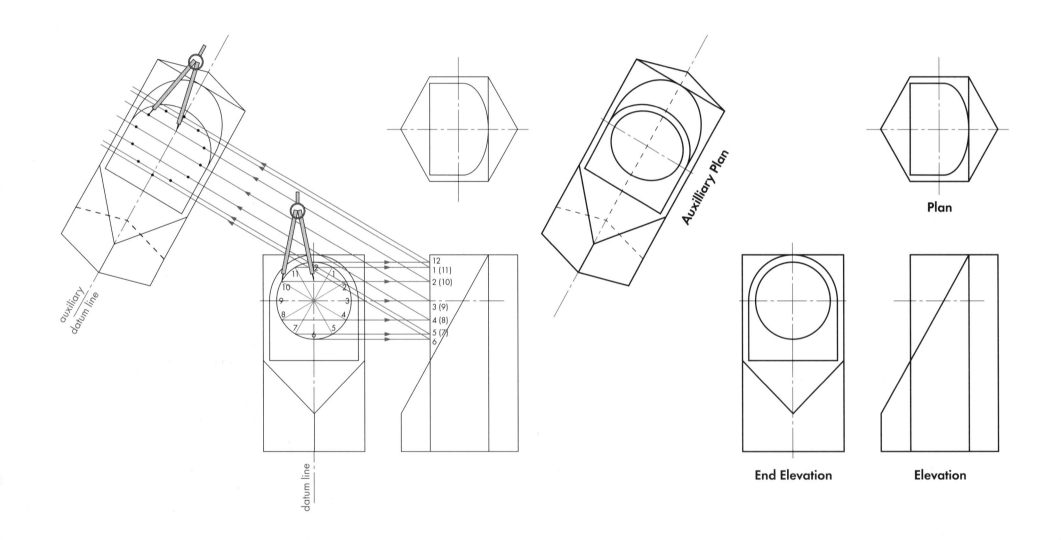

Auxilliary Plan

Plan

End Elevation

Elevation

auxiliary datum line

datum line

Auxiliary elevation

An auxiliary elevation is projected from the plan but it is projected at an angle, not straight down. This angled projection gives the reader another view point that can aid the understanding of the object or building.

Worked example

An auxiliary view of the air freshener is required.

Using the plan and elevation shown below, draw the auxiliary elevation projected at 45°, showing hidden detail.

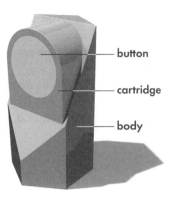

button
cartridge
body

1 Draw the hexagonal plan and project the elevation
• Draw the plan and project the elevation.
• Draw the cartridge on the elevation.

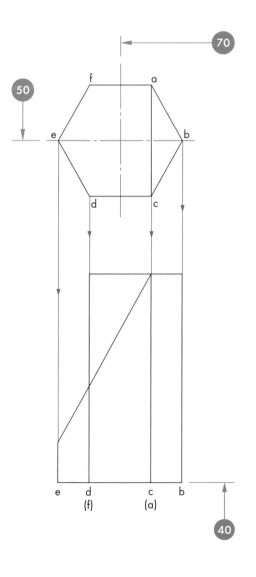

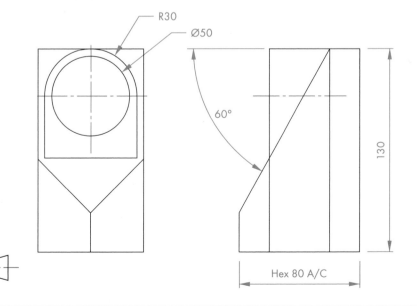

45°

R30
Ø50

60°

130

Hex 80 A/C

2 Project the line of intersection on the plan

- Draw a quarter circle construction on the elevation.
- Divide the quarter circle and project surface generators back to the line of intersection.
- Project from the line of intersection up to the plan.
- Add a semi-circular construction to the plan and project generators across the plan.
- Number the generators as shown.
- Plot the line of intersection on the plan where the generators meet.
- Firm in the line of intersection on the plan.

3 Project at the given angle and draw the datum line and the nearest surface

- Project one surface at 45°.
- Draw a **datum line** perpendicular to the projection lines. This is the **auxiliary datum line**.
- Select a datum line on the elevation – this will normally be the ground line – and label it. (Note: the datum lines on the elevation and the auxiliary datum line are the same line.)
- Lift heights along edges **d** and **e** and step them above the auxiliary datum line.

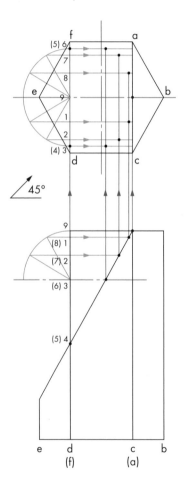

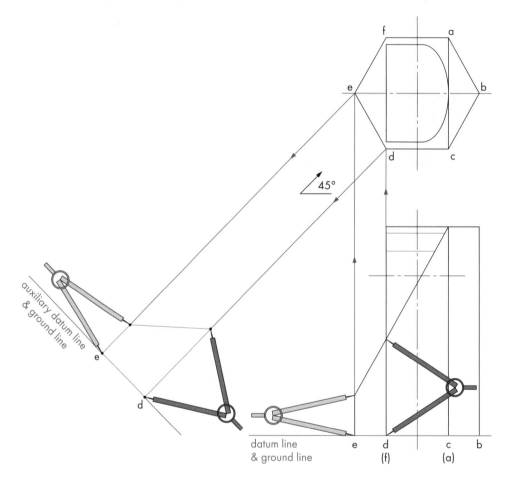

4 Project other surfaces onto the auxiliary elevation
- Project edges **c** and **f** from the plan.
- Lift heights from the elevation and step them above the auxiliary datum line.

5 Project surfaces from the back of the plan
- Follow the process through in the same way for edges **a** and **b**.

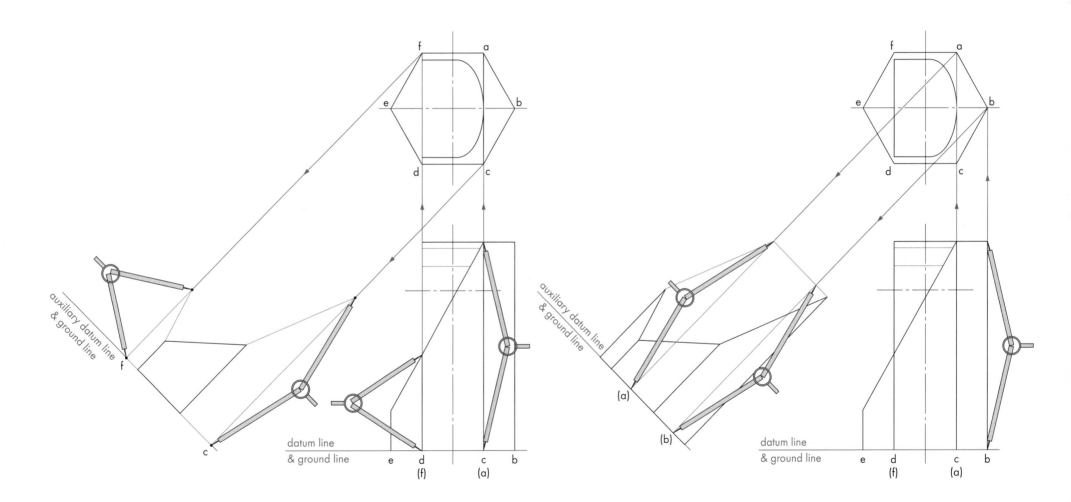

AUXILIARY ELEVATION

6 Project the front of the cartridge
- Project all nine points from the plan.
- Lift each height from the elevation and step off above the auxiliary datum line.
- Firm in the surface.

7 Project the line of intersection
- On the auxiliary elevation, project each point across the view (at 45°).
- Project from the line of intersection on the plan to meet these lines.

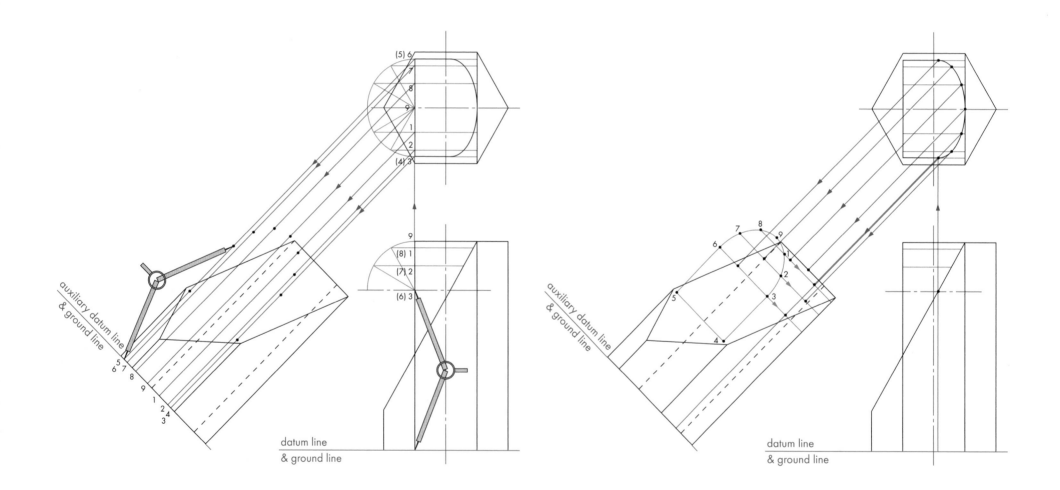

8 Draw the circular button

• Construct a semi-circle on the elevation and plan.
• Divide and number the generators and project back to the face of the cartridge.
• Project from the plan to the auxiliary elevation.
• Step heights from the elevation to the auxiliary elevation.
• Draw the button and firm in.

9 Complete the auxiliary elevation

• Firm in the auxiliary view and centre lines.
• Add hidden detail.
• Title each view.

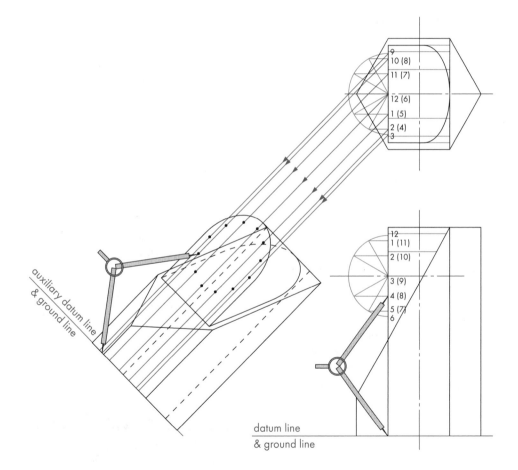

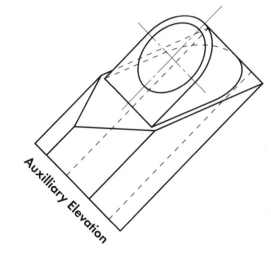

auxiliary datum line
& ground line

datum line
& ground line

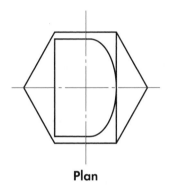

Plan

Auxiliary Elevation

Elevation

Ellipses

Ellipses are common geometric shapes. You see an ellipse when a circle is tilted at an angle.

There are two main methods of construction: the **concentric circle** method and the **trammel** method.

Concentric circle method

1 Draw the major and minor axes
- Draw centre lines to represent the major and minor axes. The long centre line on an ellipse is the major axis. The short centre line is the minor axis.

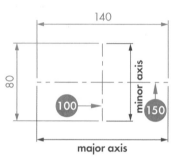

2 Draw the major and minor circles
- Draw the major circle Ø140 and the minor circle Ø80.
- Divide them into twelve with 30° and 60° generators.
- Mark four points on the ellipse.

3 Triangulate points
- Draw horizontal lines where the generators cross the inner circle and vertical lines where they cross the outer circle. Mark the eight points where these lines meet.

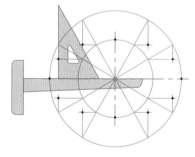

4 Complete the ellipse
- Sketch, freehand, the ellipse through the twelve points.

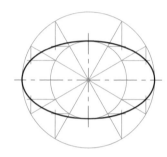

Trammel method

1 Draw the major and minor axes
- Draw the major and minor axes. Label the centre O, the major axis AA and the minor axis BB.

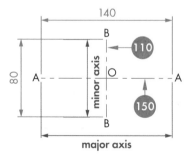

2 Make a trammel card
- Make a trammel from a strip of card. Draw a mark at one end and call it O.
- Mark the lengths from O to A and O to B on the trammel.

trammel

3 Plot points
- Line up trammel marks A and B along the axis centre lines and mark a dot beside the mark O.
- Move the trammel slightly, still keeping A and B on their axes, and mark the next dot.
- Complete one quarter of the ellipse, then move the trammel around to the next quarter. Remember that the ellipse must pass through the end points A and B.

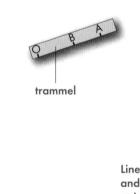

Line up points A and B along the axis centre lines.

4 Complete the ellipse
- Sketch in the ellipse through the points.

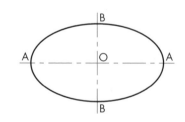

For you to do

Draw two more ellipses of the same size using each method. This time turn them so that the major axis is vertical and the minor axis is horizontal. The solution is given on page 221.

Tangency

A tangent is produced when a straight line and an arc merge together or when two arcs merge together. Your task is to find the centre point of each arc and draw them accurately so that they make tangents with each adjoining line.

Technique 1: scribing arcs

This method can only be used when you are creating an arc (radius) on a **right angled** corner.

Draw a 30mm arc on a right angled corner.

R30

Layout guide
Set your sheet out as shown to fit all three drawings from techniques 1 and 2 on a single sheet.

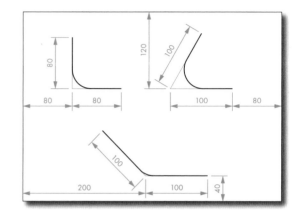

1 Draw the right angle.
• Draw the right angle.

2 Scribe arcs
• Set your compasses to 30mm.
• Scribe two arcs from the corner and across the lines.

3 Find the centre of the corner arc
• With the compasses still set to the 30mm radius, scribe two arcs as shown. The arcs cross at the centre point of the corner arc.

4 Draw the corner arc
• With the compasses still set to 30mm, draw the corner arc.
• Add centre lines and firm in the drawing.

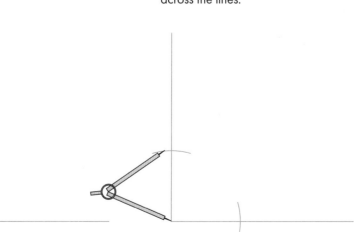

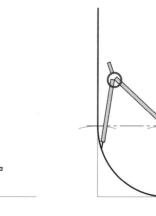

Technique 2: merging straight lines with arcs

A different method must be used on corners that are not right angles. Make sure you understand the process by completing the next two examples. The radius of the arc is 30mm in both examples. See the previous page for layout.

1 Draw the corner
• Draw the corner at 60°.

2 Scribe arcs
• Set the compasses to 30mm and scribe two arcs inside the corner. The arcs should be far enough away from the corner that they don't cross.

3 Find the centre
• Draw two lines parallel to the corner and skimming the arcs. The centre is where they cross.

4 Draw the corner arc
• Draw the corner arc carefully to make a tangent with each straight line.

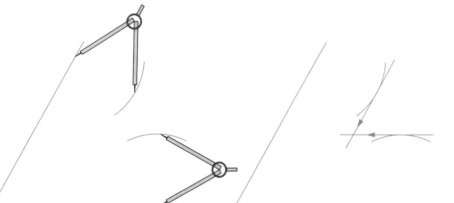
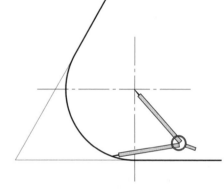

1 Draw the corner
• Draw the corner at 135°.

2 Scribe arcs
• Set the compasses to 30mm and scribe two arcs inside the corner. The arcs should be far enough away from the corner that they don't cross.

3 Find the centre
• Draw two lines parallel to the corner and skimming the arcs. The centre is where they cross.

4 Draw the corner arc
• Draw the corner arc carefully to make a tangent with each straight line.

Technique 3: merging arcs and circles

Tangency problems can also involve two arcs merging. In this case, your task is to find the centre points of each curve and draw them accurately.

A brass pivot plate for a yacht is to be made and drawings are required. Draw the elevation of the pivot plate actual size.

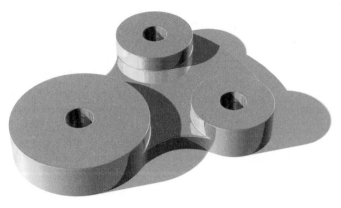

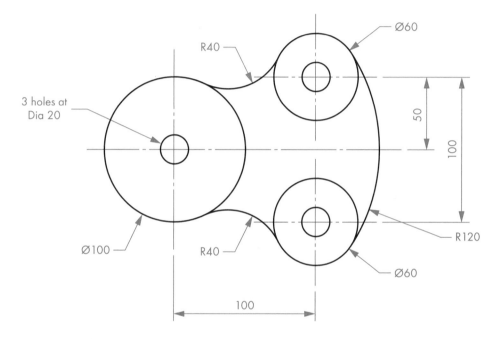

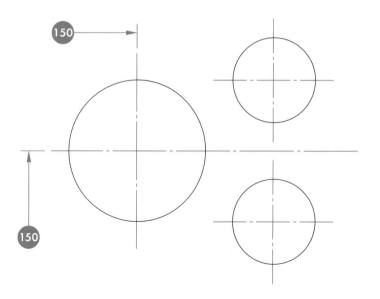

1 Draw the three large circles

• Accurately set out the centre lines and draw the three large circles.

2 Locate the centre of the upper curve

Assess the information on the dimension drawing:

- The upper curve makes a tangent with the largest circle.
- The centre of the largest circle is one of your datum points.

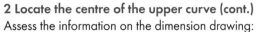

To find the centre of the upper curve:

- Picture the radius of the large circle and the upper curve pointing at each other.
- Add the radii together to find the distance between the centres: 50 + 40 = 90mm
- Set your compasses to 90mm and scribe an arc from the centre of the large circle.

2 Locate the centre of the upper curve (cont.)

Assess the information on the dimension drawing:

- The upper curve makes a tangent with the small top circle.
- You know the radius of both the upper curve (40) and the small circle (30).

To find the centre of the upper curve:

- Picture the radii pointing at each other.
- Add the radii together to find the distance between centres: 30 + 40 = 70mm
- Set your compass to 70mm and scribe an arc from the centre of the small circle.

The centre of the upper curve is where the two arcs cross.

3 Draw the upper curve

- Set your compasses to 40mm and draw the upper curve.
- Use the same process to find the centre of the lower curve and draw it.

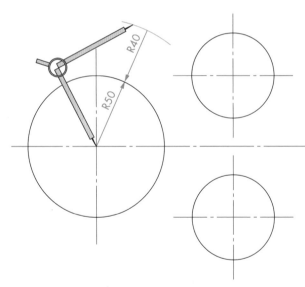

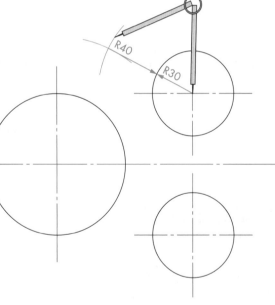

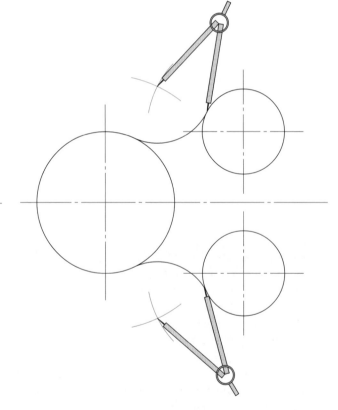

4 Locate the centre of the right hand curve

Assess the information from the dimensioned drawing:

- The right hand curve makes a tangent with both small circles.
- It has a radius of 120mm.
- The radius of the small circles is 30mm.

To find the centre of the right hand curve:

- Picture the radii in line with each other.
- Calculate the distance between the centres of the small circle and right hand curve: 120 – 30 = 90mm
- Set the compass to 90mm and scribe an arc from the centre of the small circle.
- Scribe another arc R90 from the small bottom circle.

The centre of the right hand curve is where the arcs cross.

5 Draw the outer curve

- Set the compasses to 120mm and draw the arc.

6 Complete the drawing

- Draw the three small inner circles.
- Add the centre lines for each arc.
- Firm in the outlines.

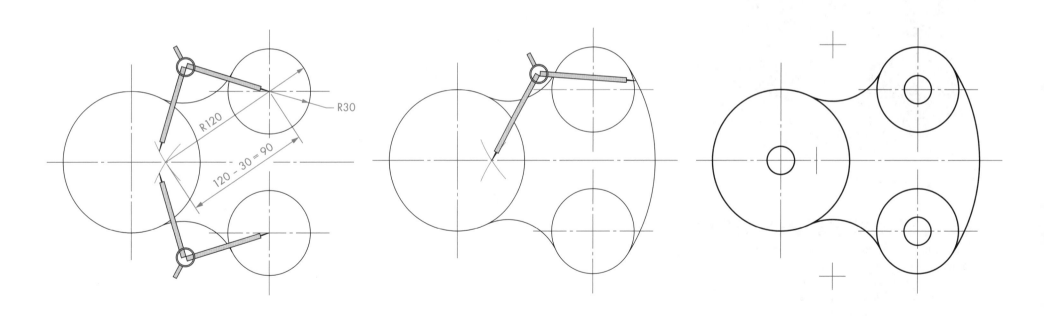

Worked example

An ornate stained glass door with two side windows is being designed for a new hotel development. The top of the door and the side windows are ellipse shaped. Drawings need to be produced so that the stained glass panels can be planned.

Draw the door and windows using the given sizes.

Problem-solving tips

- Draw what you can from the information given.
- Identify which of the three vital pieces of information required to draw each curve is missing:
 1 What is the radius of the curve?
 2 Where is the centre point?
 3 Does the curve make a tangent with adjacent lines?
- You can use the centre points of tangential curves to help you find a missing centre point.

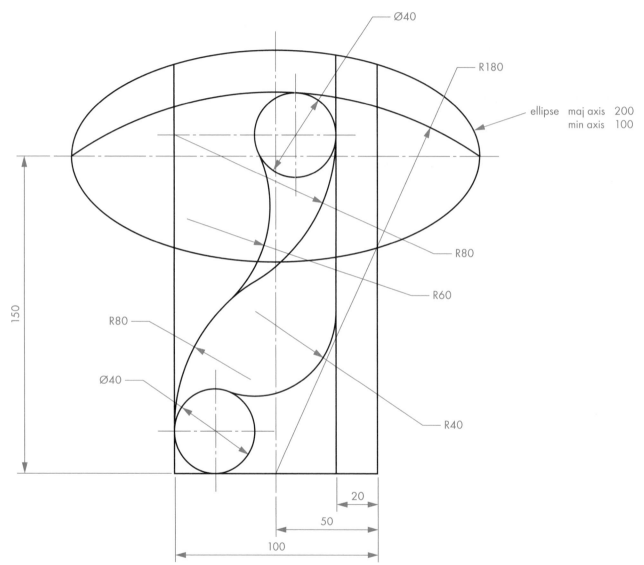

ellipse maj axis 200
min axis 100

1 Draw the ellipse
- Draw two centre lines in the position shown.
- Construct and draw the ellipse. (Refer to page 48.)

2 Draw the outline of the door
- Add all the straight lines.
- Draw curve A R180.

3 Draw the lower circle
Assess the information from the drawing. The lower circle:
- makes tangent points with both straight lines
- has a radius of radius 20mm.

We need to find its centre point.

- Set your compasses to 20mm and scribe two arcs inside the straight lines.
- Skim the tops of the arcs to find the centre.
- Draw the circle.

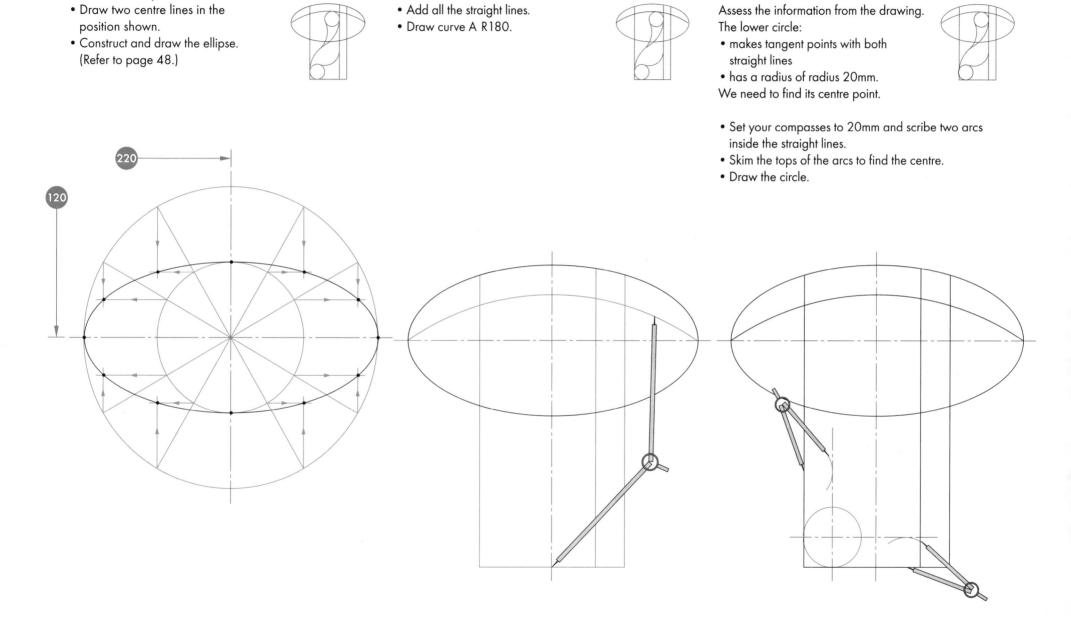

220

120

4 Draw the top circle

Assess the information from the drawing.
The top circle:
- makes tangents with the vertical line and curve A
- has a radius of 20mm.

We need to find its centre.

- Set your compasses to 20mm and scribe an arc inside the line.
- Skim the arc with a vertical to find the vertical centre line.
- Draw an arc 160mm from the centre of curve A (180 – 20 = 160mm).
- From the crossed line draw the top circle.

5 Draw curve B

Assess the information from the drawing.
Curve B:
- makes a tangent with the top circle
- has a radius of 80mm
- has its centre on the centre line of the top circle.

We can calculate that the centre of curve B will be 60mm from the centre of the top circle (80 – 20 = 60mm).

- Set your compasses to 60mm and scribe an arc along the centre line.
- Draw curve B from this centre.

6 Locate the centre of curve C

Assess the information from the drawing.
Curve C:
- makes a tangent with both the bottom circle and curve B
- has a radius of 80mm
- has its centre somewhere to the bottom right of the drawing and we need to find out exactly where.

- Set your compasses to 60mm and scribe an arc from the centre of the bottom circle (80 – 20 = 60mm).
- Set your compasses to 160mm and scribe an arc from the centre of curve B (80 + 80 = 160mm).

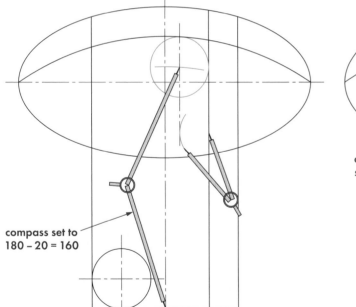

compass set to
180 – 20 = 160

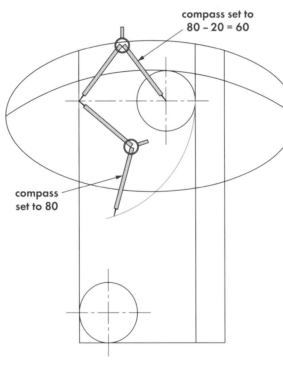

compass set to
80 – 20 = 60

compass set to 80

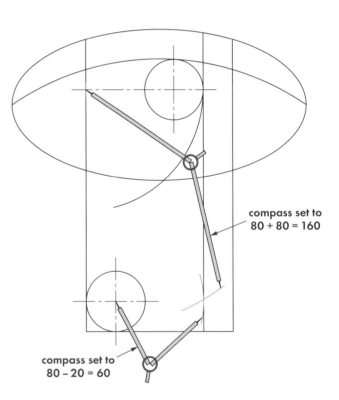

compass set to
80 + 80 = 160

compass set to
80 – 20 = 60

7 Draw curve C

The missing centre is where the arcs cross.

• Set your compasses to 80mm and draw the curve.

8 Locate the centre of curve D

Assess the information from the drawing.
Curve D:

• makes tangent points with both the upper circle and curve C

• has a radius of 60mm.

We need to find its centre.

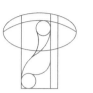

• Set your compasses to 80mm and scribe an arc from the centre of the top circle (60 + 20 = 80mm).

• Set your compasses to 140mm and scribe an arc from the centre of curve C (60 + 80 = 140mm).

9 Draw curve D

The crossing arcs marks the new centre point.

• Set the compasses to 60mm and draw the curve from the new centre point.

compass set to
20 + 60 = 80

R60 R20

R60 R80

compass set to
80 + 60 = 140

10 Locate the centre of curve E

Assess the information from the drawing.

Curve E:

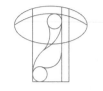

- makes a tangent with both the bottom circle and the vertical line
- has a radius of 40mm.

We need to find its centre.

- Set your compasses to 40mm and scribe an arc from the vertical line.
- Skim this arc with a vertical line.
- Set the compasses to 60mm and scribe an arc from the centre of the bottom circle (20 + 40 = 60mm).

11 Draw curve E

The new centre point is where arc and line cross.

- Set your compasses to 40mm and draw the curve from the new centre.

12 Firm in the outlines

- Firm in outlines.
- Add centre lines.

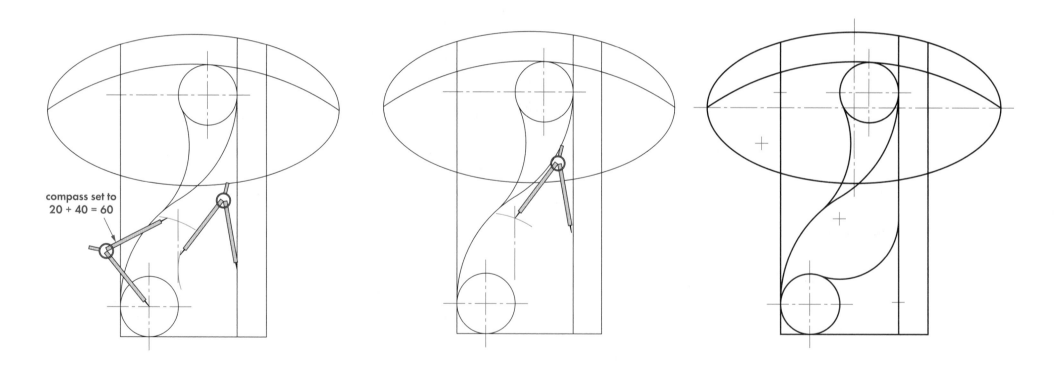

compass set to
20 + 40 = 60

Intersection of surfaces

When a solid object is cut a new surface is created. This new surface meets the original surface of the solid object along a **line of intersection**. At Higher level, questions will often involve curved intersecting surfaces.

Worked example

Production drawings are required for the body of a new corkscrew.
The body is a hollow cylinder with a segment cut away.

Draw:
• the elevation
• the end elevation
• the plan showing the lines of intersection.
Do not show hidden detail.

Problem-solving tips

These drawings are not difficult but require accuracy and a grasp of orthographic projection. Keep both pencil and compass sharp and take measurements carefully. You will learn the **cutting plane method** to enable you to slice up a curved surface – remember this procedure! It is used extensively in the Higher course.

Plan

120

R60

R100

Elevation

190

60

wall thickness 3mm

110

Ø60

Ø12

100

End Elevation

1 Draw the three main views
• Draw the end elevation and project the elevation.
• Use a 45° bounce line to project the plan.

Remember

Always draw the complete cylinder before any parts are removed.

2 Locate the centre of the R100 curve on the elevation

- Draw the vertical centre line common to both curves.
- Set the compass to R100 and scribe an arc across the centre line as shown.

3 Draw the R100 curve

- Draw the curve from its centre.

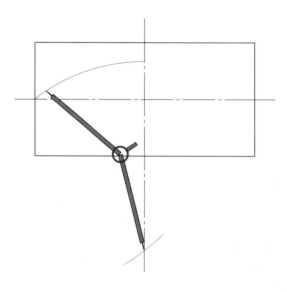

4 Draw the R60 curve

- Set the compass to R60 and scribe an arc to locate the centre on the vertical centre line.
- Draw the R60 curve from this centre.

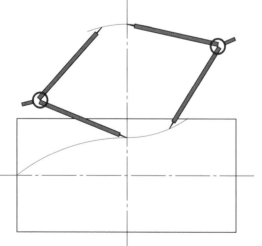

5 Identify the line of intersection

- Draw the straight edge across the end elevation.
- Identify the lines of intersection on the elevation and end elevation. These have been highlighted in red. Once these have been identified they can be projected onto the plan.

Intersection of solids and surfaces

When a solid object projects into a surface, a join line or **line of intersection** is created. You will complete several drawings which require you to plot and draw a line of intersection between a solid and a surface.

Worked example

A new air freshener is being designed. The body is an hexagonal prism with a 60° slice that creates a sloping surface. The slope is intersected by the replaceable cartridge. Drawings are needed to plan colour schemes and graphics.

Draw:
- the elevation
- the end elevation to the left
- the plan including the line of intersection
- the true shape of the sloping surface, including the hole for the cartridge
- the surface development of half of the prism.

Problem-solving tips

When you draw the elevation and end elevation, you will see the line of intersection on each view. On the plan view you will plot the line of intersection by projecting from the other views.

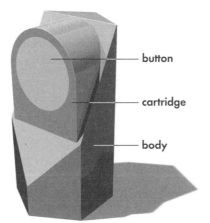

button

cartridge

body

1 Draw the plan and elevation
- Draw the hexagon for the plan.
- Project the elevation.
- Label the edges of both views **a** to **f** as shown.

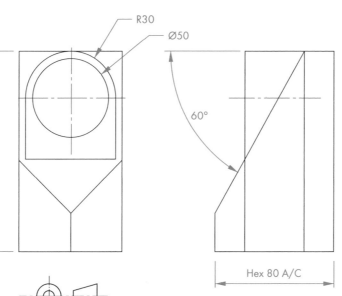

R30

Ø50

60°

130

Hex 80 A/C

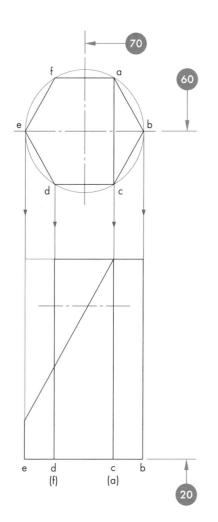

2 Project the end elevation
- Position a 45° bounce line.
- Project the end elevation from the plan and elevation.
- Label the edges on the end elevation **a** to **f** as shown.

Note

Note that you can see the line of intersection on both views. This will enable you to project the intersection line onto the plan.

3 Create surface generators on the cartridge
- Divide the cartridge as shown on the end elevation.
- Number the surface generators and corners.
- Project across to divide the cartridge on the elevation and number each generator.

4 Project the line of intersection on the plan (alternative method)
- Project each generator from the elevation and end elevation up to the plan.
- Plot and mark each point on the plan.
- Firm in the line of intersection.

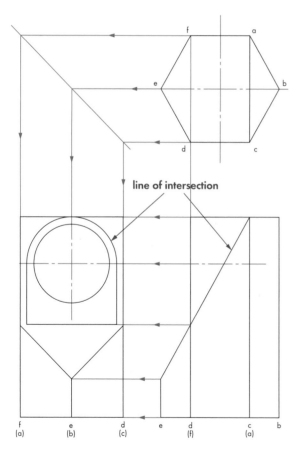

line of intersection

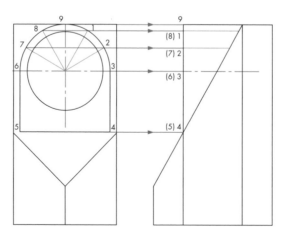

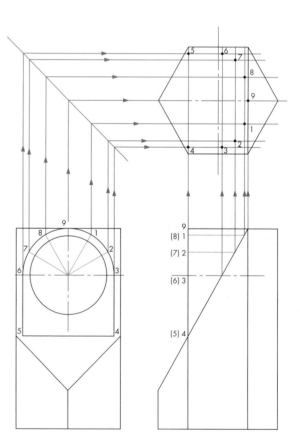

5 Project the true shape of the sloping surface
- Project each corner at 90° to the sloping surface on the elevation.
- Add a datum line at 90° to the projection lines.
- Select and label a datum line on the plan. (Centre lines can be used if the plan has a line of symmetry.)

6 Draw the true shape
- Lift breadths from the datum line on the plan.
- Step them off from the true shape datum line.
- Mark and label points **a** to **f** as shown.
- Firm in the true shape.

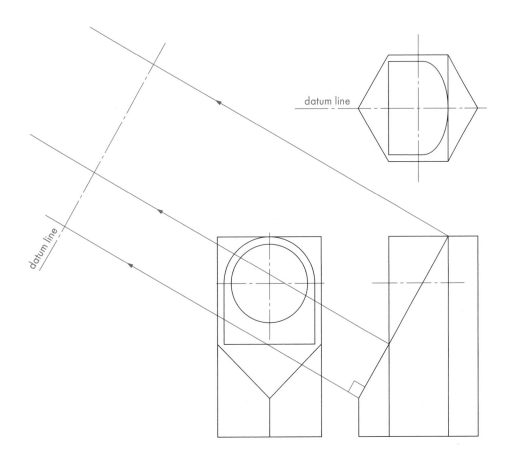

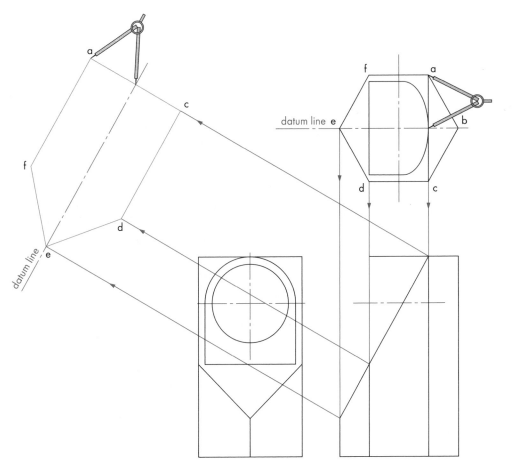

7 Plot the hole for the cartridge
- Project from the line of intersection on the elevation.
- Lift breadths from the plan.
- Step the breadths off from the datum line on the true shape.
- Sketch in the curve.
- Firm in the true shape.

8 Project the surface development of half the prism
- Project the full height from the end elevation.
- Step off one flat three times.
- Starting with the shortest edge, number each edge as per the elevation.

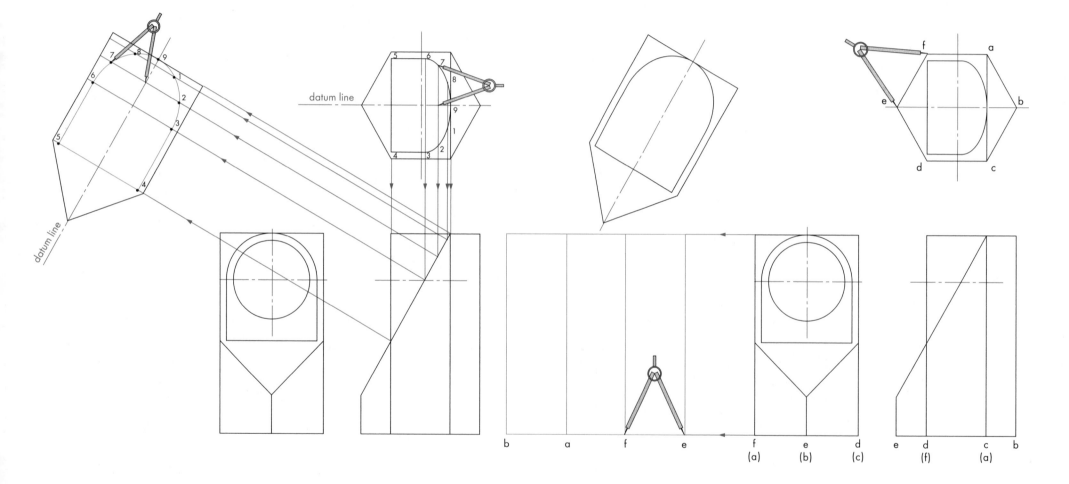

9 Project the remaining heights and firm in
• Project the height of each edge onto the development.
• Plot the sloping edges.

10 Firm in and title views
• Firm in outlines and fold lines.
• Title each view.

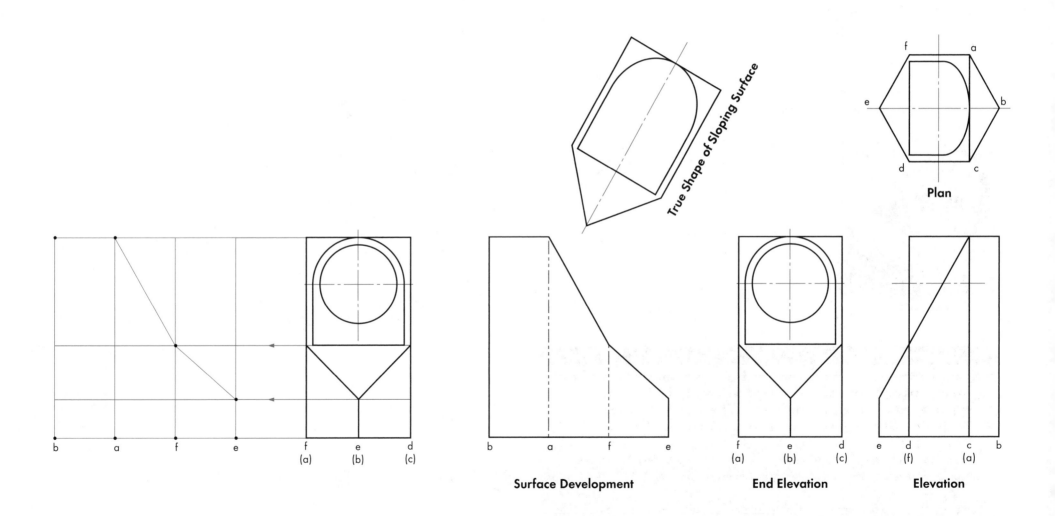

True Shape of Sloping Surface

Plan

Surface Development

End Elevation

Elevation

INTERPENETRATION OF CYLINDERS

Interpenetration of cylinders

Cylinders are geometric forms and are commonly used in the engineering, construction, packaging and fashion industries. Joining two cylinders together can be tricky because the curved surfaces have no edges or corners.

Worked example

A small watering can is being designed. The main part of the can and the lower spout are cylinders which join along a line of interpenetration.

Draw:
- the plan view of the interconnecting cylinders
- the elevation of the interconnecting cylinders showing the line of interpenetration
- the surface development of the cylindrical spout
- a development of half of the large cylinder.

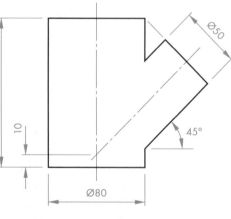

Problem-solving tips

Think of the cylinders as two interconnecting pipes. One is the **main pipe**, the other is the **branch pipe**. The main pipe normally passes straight through the junction. The branch pipe normally stops when it meets the main pipe. The branch pipe often has a smaller diameter than the main pipe, though they can be the same diameter.

You will be asked to plot the **line of interpenetration** on one view. This line will be visible on another view. You need to identify it before you can complete the drawing.

When plotting the line of interpenetration, always divide and draw surface generators on the **branch pipe only**.

1 Draw the main cylinder
- Draw the plan of the **main pipe** in the position shown.
- Project the elevation.
- Use the compass to draw the **branch pipe** on the elevation.

2 Divide the branch pipe into 12
- Construct a half plan on the end of the branch pipe (spout).
- Divide it into six with your compass.
- Project the surface generators back to the end of the pipe.
- Number each of the twelve points.

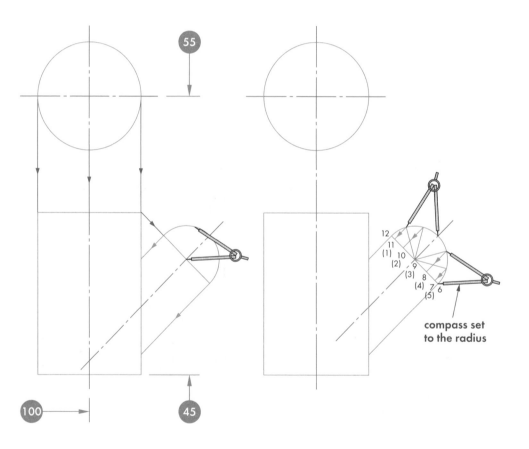

compass set to the radius

3 Draw the ellipse on the plan
- Project the generators up to the plan.
- Transfer breadths from the elevation to the plan.
- Sketch in the ellipse.
- Number each point as per the elevation.

4 Identify the line of interpenetration
- On the plan, project the generators back to the main pipe. The red line indicates the line of interpenetration.
- Once the line of interpenetration has been identified, project it down to the elevation.

5 Project and draw the line of interpenetration
- Project generators down the branch pipe to meet the lines from the plan.
- Follow your numbers to identify points on the line of interpenetration on the elevation.
- Mark each point with a dot.
- Sketch in the line of interpenetration through the points.

6 Firm in
- Firm in both views.

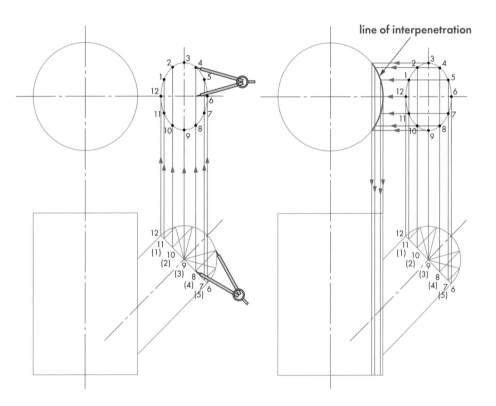

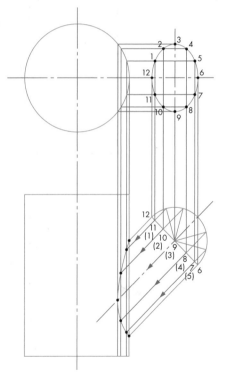

line of interpenetration

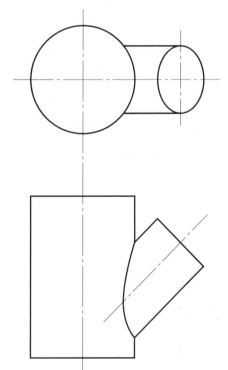

7 Draw the surface development of the branch pipe
- Draw a horizontal line and step off the circumference.
- Project vertical generators and number each generator (shortest at the joint).

8 Add the curve
- Transfer the height of each generator from the elevation.
- Sketch in the curve.
- Firm in the outline.

9 Divide the main pipe and add surface generators
To draw the development of half of the large cylinder you can work from the plan or draw a half plan under the main pipe. The drawings here show a half plan.
- Draw a half plan and divide it into six.
- Project surface generators up the main pipe and number.

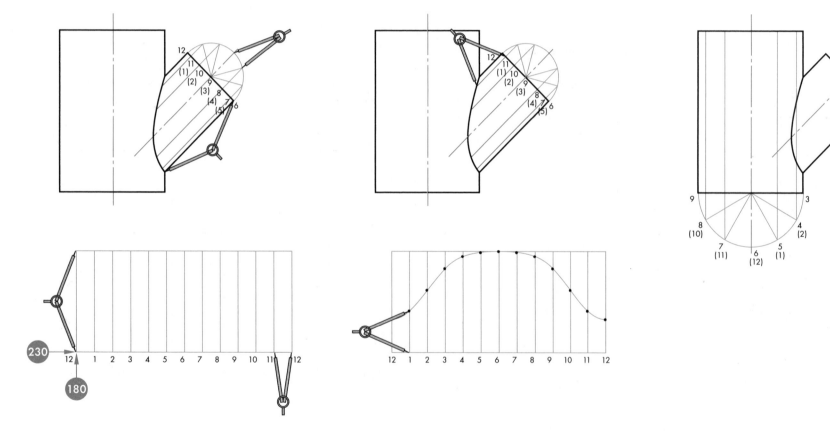

10 Draw the development of the main cylinder

- Project the ground line across from the elevation and step off half the circumference with the compass.
- Draw the surface generators and number them.
- Project the heights across from the line of interpenetration on the elevation.
- Mark the interpenetration points on generators 3 and 4.

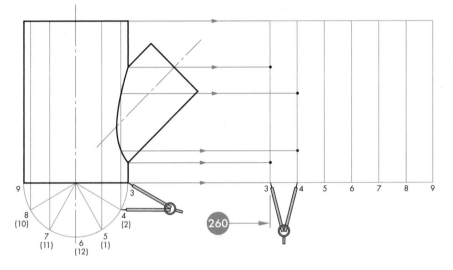

11 Project the turning point of the line of interpenetration

You need to plot the **turning point** where the centre line of the spout meets the line of interpenetration.

- On the elevation, project this point down to the half plan and label it X.
- Transfer X to the surface development with the compass.
- Draw in the generator X on the development.
- Project the turning point across from the elevation.

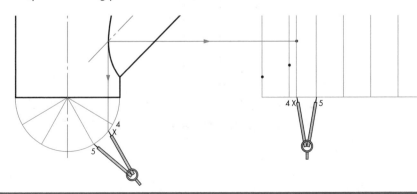

12 Finish the drawing

- Firm in the outline.
- Title the views.

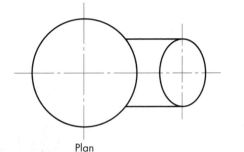

Plan

Surface Development – branch cylinder

Elevation

Surface Development – main cylinder

INTERPENETRATION OF HEXAGONAL PRISMS AND CYLINDERS

Interpenetration of hexagonal prisms and cylinders

Interpenetrations can involve any combination of solids. At Higher level, you can be asked to draw interpenetrations of all kinds of prisms and cylinders. The worked example here looks at interpenetrations between solids and hollow forms with straight and curved surfaces.

Worked example

A bird feeder for an aviary is shown. It consists of three parts:

1 The seed tube is a **hollow hexagonal prism** with solid end caps.
2 The feed tray is a **hollow hexagonal prism** with solid end caps and an open top.
3 The filler chute is a **half cylinder**.

The feed tray and main seed tube are inside the aviary while the filler chute sticks out of the cage so it can be filled from the outside.

Draw:
• the plan
• the end elevation
• the elevation showing the lines of interpenetration
• the surface development of the filler chute
• the surface development of the feed tray.

Do not show hidden detail.

Problem-solving tips

Remember the advice from page 68. Identify the main pipe (the seed tube) and the branch pipes (the feed tray and the filler chute). When drawing the line of interpenetration, always divide and draw surface generators on the branch pipes only.

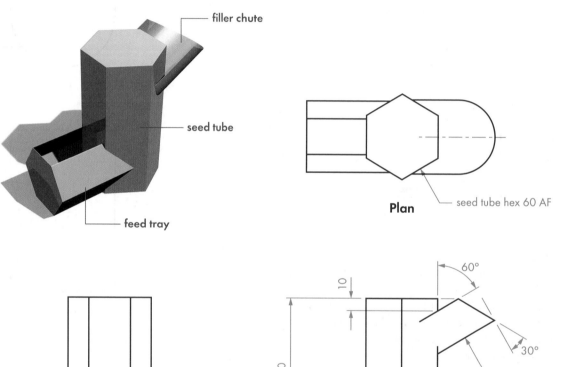

filler chute

seed tube

feed tray

Plan

seed tube hex 60 AF

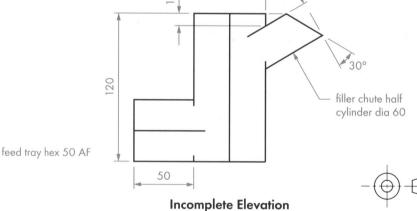

feed tray hex 50 AF

End Elevation

120

10

50

60°

30°

filler chute half cylinder dia 60

Incomplete Elevation

1 Draw the plan, end elevation and elevation of the seed tube

- Construct the hexagonal plan of the seed tube using the 30°/60° set square.
- Project the elevation of the seed tube.
- Add a 45° bounce line and project the seed tube on the end elevation.

2 Draw the feed tray

- Draw the hexagonal feed tray on the end elevation.
- Project this via the 45° bounce line to the plan.
- Draw the feed tray on the plan and project the end down to the elevation.
- Project the heights across to the elevation.
- Number the edges as shown.

Note

Note that the line of interpenetration is shown in red on both plan and end elevation.

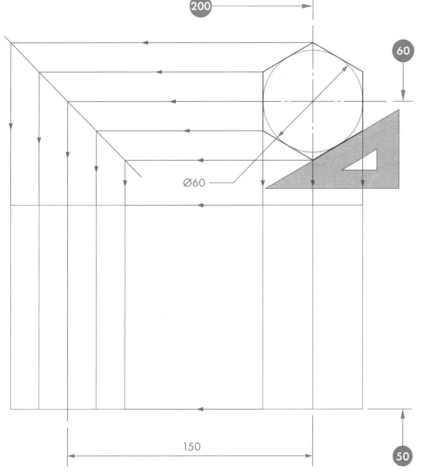

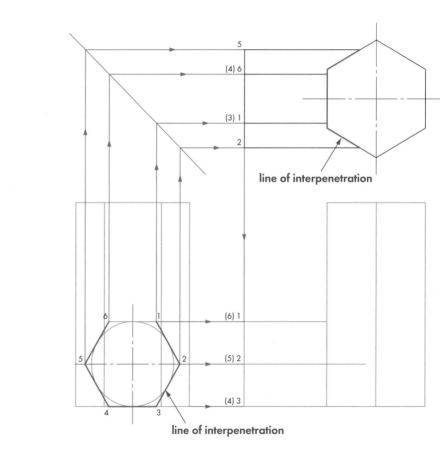

line of interpenetration

line of interpenetration

3 Draw the line of interpenetration on the elevation
- Project from the plan and end elevation to find the line of interpenetration.
- There are turning points on the end elevation (where the line changes direction) at X and Y. Project these across to the elevation.
- Follow the numbers along projection lines to complete the line of interpenetration.

The filler chute

You can use the bounce line to project the filler chute but is worth considering another method. Constructing part circles to create surface generators will enable you to project between plan and elevation without the need for a bounce line.

4 Draw the filler chute
- Position the 30° centre line of the filler chute on the elevation.
- Draw a quarter circle construction (half plan) from the centre line. The exact position is not important.
- Divide this into three and project generators back to the seed tube.

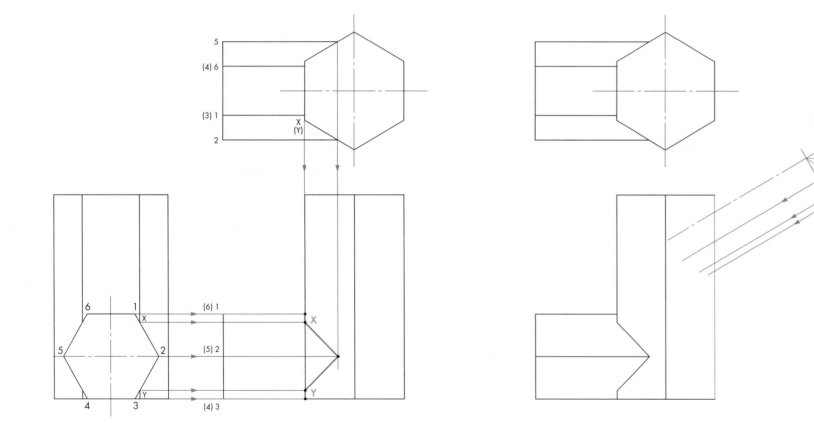

5 Construct the chute and plot the line of interpenetration on the plan
- Draw a semicircle (half plan) along the centre line.
- Divide into six and project surface generators back to the seed tube.
- Number the generators on both the plan and elevation.
- The line of interpenetration can be seen in red on the plan.
- Project the line of interpenetration from the plan to elevation.
- Follow the numbered generators to plot the line of intersection on the elevation.

6 Draw the additional generators
- There are turning points on the plan at the corners of the seed tube. Label these X and Y and project them to the semi-circle.
- Transfer their locations with your compass to the quarter circle on the elevation.
- Project back to the seed tube to find the turning point on the elevation.

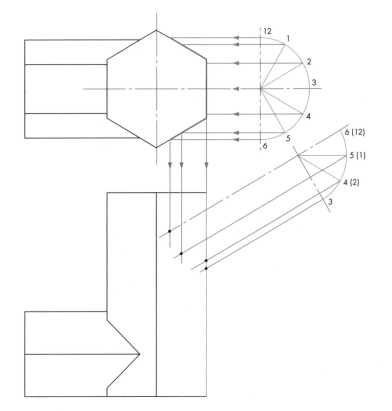

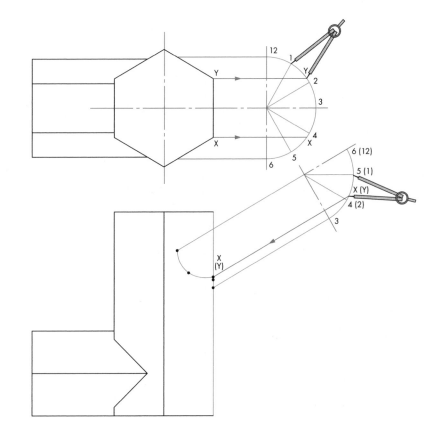

7 Complete the filler chute

- Draw the sloping end of the chute on the elevation.
- Project upwards where the sloping end meets the surface generators.
- Plot the line on the plan – use your numbering to keep you right.
- Firm in the curve on the plan.

8 Draw the surface development of the chute

- Draw the development of the complete half cylinder.
- Project the length of the chute.
- Step off and number six line segments to give the circumference.
- Draw in the surface generators.
- Add the two additional generators X and Y.

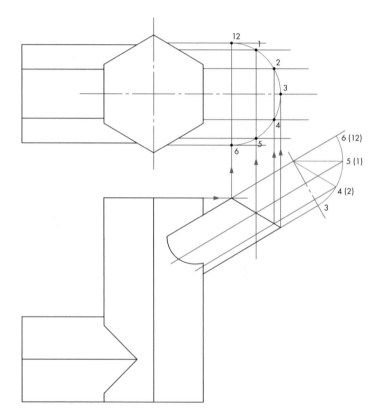

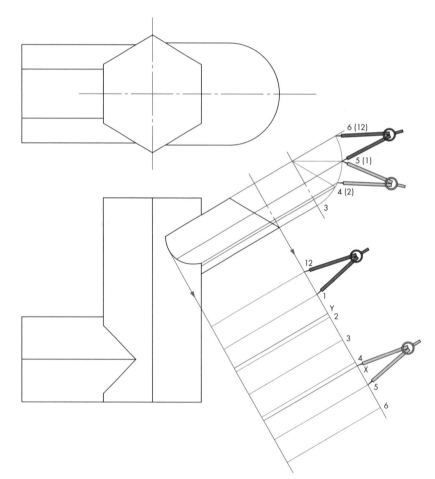

9 Complete the development

- Project all reference points from the elevation.
- Use the numbering to plot the curves on the development.
- Firm in the surface development.

10 Surface development of the feed tray

- Draw the surface development of the full prism (five sides).
- Add surface generators for all edges.
- Add generators for turning points A, B, C and D.

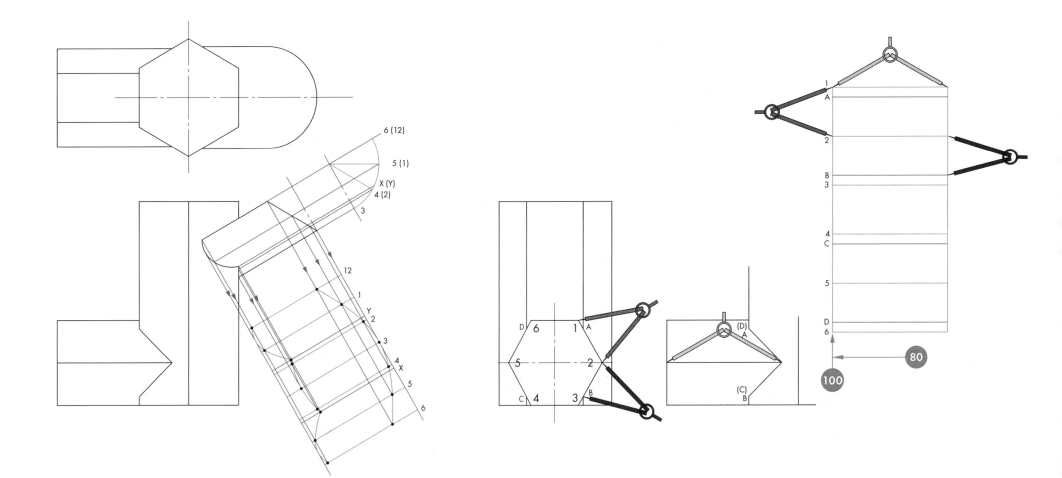

INTERPENETRATION OF HEXAGONAL PRISMS AND CYLINDERS

11 Complete the development
- Transfer lengths with your compass along each edge.
- Add fold lines.
- Firm in the outline.
- Title all views.

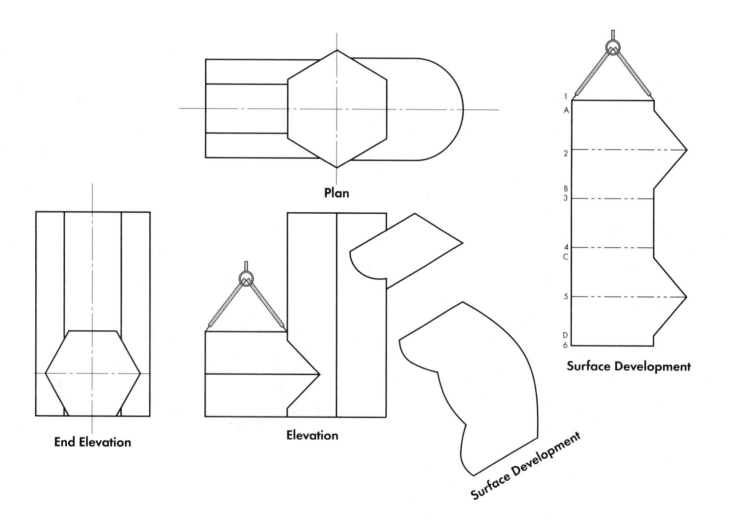

Plan

End Elevation

Elevation

Surface Development

Surface Development

Isometric drawing

Isometric drawing is a form of pictorial drawing which shows all three dimensions (length, breadth and height) in one view. At Higher level you will be required to draw isometric views of components and assemblies.

In this example you will need to draw isometric circles on each side of the object and construct the curve created when a circular section is cut at an angle.

Worked example

A machined component – the top bracket – from a set of bicycle aerobars is shown. The product needs to be assembled by the cyclist and a drawing is required to add clarity to the instruction manual.

Draw the isometric view of the top bracket to a scale of 2:1. Omit part D, the grip.

<div class="box">

Problem-solving tips

The first step in isometric drawing is always to draw the basic **isometric crate**. This crate is an imaginary box that the whole component could fit inside. The dimensions of the crate are:

max length × max height × max breadth

Starting isometric drawings in this way allows you to see the boundaries in which the drawing must fit.

</div>

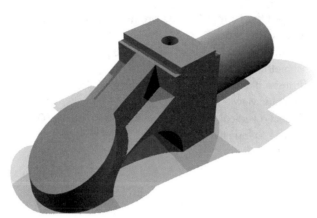

1 Draw the isometric crate and construct the outline for the bracket

- Using **A** as your starting point, draw the isometric crate and outline of the bracket using the given sizes. Omit the stub shaft for now.

Remember

Remember, the scale is 2:1 so you will need to double all the given sizes.

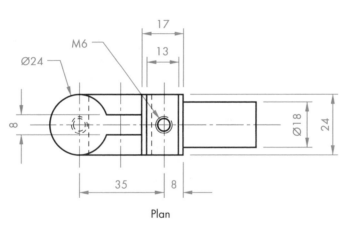

Plan

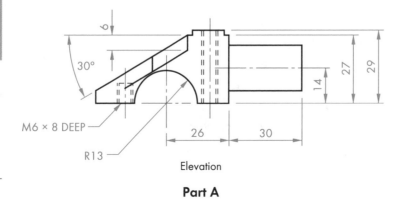

Elevation

Part A

2 Draw the elevation and construct the circular end of the bracket

- Draw the elevation of the bracket at a scale of 2:1. (This type of construction work is necessary to draw the isometric view and is common in the Higher course.)
- Draw a half plan of the circular end and divide it into six.
- Step off and number each point on the isometric crate. This will allow you to construct the lower isometric circle.

3 Project the isometric circle on the sloping surface end of the bracket

- Project vertical lines from each of the points on the isometric circle.
- Transfer the vertical heights from the elevation to the isometric view.
- Project a vertical line at a tangent between points 10 and 11 to form the left-hand edge of the bracket.

4 Construct the semi-circular cut-out

- Divide the semi-circular cut-out on the elevation into six.
- Number each point and step off the horizontal sizes from the elevation.
- Project vertical lines from each point on the isometric view.
- Step off the vertical heights from the elevation onto the isometric view to construct the cut-out.
- Project a line at 30° from point 3 to form the inside edge of the cut-out.

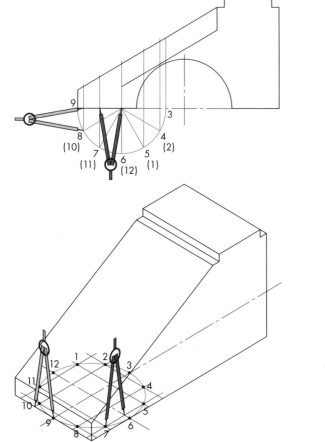

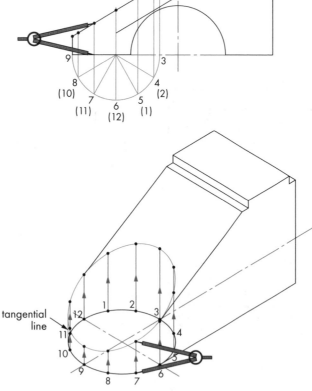

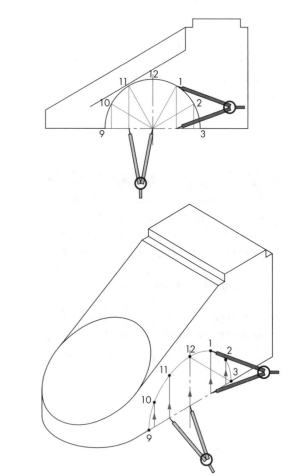

5 Construct the web detail on the sloping surface

- Using the sizes from the elevation and plan, construct the web detail on the isometric view.

Remember

Remember, the scale is 2:1 so you will need to double all the given sizes.

6 Construct the line of intersection between the boss and the slope

- Use the generators from step 3 to step down the height of the web on points 6 through to 12.

7 Construct the stub shaft

- Locate the centre lines on the right-hand end of the bracket and project out to find the centre lines at the end of the shaft.
- Construct a circle the same size as the stub shaft and divide it into twelve.
- Step off and number each point along the centre line.
- Step off the vertical heights from the end elevation onto the isometric view and draw the isometric circle.
- Project 30° lines at a tangent to the isometric circle between points 4 and 5, and 10 and 11 to form the upper and lower edges of the shaft.

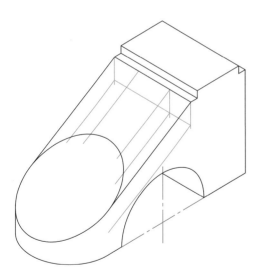

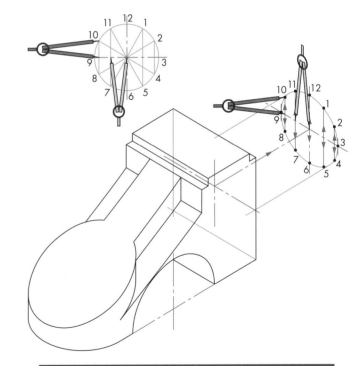

boss

TIP

Note you will only see part of the line of intersection, but it is good practice to construct the whole line.

TIP

In most cases the drawing is constructed completely within the isometric crate. However, it is sometimes easier to construct round or cylindrical sections and add these onto the crate, as is done here.

ISOMETRIC DRAWING

8 Construct the tapped hole on the top of the bracket

- Locate the centre lines on the top of the bracket.
- Draw a plan view of the inner circle that represents the M6 screw thread and divide it into twelve.
- Number and step off each point along the centre line.
- Step off the vertical heights from your plan onto the isometric view and draw the isometric circle.
- Repeat these steps to construct the outer circle.

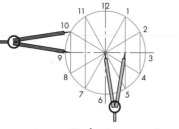

Inner Circle Construction

Outer Circle Construction

9 Firm in

- Firm in the outline of the bracket, remembering to leave the outer circle of the threaded hole broken.
- Title the view.

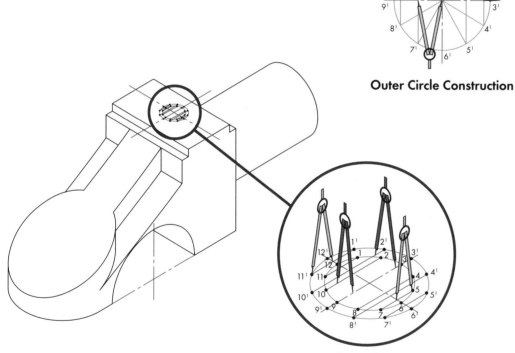

Enlarged View

Isometric View

Isometric sections

Sectional isometric views of components are commonly used in instruction manuals where information on the internal details of a product needs to be shown. Sectioning allows the graphic to show the internal features without the need for hidden detail lines. It displays the information in a way that is easier to understand.

Rules of sectional isometric drawing

When completing sectional isometric drawing, the basic rules of both isometric and sectional drawing apply. Refer to pages 79 and 22 for these rules.

Worked example

The top bracket from a set of bicycle aerobars is shown. Draw the sectional isometric view of the top bracket to a scale of 2:1. Omit part D, the grip.

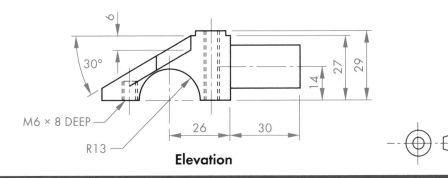

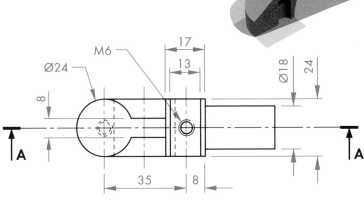

Plan

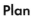

Elevation

1 Draw the isometric crate and construct the outline of the bracket
- Draw the elevation of the bracket at a scale of 2:1.
- Using **A** as the starting point, draw the isometric crate that will form the back half of the bracket.
- Divide the semi-circular cut-out on the elevation into six and number the points.
- Locate the centre lines on the isometric view.
- Step off the lengths and breadths from the elevation.
- Construct the remainder of the outline of the cut surface on the front face of the crate.

ISOMETRIC SECTIONS

2 Construct the circular end of the bracket
- Draw a half plan of the circular end and divide it into six.
- Number and step off each point. This will allow you to construct the lower isometric circle.

3 Construct the isometric curve on the sloping surface of the bracket
- Project vertical lines from each point on the base.
- Step off the heights from the elevation onto the isometric view.
- Project the vertical tangent to form the left edge of the bracket.

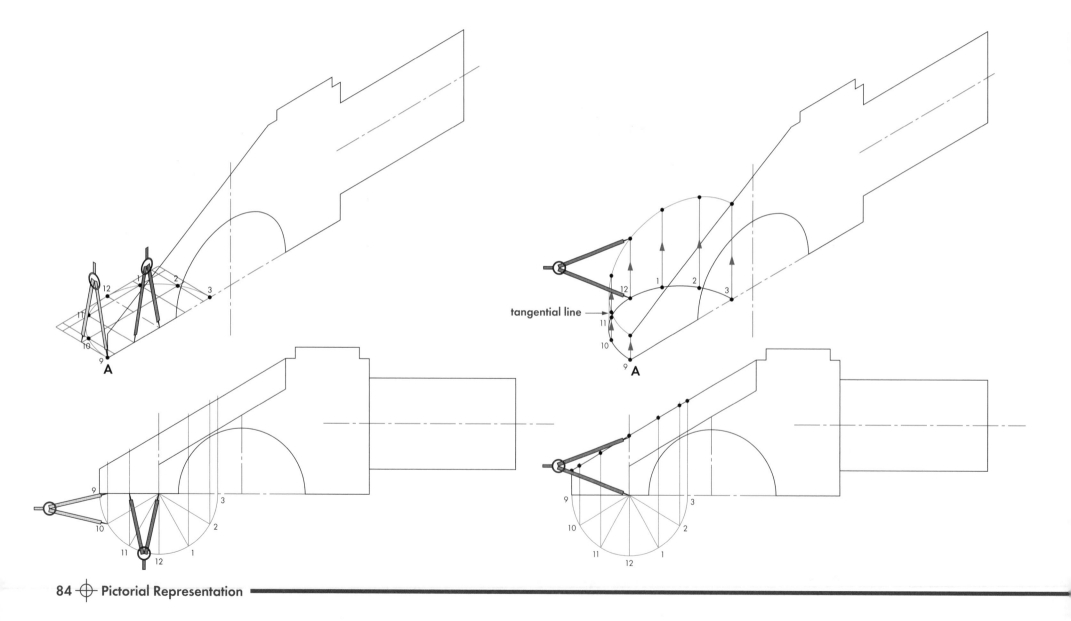

tangential line →

4 Construct the back edge of the bracket

- Project isometric lines from each of the four points on top of the bracket.
- Step these back by half the width of the bracket.
- Draw the back edge of the bracket.
- Project an isometric line at the inside edge of the semi-circle.

5 Construct the stub shaft at the end of the bracket

- Locate the centre lines at the end of the stub shaft.
- Construct half an end elevation of the stub shaft, divide it into six and number the points.
- Step off the heights and breadths onto the isometric view.
- Draw the tangent edge of the stub shaft.

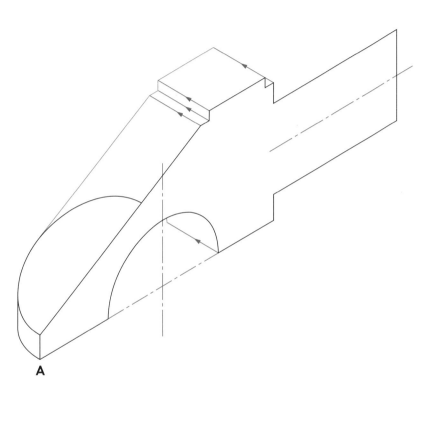

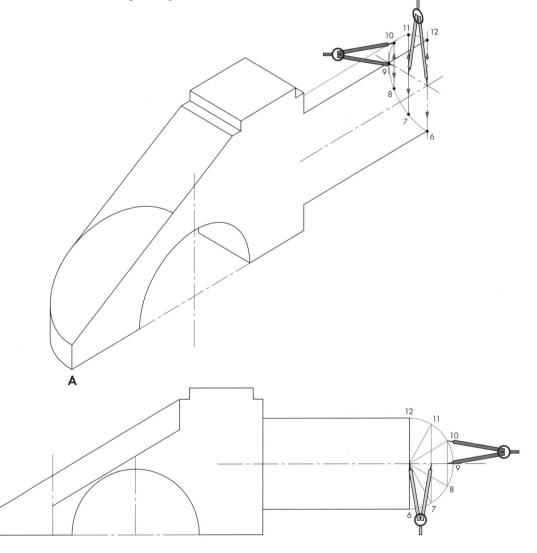

6 Construct the web detail on the sloping surface
- Construct the web detail at the rear of the isometric view.
- Construct the web on the cut surface. (Remember, this will not be cross-hatched.)
- Remember the scale is 2:1 so you will need to double all the given sizes.

7 Construct the screw thread on the top of the bracket
- Locate the centre lines on the top of the bracket.
- Draw a Ø10 circle to represent the inside of the screw thread.
- Divide it into twelve and number the points.
- Step off lengths and breadths from this construction.
- Repeat these steps to construct the outer circle.
- Draw in the isometric circles, remembering to leave the outer circle broken.
- Project vertical lines down from points 3, 9, 3^1 and 9^1 and finish off the bottom of the threaded hole.

A

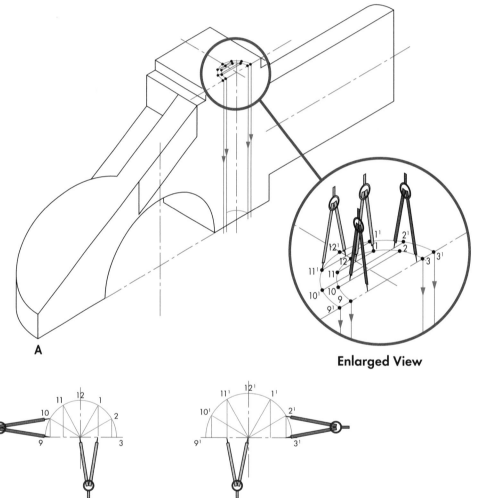

A

Enlarged View

Inner Circle Construction **Outer Circle Construction**

8 Construct the blind screw thread on the underside of the bracket
- Locate the centre lines on the underside of the bracket.
- Use the construction for the inner circle from the previous step to construct the screw thread on the underside of the bracket. (They are the same size.)
- Project vertical lines up from points 3 and 9.
- Step up 16mm to the end of the blind hole. This should form the end of the threaded section. (Remember to add 2mm on the end of this for the tapping drill.)

9 Cross hatch and firm in
- Add hatching lines at 45°. Remember that webs are not hatched when the cutting plane passes along them. Note that the hatching lines finish on the inside line of the internal screw threads.
- Complete the outline of the bracket, remembering to leave the outer circle of the threaded hole broken.
- Title the view.

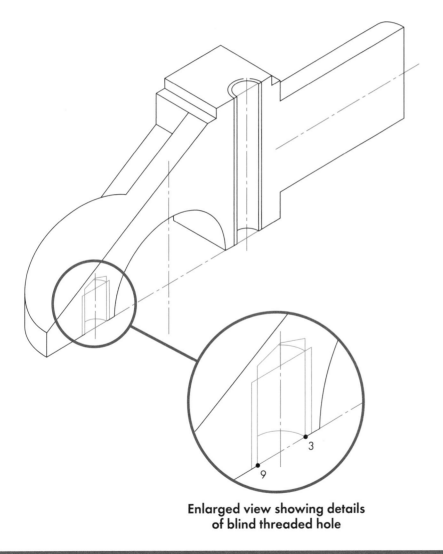

**Enlarged view showing details
of blind threaded hole**

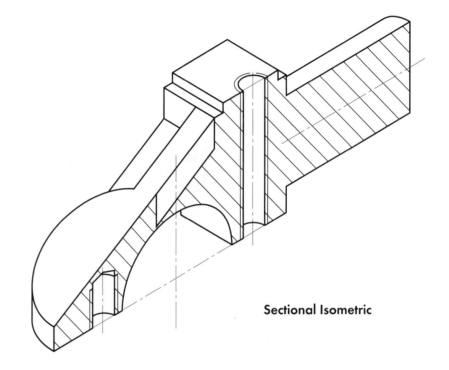

Sectional Isometric

ISOMETRIC ASSEMBLY

Isometric assembly

Isometric assembly drawings are commonly used in instruction manuals to show how individual parts of the product fit together. Isometric assembly drawings display information pictorially in a way that can be easily understood, and are used to add clarity to instructions.

At Higher level, you will be asked to create isometric assembly drawings from a number of individual components. There will be detailed drawings of each component which need to be assembled correctly.

Worked example

A pictorial view of a set of bicycle aerobars is shown. (See page 17 for details of the individual component parts.) The product requires final assembly by the cyclist and a drawing is needed for the instruction manual.

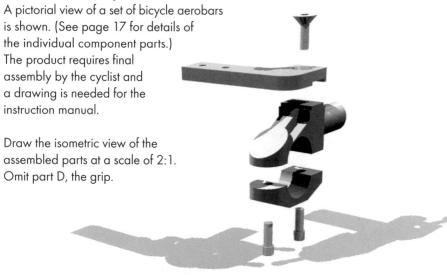

Draw the isometric view of the assembled parts at a scale of 2:1. Omit part D, the grip.

Problem-solving tips

Study all the information you are given, including any illustrations or exploded views.

Select and draw the main component. You may be given a starting point on the question paper. Look for clues to help you assemble the next part:
- holes that line up
- shafts that fit in holes
- other interlocking features.

Remember to tackle the drawing in a methodical manner, adding one component after another until the assembly is complete.

1–7 Draw the top bracket (part A)
- Follow steps 1 to 7 from the isometric drawing section on pages 79–81.

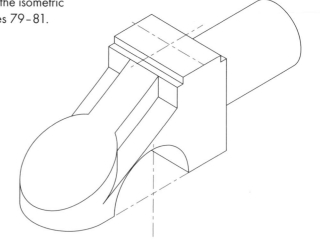

8 Draw the isometric crate and the outline of the bottom bracket (part B)
- Project down from the right-hand end edge of the top bracket.
- Positioning the start of the crate is vital here. The crate must start 4mm below the bottom of the top bracket.
- Construct the outline of the bottom bracket, remembering to work to a scale of 2:1.

9 Construct the semi-circular cut-out

- Draw the elevation of the bottom bracket and divide the semi-circular cut-out on the elevation into six.
- Number each point and step off the horizontal sizes from the elevation.
- Project vertical lines from each point on the isometric view.
- Step off the vertical heights from the elevation onto the isometric.
- Remember to add isometric lines just below points 3 and 9.

10 Construct the curved end of the bracket

- Project down 4mm from points 6 to 12 on the top bracket to form the curve on the top surface of the bottom bracket. There is no need to do a full construction here as you have already done the groundwork earlier in the drawing.
- Step down the heights from the elevation to form the curve on the lower end of the bottom bracket.
- Draw in the curves.

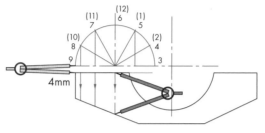

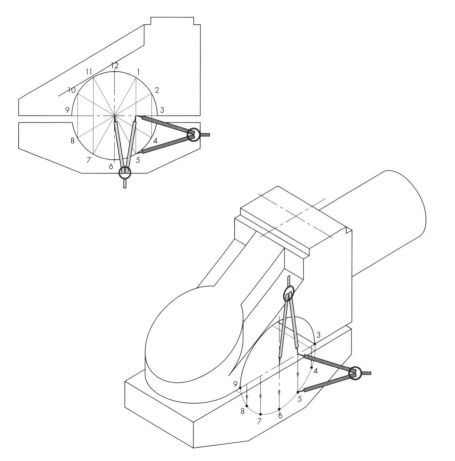

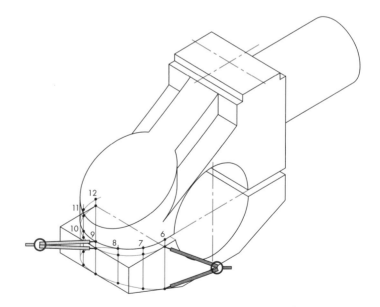

11 Draw the isometric crate and the outline of the arm (part C)

- Position the start of the crate on the corner of the top bracket, **X**.
- Draw the outline of the arm. Note how the slot in the arm mates with the ridge on the top bracket.

12 Construct fillets on the arm

- Construct a circle the same size as the curve on the arm, divide it into twelve and number the points.
- Step the lengths and breadths onto the isometric view.
- Repeat this for the second curve.
- Project down from points 6 to 9 and step off the thickness of the arm to construct the lower curve.
- Draw in the curves.

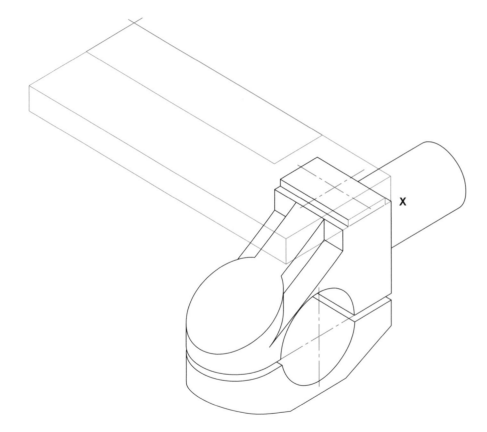

13 Construct the screw threads on top of the arm

- Draw a Ø8 circle to represent the inside of the screw thread.
- Divide it into twelve and number the points.
- Step off lengths and breadths from this construction.
- Repeat these steps to construct the outer circle.
- Draw in the isometric circles, remembering to leave the outer circle broken.

14 Draw the head of the countersunk screw (part F)

- Draw a plan view of the outer circle that represents the top of the countersink, divide it into twelve and number the points.
- Step off the lengths and breadths from the plan.
- Draw in the isometric curve.

Inner Circle Construction

Outer Circle Construction

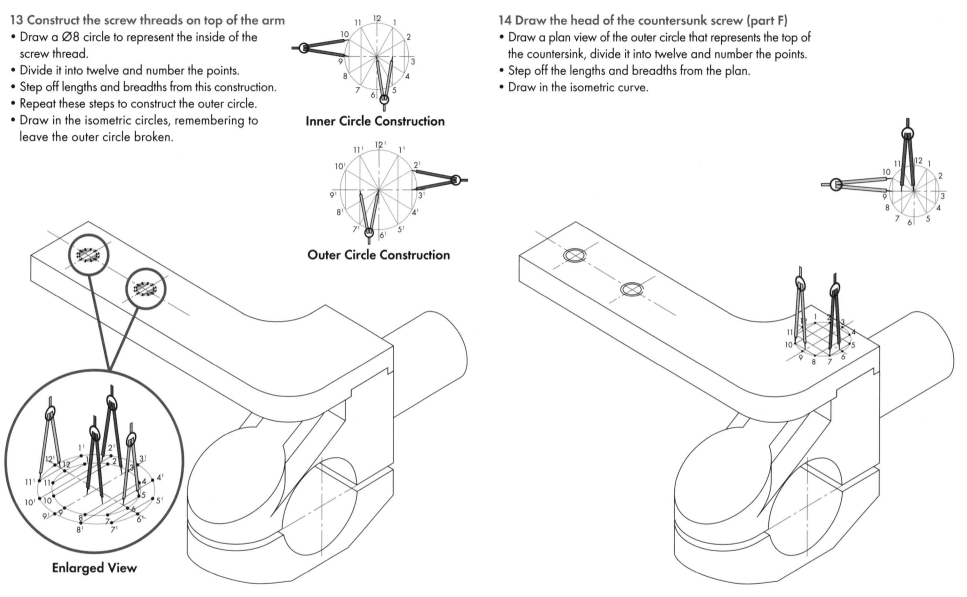

Enlarged View

15 Construct the hexagonal detail on the screw head
- Draw a plan view of the hexagonal detail and number each point.
- Step off the lengths and breadths from the plan.
- Join the points 1 through to 6 to form the hexagon.
- Project vertical lines from points 5 and 6.

16 Firm in
- Complete the outline of the assembled bracket.
- Title the view.

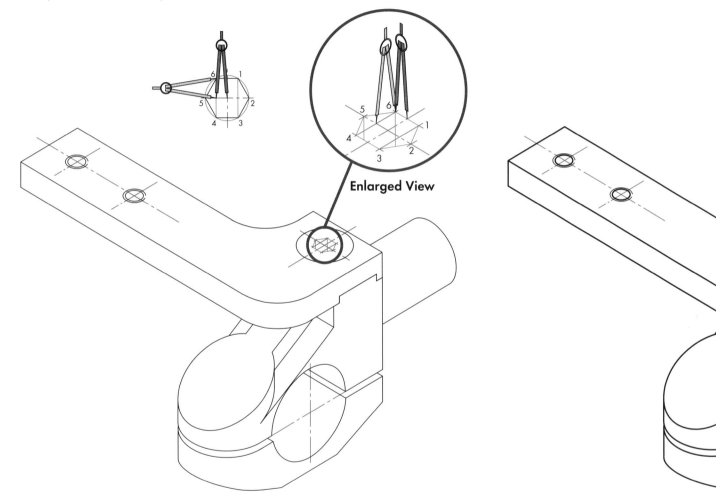

Enlarged View

Isometric Assembly

Exploded isometric drawing

Exploded isometric drawings are commonly used alongside parts lists in manuals and assembly guides. They show information on the positioning of individual parts in relation to one and other. They can be of more benefit in some circumstances than isometric assembly drawing because smaller parts are more visible.

At Higher level you will be asked to create exploded drawings from a number of individual components. There will be detailed drawings of each component and they need to be positioned correctly.

Rules of exploded isometric drawing

• Parts should be exploded along the axis or plane that connects them when they are assembled.
• There must be clear space between each individual component part.

Worked example

The pictorial view of a set of bicycle aerobars is shown. (See page 17 for details of the individual component parts.) The product will be assembled by the cyclist and a drawing is required to accompany the parts list in the instruction manual.

Draw the exploded isometric view of the component parts to a scale of 2:1. Omit part D, the grip.

Problem-solving tips

Study all the information you are given, including illustrations and pictorial views. These may show the assembled parts in position.

Select and draw the main component. You may be given a starting point on the question paper. Look for clues as to where to position the next part:
• holes that line up
• shafts that fit in a hole
• other interlocking features.

Remember to tackle the drawing in a methodical manner, adding one component after another until the drawing is complete.

1–8 Draw the top bracket (part A)

• Set up your A3 page in **portrait format** and locate the starting point for the isometric crate shown.
• Follow steps 1 to 8 from the isometric drawing section on pages 79–82.

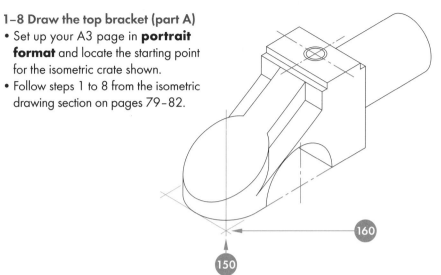

9 Construct the isometric crate and the outline of the bottom bracket (part B)

• Project down from the right-hand edge of the top bracket.
• Positioning the start of the crate is vital here as all exploded views should show clear space between the exploded parts. In this drawing you will need to project down 50mm to start the crate.
• Construct the outline of the bottom bracket.

EXPLODED ISOMETRIC DRAWING

10 Construct the semi-circular cut-out
- Locate and draw the centre lines above the bottom bracket. This is 4mm above the upper edge of the bottom bracket (remember to scale the 2mm gap by 2:1).
- Draw the elevation of the bottom bracket and divide the semi-circular cut-out into six.
- Step off the sizes to construct the cut-out on the isometric drawing.
- Project isometric lines from points 3 to 9 and step off the breadth of the bracket to form the rear curve.

11 Construct the curved end of the bottom bracket
- Project down 50mm from points 6 to 12 on the top bracket. There is no need to do a new full construction here as you have already done the groundwork earlier in the drawing.
- Step down the heights from the elevation to form the curve on the end of the bottom bracket.

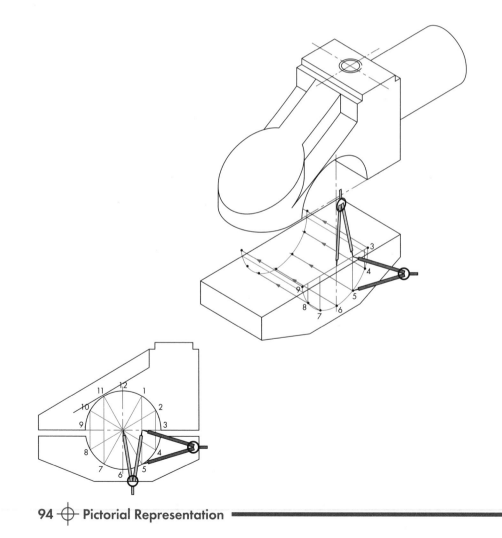

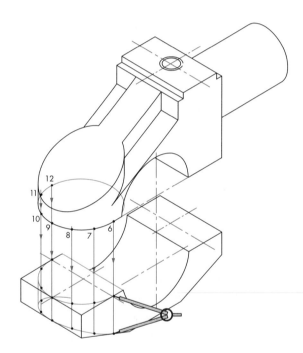

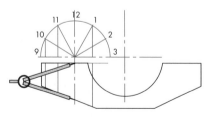

12 Construct the clearance hole on the bottom bracket

- Locate and draw the centre lines for the clearance holes.
- Construct a plan view of the circle that represents the clearance hole and divide it into twelve.
- Number and step off each point.
- Step off the breadths from the plan onto the isometric view.
- Line in the isometric circles.

13 Construct the isometric crate and the outline of the arm (part C)

- Project up from the right-hand end edge of the top bracket.
- Again, positioning the start of the crate is vital. You will need to project up 55mm to start the crate.
- Construct the outline of the arm, using the construction from the top bracket where possible (i.e. to align the slot correctly).

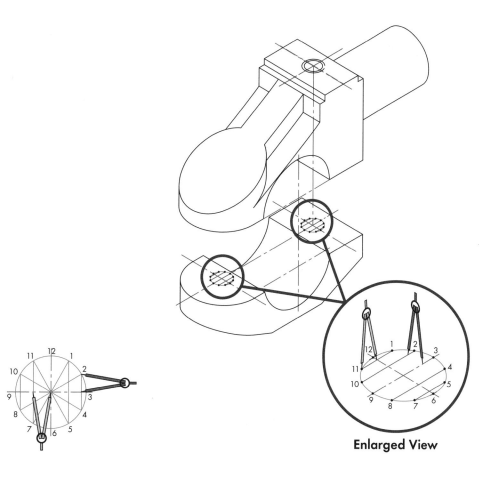

Enlarged View

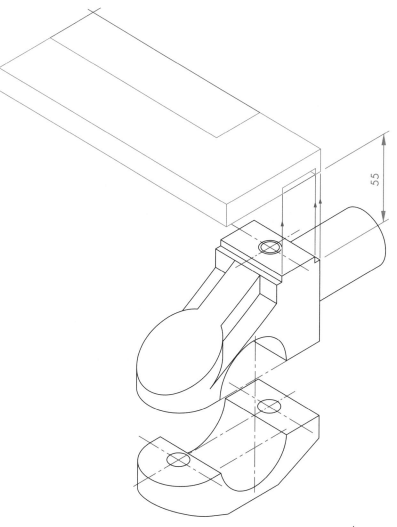

55

14 Construct fillets on the arm

- Construct a circle the same size as the curve on the arm, divide it into twelve and number the points.
- Step the lengths and breadths onto the isometric view.
- Repeat this for the second curve.
- Project down from points 6 to 9 and step off the thickness of the arm to construct the lower curve.
- Draw in the curves.

15 Construct the screw threads on top of the arm

- Draw a Ø8 circle to represent the inside of the screw thread.
- Divide it into twelve and number the points.
- Step off lengths and breadths from this construction.
- Repeat these steps to construct the outer circles.
- Draw in the isometric circles, remembering to leave the outer circle broken.

Inner Circle Construction

Outer Circle Construction

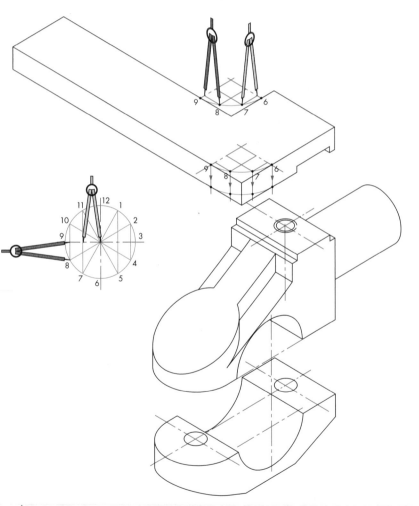

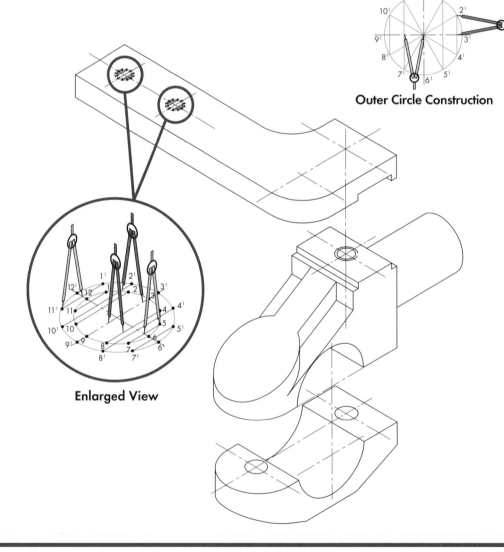

Enlarged View

16 Construct the countersunk hole on the top of the arm
- Locate and draw the centre lines on the top of the arm.
- Construct a plan view of the outer circle that represents the top of the countersink and divide it into twelve.
- Number and step off each point along the centre line.
- Step off the lengths and breadths from the plan onto the isometric view.
- Project down from the centre of the circle to locate the centre of the clearance hole and construct the isometric circle as described in previous steps.

17 Construct the two Allen capped screws (part E)

- Project down from the centre of each of the two clearance holes on the bottom bracket.
- Construct the isometric circles that form the two screws as described in the previous steps.

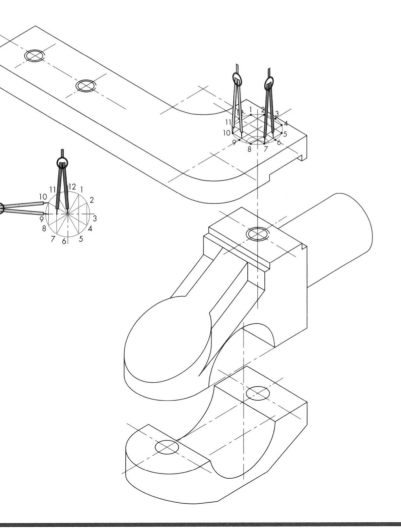

18 Construct the countersunk headed screw (part F)

- Project up from the centre of the clearance hole on the arm.
- Construct the isometric circles that form the countersunk headed screw as described in the previous steps.
- Omit the detail on the CSK screw.

19 Firm in
- Firm in the visible edges of the exploded parts.
- Title the view.

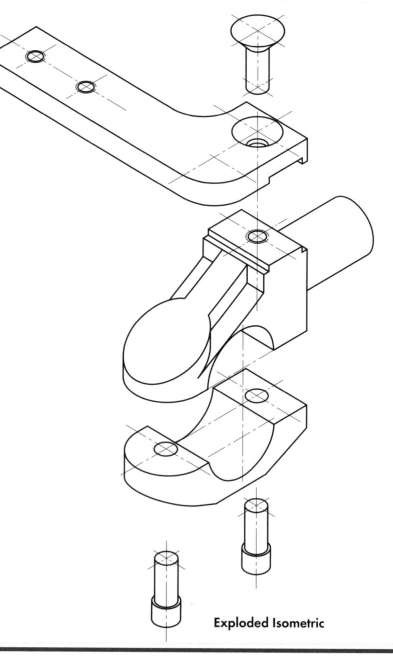

Exploded Isometric

Cabinet oblique

Cabinet oblique drawing is a form of pictorial drawing used when it is important to retain the front view of the object being drawn or when the front view contains a number of circles.

Rules of cabinet oblique drawing

• The front surfaces of the object are shown as true shapes.
• All breadths are projected back at 45°.
• To appear more realistic, all breadths are reduced to half their actual size.
• Lines drawn at 45° are known as oblique lines.

Worked example

A model-making company has produced a block model of a prototype camera. Orthographic views of the camera components are shown here.

Use instruments to draw an oblique view of the camera body. All breadths should be halved. Do not show hidden detail.

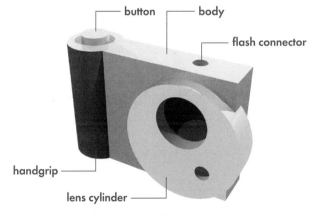

Problem-solving tips

Tackle oblique drawings by considering the object as a series of layers, drawing what you encounter as you move backwards or forwards, layer by layer, through the object.

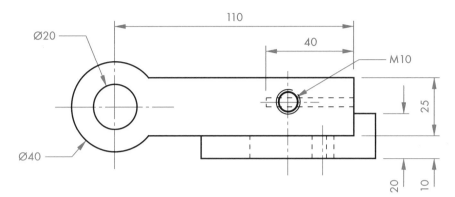

Plan

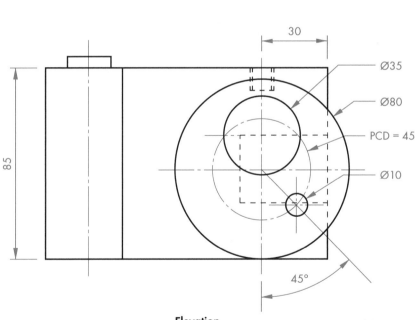

Elevation

Camera Body

End Elevation

CABINET OBLIQUE

1 Draw the front surface of the lens cylinder

- Construct the front surface of the lens cylinder.

2 Construct the next surface of the camera

- Project lines back from the centres of each of the three circles at 45°.
- Halve the breadths to give the new centres.
- Construct the three circles that form the back of the two holes and the edge where the lens cylinder meets the camera body.

3 Construct the front surface of the camera body

- Using the centre of the lens cylinder as a datum point, construct the front surface of the camera body (as far as the centre of the hand grip).
- Project the centre of the lens cylinder back at 45° and halve the breadth.
- Construct the final large circle that forms the back surface of the lens cylinder.

4 Draw the back surface of the camera body

- Project lines at 45° from the corners of the body and halve the breadths.
- Construct the back surface of the camera body.
- Construct the edge that appears where the lens cylinder meets the side of the body.
- Construct the tangent edges of the lens cylinder.
- Construct the centre lines for the hand grip.

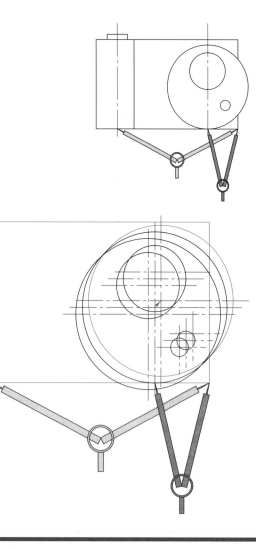

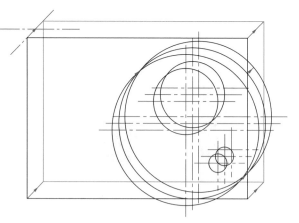

5 Construct the oblique circle of the hand grip
- Draw two circles, Ø20 and Ø40. Divide both into twelve segments and number each generator.
- Lift sizes from the Ø40 circle to step off lengths along the horizontal axis of the hand grip.
- Project 45° lines through these points.
- Lift sizes from the Ø20 circle to step off breadths along the 45° lines.
- Label these points and draw the oblique circle freehand.

6 Construct the bottom edge of the hand grip
- Project verticals down from the circle.
- Step the height down each vertical.
- Draw the bottom edge freehand.

7 Construct the oblique circle of the button
- Construct an oblique box 20 × 10 on top of the hand grip.
- Where the centre lines cut through the square, draw in an oblique circle freehand.

> **TIP**
> This method can be used when drawing small circles and curves.

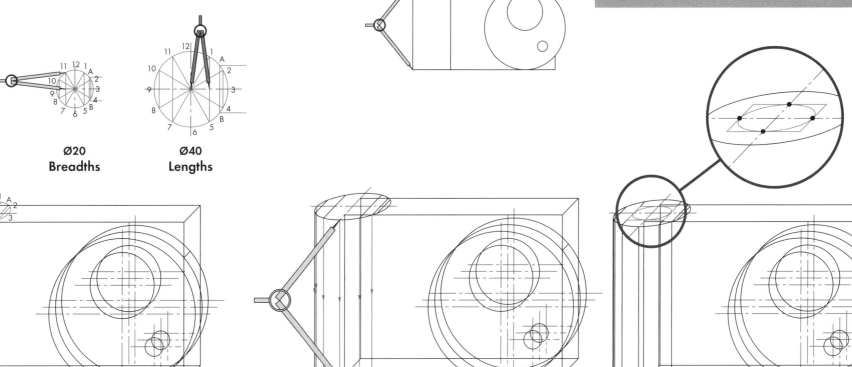

Ø20
Breadths

Ø40
Lengths

8 Construct the top oblique circle of the button
- Project verticals up from the bottom oblique square.
- Step off the height along each line.
- Draw the top oblique circle freehand.

9 Draw the oblique circle for the flash connector point
- Using the same method as in the previous stages and lifting sizes from the plan, draw an oblique box and circle 10 × 5.

10 Firm in the camera
- Complete the drawing by firming in the visible edges of the camera.
- Do not show hidden detail.
- Title the view.

Cabinet Oblique

Oblique assembly

Oblique assembly drawings show the component parts of a product in their assembled positions. Oblique assembly drawings are commonly found in:
• flat-pack furniture assembly instructions
• maintenance manuals for cars and household products
• assembly instructions for model kits.

Worked example

A model-making company has produced a block model of a prototype camera. Orthographic views of the camera body and components are shown here. Drawings are required to show how the lens, the detachable flash and the memory card are assembled with the camera body.

Using instruments, draw an oblique view of the camera to show clearly the component parts assembled together. Do not show hidden detail.

Memory Card

Problem solving tips

In any assembly drawing you will be given clues to help you work ot how the parts fit together. Spend a few minutes studying the question and all the graphical information.

In this example, the exploded view shows the lens, flash and memory card in pre-assembly positions. Even without this view you can find assembly clues in the other drawings:
• The M10 screw threads (flash and camera body) clearly fit together.
• There are only two Ø35 cylinders, one on the lens, the other on the body.

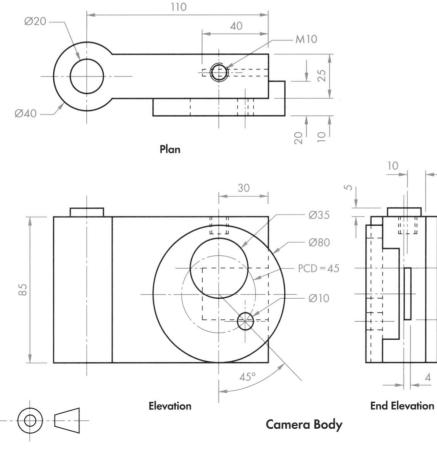

Plan

Elevation

End Elevation

Camera Body

Flash

Lens

OBLIQUE ASSEMBLY

1–9 Draw the camera body
- Follow steps 1 to 9 from the Cabinet Oblique drawing section on pages 100–102.
- Do not draw the oblique circle for the flash connection point.

10 Draw the back surface of the lens
- Project back from the centre and draw the circle that forms the inner edge of the lens.
- On the front surface, draw the circle that forms the shoulder of the lens.

11 Draw the front surface of the lens
- To draw the front of the lens, project the centre forward and locate the new centre. (Remember to halve the breadth.)
- Draw the two circles that form the front of the lens.
- Draw the two oblique tangent lines of the lens.

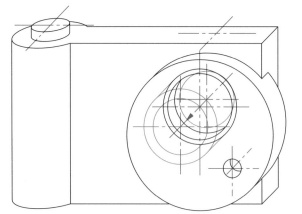

12 Draw the crate for the flash
- Construct the bottom surface of the flash.
- Project up from the four corners.
- Construct the top of the crate.

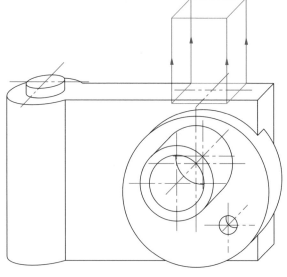

13 Draw the side profile of the flash
• Draw the profile of the flash on the right side of the crate.

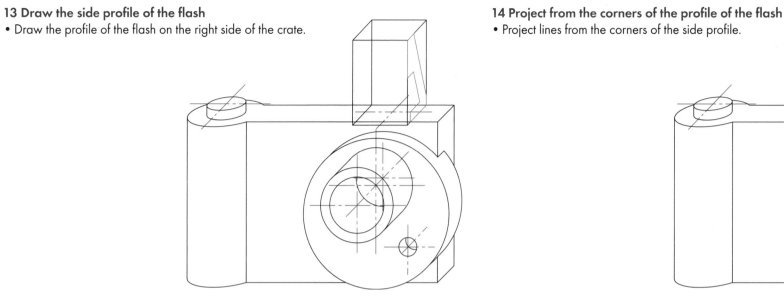

14 Project from the corners of the profile of the flash
• Project lines from the corners of the side profile.

15 Draw the opposing profile of the flash
• Draw the opposing profile of the flash.

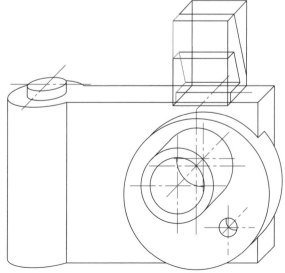

16 Firm in the drawing
• Complete the drawing by firming in the visible edges of the camera. (The slot for the memory card is not visible so does not need to be constructed.)
• Do not show hidden detail.
• Title the view.

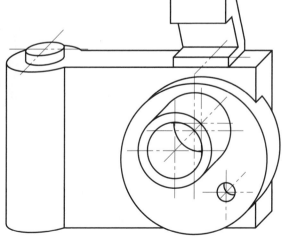

Oblique Assembly

Oblique sectional assembly

Oblique sectional assembly views show the component parts of a product in their assembled positions. A cutting plane passes through a section of the assembled product and gives a clearer picture of internal details.

These types of drawings are commonly found in:
- flatpack furniture assembly instructions
- maintenance manuals for cars and household products
- assembly instructions for model kits.

Worked example

The pictorial view of the block model of a prototype camera is shown. A sectional view of the assembled camera is required to allow the model makers to see how the component parts fit together in final assembly.

Draw the sectional oblique view of the assembled parts on A–A. Do not show hidden detail. Refer to page 103 for details of the individual parts.

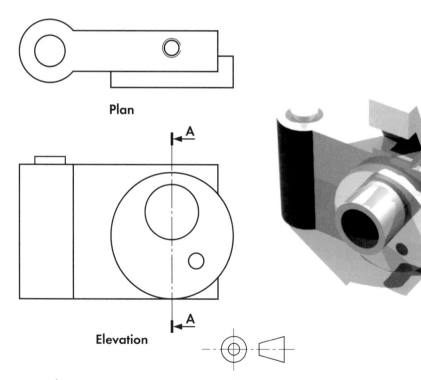

Plan

Elevation

1–9 Draw the camera body
- Follow steps 1 to 9 from the Cabinet Oblique drawing section on pages 100–102.
- Do not draw the small hole on the front surface.

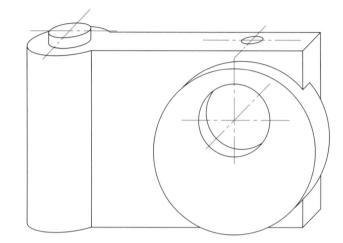

Problem-solving tips

To help visualise the cutting plane, it is shown here as a piece of glass slicing through the object along section A–A.

Details which are behind the arrows and will not be seen are shown here in green.

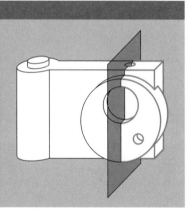

10 Draw the cut surface of the camera front and body

- Project a vertical line on the front surface of the lens cylinder.
- Project an oblique line back along the top of the cylinder.
- Project this line around the camera.

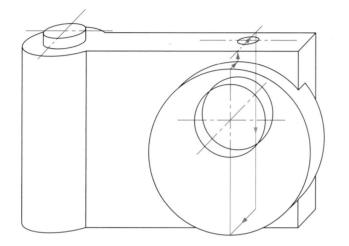

11 Draw the recesses and slot

- Project inwards at the lens aperture and down from the flash connection point.
- Draw the slot for the memory card on the cut surface.

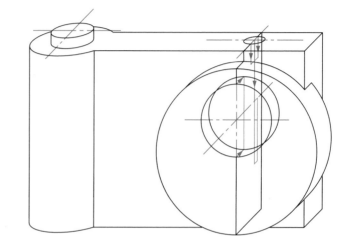

12 Firm in the visible edges

- Firm in the visible edges of the cut surface and the remainder of the camera body.
- Note that not all of the lines are firmed in as there are components still to assemble.

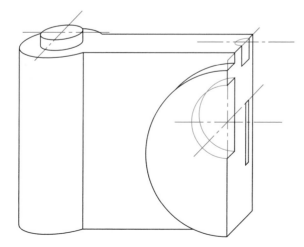

13 Draw the lens

- Extend the oblique centre line and position centre lines for the front and back of the lens.
- Draw the edges of the lens.

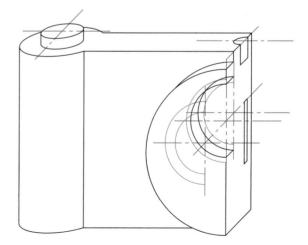

OBLIQUE SECTIONAL ASSEMBLY

14 Connect the edges
- Construct the oblique lines that connect the three surfaces of the lens.
- Firm in the visible edges of the lens.

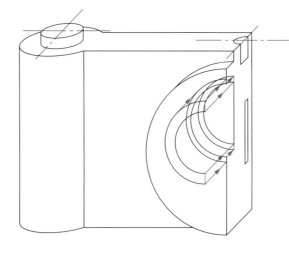

15 Draw the flash
- Construct the side profile of the flash. (Use the flash connection point as the starting point.)
- Project horizontals from the corners.
- Mark off half the width of the flash on each line.

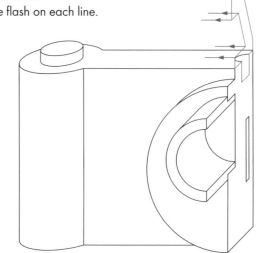

Problem-solving tips

Vary the direction and spacing of the hatching for each of the separate components, to give greater clarity to the finished drawing.

As a general rule, the smaller the component in a sectioned assembly, the closer together the hatching should become.

As a result of the steep angle that the cut surface is being viewed at and to give greater realism to the final drawing it is necessary to change the angle of the hatching from the normal 45° to a steeper angle. This is done by using the 45° and 30° set squares together.

16 Cross hatch and firm in
- Complete the other side of the flash.
- Firm in all visible edges.
- Add cross-hatching to the cut surfaces. (Remember this is a block model.)
- Do not show screw threads.
- Do not show hidden detail.
- Title the view.

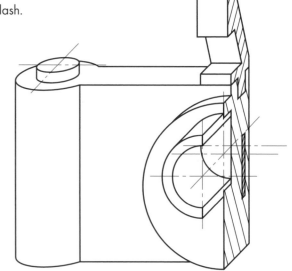

Oblique Sectional Assembly

Exploded oblique drawing

Exploded oblique views are pictorial drawings that show components in a pre-assembly layout. Components are separated with daylight between them and are in line with their final assembly position. This gives a clear view of each part and shows how the parts fit together in an assembly.

These types of drawings are commonly found in:
• flatpack furniture assembly instructions
• maintenance manuals for cars and household products
• assembly instructions for model kits.

Worked example

The pictorial view of a block model of a prototype camera is shown. An exploded view of the camera assembly is needed for an instruction manual. This manual will show how the component parts are assembled.

Using instruments, draw an exploded oblique view of the camera to show clearly the four component parts. All breadths should be halved. Do not show hidden detail. Refer to page 103 for details of the individual parts.

1–9 Draw the camera body
• Follow steps 1 to 9 from the Cabinet Oblique drawing section on pages 100–102.

10 Draw the front surface of the lens
• Draw an oblique centre line from the centre of the aperture. Extend it 125mm forward.
• Construct the circles that form the front of the lens.

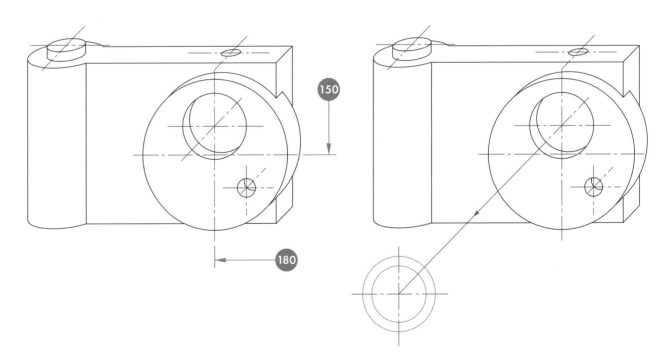

EXPLODED OBLIQUE DRAWING

11 Draw the back of the lens
- Measure back along the oblique centre line and position two new centre points. (Remember to halve the breadths.)
- Draw three new circles from the new centre points, then draw the tangential edges.

12 Draw the bottom surface of the flash connector
- Construct a vertical line from the centre of the hole.
- Use the oblique square method used earlier to construct the oblique circle.

13 Draw the crate of the flash
- Construct a vertical line from the centre of the oblique circle and step off the height.
- Construct the bottom surface of the flash.
- Project up from the four corners.
- Construct the top of the crate.

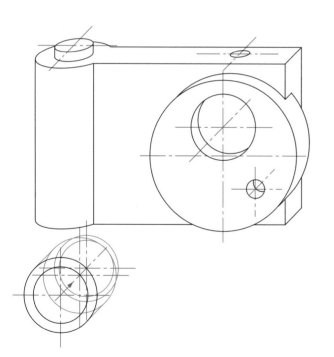

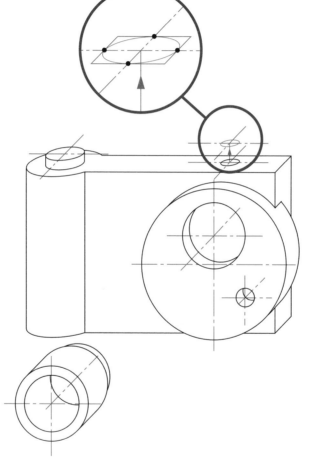

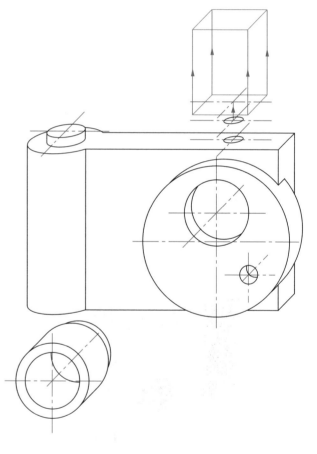

14 Draw the side profile of the flash
- Draw the profile of the flash on the right side of the crate.

15 Project the profile
- Project lines from the corners of the side profile.
- Draw the opposing profile of the flash.
- Complete the connector.

16 Draw the memory card cavity
- Project a line from the centre of the connector hole along the top and down the side of the camera body.
- Construct the cavity for the memory card.
- Project lines out from the four corners of the cavity.

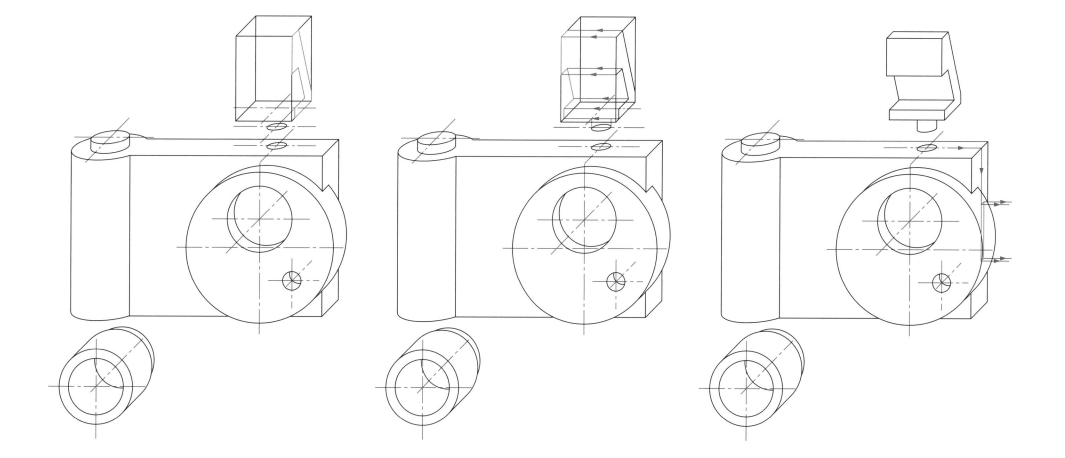

EXPLODED OBLIQUE DRAWING

17 Draw the memory card
- Construct the memory card, remembering to leave daylight between this and the camera body.

18 Firm in final lines
- Complete the drawing by firming in the visible edges of the objects in the exploded oblique view.
- Title the view.

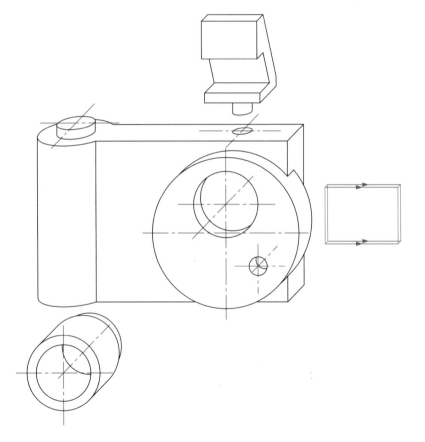

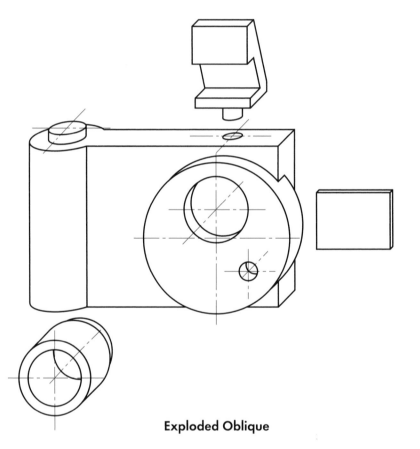

Exploded Oblique

Planometric projection

Planometric projection is a form of pictorial drawing favoured by architects and interior designers. It is easy to construct, and gives a clear picture of interior spaces. A planometric drawing shows the objects or areas as if the viewer was hovering above them.

Rules of planometric projection

- The base is a true plan view, rotated at an angle to the horizontal.
- Angles of rotation can be 30°, 45° or 60°.
- All vertical edges remain vertical and project upwards from the base.
- All measurements on the base are true.
- All vertical measurements (heights) are full size.

Worked example

Two views of a scale model for an indoor pool area are shown. It comprises a pool, walls, path, deck and lounger.

Draw to the given sizes a planometric view of this area to show the pool, walls, path, deck and lounger.

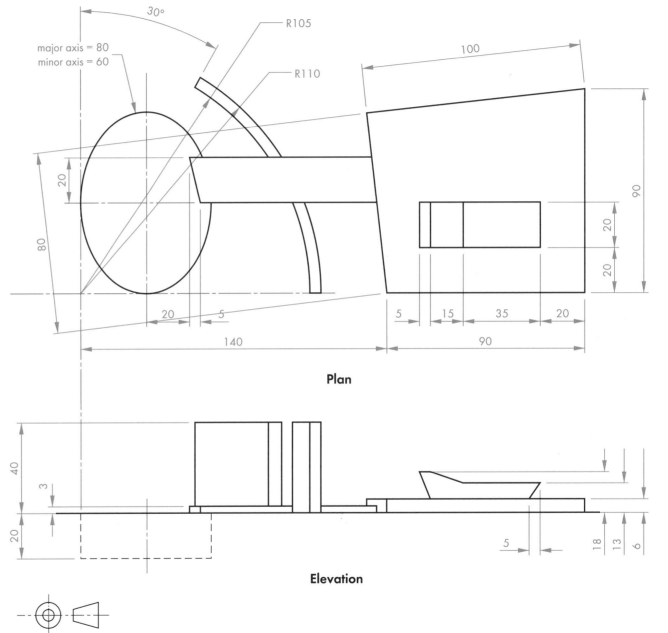

Plan

Elevation

PLANOMETRIC PROJECTION

1 Draw the rotated ellipse
- Draw the ellipse rotated at 30°.
- The ellipse is constructed using the concentric circle method.

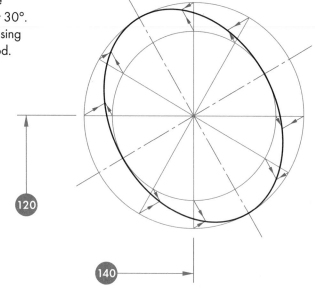

120

140

2 Draw the rotated plan
- Draw the deck area. Corner **X** is a right angle. Locate this corner and draw the right angle.
- Complete the deck using your compass.
- Draw the path and the wall.

X

3 Add heights
- Project lines vertically from the rotated plan view (note that the pool projects downwards).
- Step off heights (full size) with your compass.

4 Draw the top surfaces
- Project the centre of the wall vertically and mark the new centre.
- Draw lines around each of the projected surfaces.
- The walls are completed using a compass from the top of the projected centre.
- The bottom of the elliptical pool is drawn freehand.

5 Draw the plan view of the lounger
• Draw the plan of the lounger on the top surface of the deck.

6 Add heights
• Project heights vertically.
• Step off heights (full size).

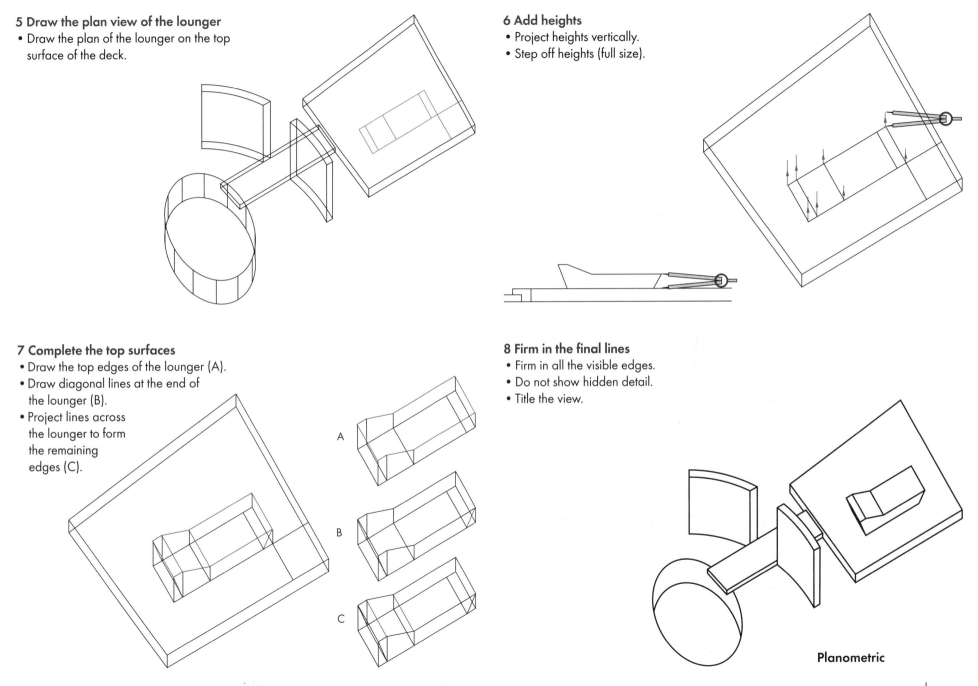

7 Complete the top surfaces
• Draw the top edges of the lounger (A).
• Draw diagonal lines at the end of the lounger (B).
• Project lines across the lounger to form the remaining edges (C).

A

B

C

8 Firm in the final lines
• Firm in all the visible edges.
• Do not show hidden detail.
• Title the view.

Planometric

MEASURED PERSPECTIVE

Measured perspective

Measured perspective drawings are often used when architects or designers want realistic images of buildings. This style of drawing provides an image that is very close to what our eyes recognise as a real 3D structure.

Worked example

A number of small riverside holiday villas are to be built. A measured perspective drawing of one of the villas will give the marketing team the realistic drawings they need for brochures and other promotional publications.

Draw a measured perspective view of the villa using the rotated plan method. Positions of the Eye Level, Ground Line, Picture Plane and Spectator Point are given. Actual dimensions are given on the elevations. The perspective view should be drawn to a scale of 1:100.

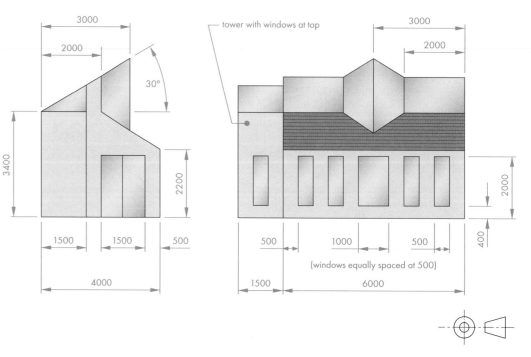

1 Draw the elevation and end elevation
• Draw the given views to a scale of 1:100. (Position them in the lower left hand corner of your sheet.)

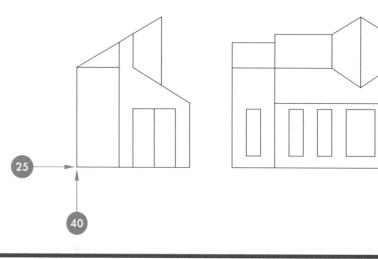

2 Draw the rotated plan

- Draw the **spectator point** (SP).
- Draw the plan view, rotated to 45°, in the position shown.
- Draw the **picture plane** (PP), **ground line** (GL) and **eye level** (EL) lines in the positions shown.

3 Find the vanishing points

- Project two lines from the spectator point, parallel to the rotated plan view, onto the picture plane.
- Project both lines vertically upwards to eye level and locate the **vanishing points** (VPs).
- Label the vanishing points.

TIP

Lines that project from the spectator point should always become vertical after meeting the picture plane.

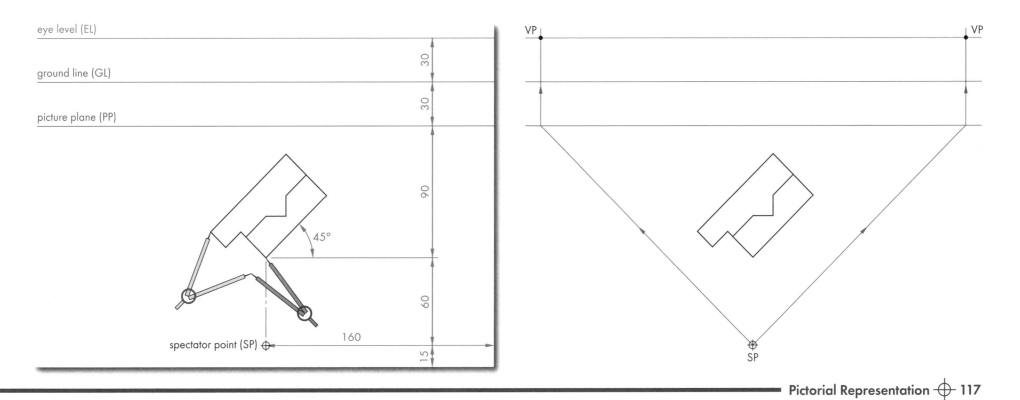

MEASURED PERSPECTIVE

4 Draw the height line

- Choose which **part of the building** to draw first. In this example, the main building will be drawn first. Leave the tower till later.
- Now choose the **surface** you want to draw first. The **gable end** of a building is often a good place to start as it gives you all the main heights.
- Extend a line from the gable onto the picture plane then vertically upwards.
- From the ground line, measure and mark the main heights on the surface (ridge (R), front eaves (FE), back eaves (BE), and ground level (G)).
- Label the height line and each height.

5 Project the gable

- Project a **vanishing line** from the vanishing point through each height.
- Project **sight lines** from the spectator point through each corner of the gable and onto the picture plane.
- From the picture plane, project the sight lines vertically up (or down) until they meet the corresponding vanishing lines.
- Mark the intersection points.

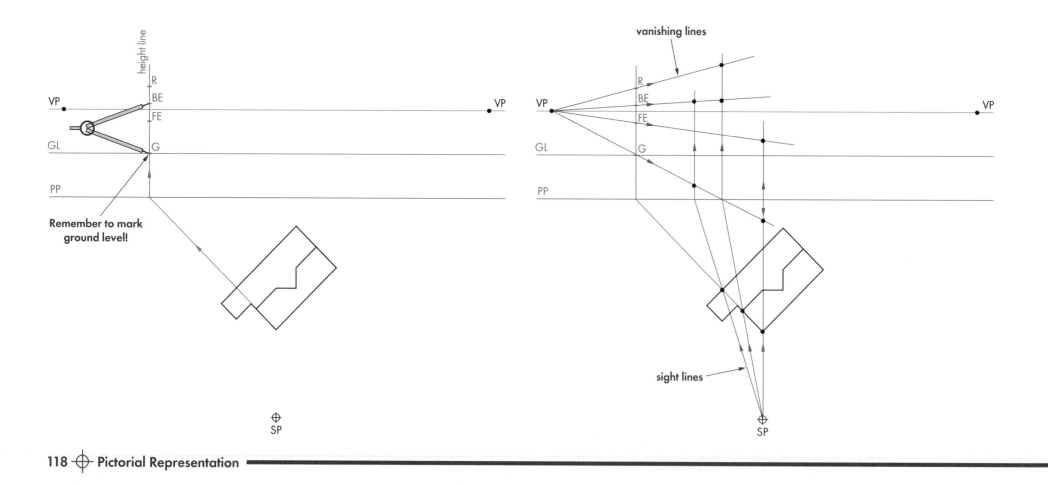

Remember to mark ground level!

vanishing lines

sight lines

6 Draw in the gable

• Complete the shape of the gable.

TIP

Once you reach this stage you have all but beaten the drawing. Memorise those first four steps. They are the same in most measured perspective drawings.

• Project from the gable back to the opposite vanishing point.

7 Complete the main part of the villa

• Project sight lines from the spectator point through the corners on plan and up to the picture plane.
• Project the sight lines vertically upwards to the corresponding vanishing lines.
• Draw the far end of the building.

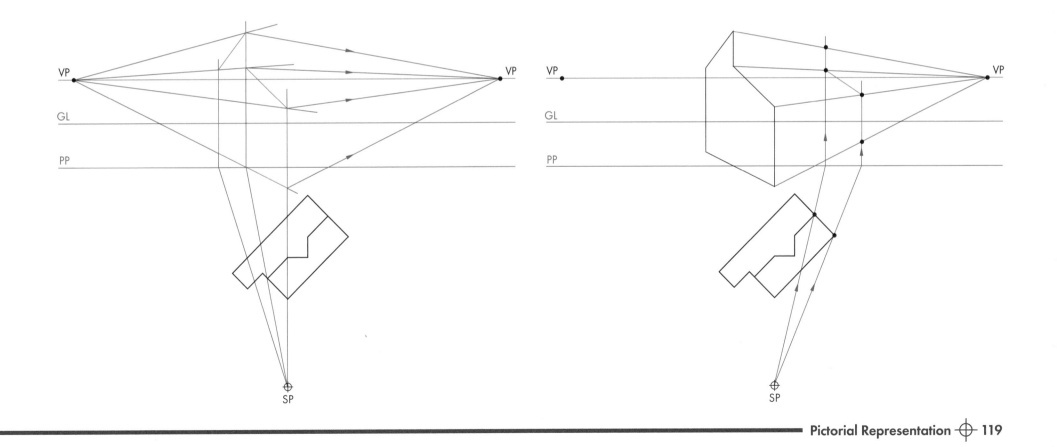

7 Draw the pointed window

- Project a height line from the edge of the pointed window to the picture plane and project it upwards.
- Measure and mark the heights at the bottom and top of the pointed window.
- Project vanishing lines through the heights.
- Project sight lines from the spectator point through the corners on the plan to the picture plane and upwards.
- Draw in the pointed window.

9 Draw the tower

- Select the gable end of the tower and project a height line to the picture plane.
- Project the height line vertically upwards and add the heights. Remember this wall only has three heights: ground level (G), back eaves (BE) and ridge (tower R).
- Project vanishing lines through all 3 heights.
- Project sight lines from spectator point through the corners to the picture plane and upwards.
- Draw in the gable wall.

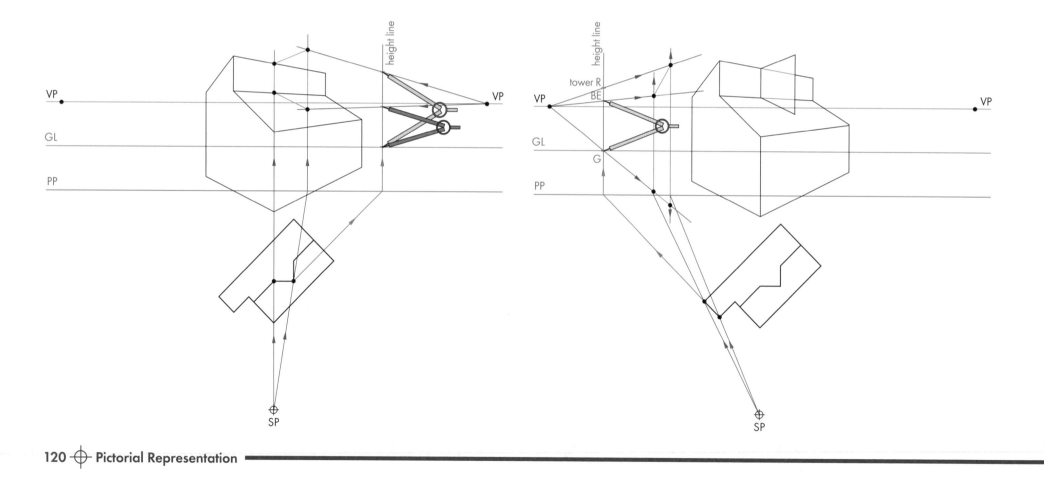

10 Complete the tower

- Project vanishing lines back to the other vanishing point.
- Draw the corner where the tower meets the main building.
- Draw the windows at the top of the tower.

11 Draw the windows on the main building

- Measure and mark the position of the windows on the rotated plan.
- Extend a height line from the front wall to the picture plane and project the height line upwards.
- Mark the window heights (top and bottom) on this height line.
- Project vanishing lines through both heights.
- Project sight lines from the spectator point through the plan to the picture plane and upwards.
- Line in the windows.

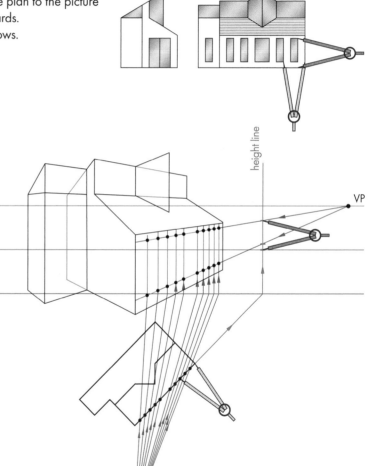

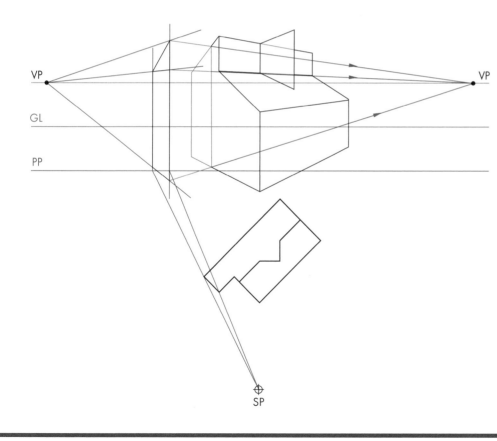

12 French door and tower window

- Mark the positions of the French door and window on the rotated plan.
- Extend a line from the wall with the door and raise a new height line.
- Measure and mark the French door height.
- Project a vanishing line through this height.
- Project sight lines from the spectator point through the plan and bounce upwards from the picture plane.
- Line in the French door.
- Repeat this process to draw the tower window.

13 Firm in the drawing

- Firm in each line.
- Do not show hidden detail.

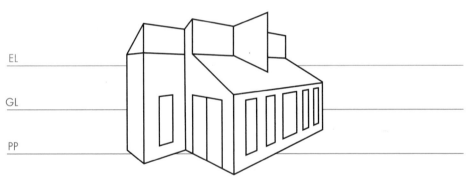

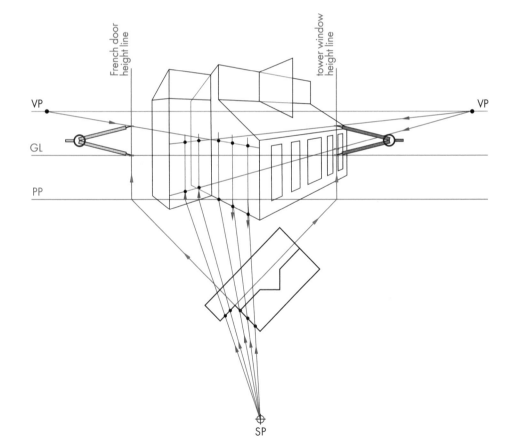

Construction drawing

Building projects require several types of specialised drawings. This collection of drawings, known as a **project set**, includes:

- location plans
- site plans
- floor plans
- elevations
- sectional views
- schematic diagrams
- rendered illustrations.

Buildings are designed by architects who are often supported by draughtsmen and women, technicians and structural engineers. This design team ensures that the building meets the needs of its occupants. It must also satisfy the local authority that the structural design of the building is sound and therefore safe and that the building is energy efficient.

The local authority's **Building Control Department** checks the structural design and energy efficiency of the building, while the **Planning Department** is responsible for regulating the external design of the building (how it looks on the outside). Each of these features is checked before construction work begins and this is done by studying the project set of drawings.

The drawings in the project set should comply with British Standards. Architects are guided by the **Standards document BS8888**. It is important that the drawings can be understood by all those involved in building construction. It is now common for buildings built in Britain to be designed in Germany or Scandinavia. International standardization is becoming increasingly important.

All construction drawings should be drawn using the correct British Standards symbols and conventions. Make sure you refer to the BS8888 document when you are preparing construction drawings and try to become familiar with the common symbols so that you can recognize and use them in the final exam.

Location plan

**Location Plan
scale 1:1250**

The **location plan** identifies the geographical location of the construction site. Ordnance Survey (OS) location plans for every city, town and village are available on a national database and can be bought or downloaded by architects. An entirely new development such as a housing estate will require a new location plan. OS maps are downloaded and the new location plan is superimposed on the map.

Location plans include:
- all neighbouring buildings and their plot boundaries
- street names and house numbers
- roads, pavements, footpaths, parks and fields
- a north direction arrow
- the scale of the drawing.

A new build in an existing street is highlighted by a thick outline and shading or colour.

The scale is normally **1:1250** (a standard OS scale).

Site plan

**Site Plan
scale 1:200**

Site plans show a larger view of the plot highlighted in the location plan. The builder needs to know exactly where on the plot the building is to be constructed. The site plan allows the builder to mark out the site before digging trenches for foundations and drains.

A site plan may include:
- boundaries of the plot
- the position (dimensions) of the building within the plot
- access paths
- drainage information for the removal of waste: pipe runs, manholes and the location of the main sewer
- contour lines to indicate the direction and gradient of sloping ground
- existing trees and the positions of any new trees that are required
- a north direction arrow
- the scale of the drawing.

The scale is normally **1:200** for domestic buildings.

Floor plan

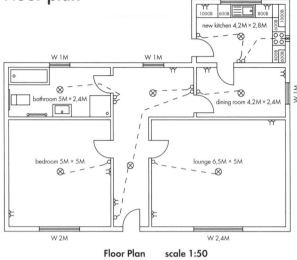

Floor Plan scale 1:50

The **floor plan** is an internal view of the house from above. It is used by all building trades (bricklayers, plumbers, electricians and joiners) to plan and cost their work. It gives information to trades people but is also used to show the client or customer the layout and dimensions of the house before it is built. Floor plans often form part of the promotional pack that customers get when they view a new house. These plans are usually coloured and simplified to make them easier to understand.

A floor plan may include:
- the layout and dimensions of rooms inside the building
- positions and dimensions of doors and windows
- layout of kitchen and bathroom fixtures and fittings
- lights, light switches, electrical sockets, electric cables and fuse boxes
- the layout of water pipes (plumbing)
- the scale of the drawing.

The scale is normally **1:50**.

Elevations

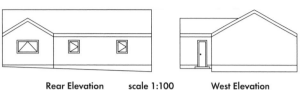

Rear Elevation scale 1:100 West Elevation

The planning department checks that the style of the building is in keeping with the local environment. Elevations are orthographic views of the outside of the building that enable these checks to be made. The builder needs information about the style of roof and wall finishes while clients and customers also want to know what a building will look like. Elevations can provide this information.

Elevations show:
- the style of the building (for example, bungalow, villa or flat)
- the external proportions of the building
- the external features of the building; window styles and wall finishes, etc.
- the type of roof: gable, hipped or flat roof
- the positions of doors and windows from the outside.

The scale is normally **1:100** or **1:50**.

Sections

Sectional views are detailed technical drawings showing a slice through a wall. The section is normally taken through a part of the building that will show most detail. In the example shown here, the section passes through a window. The detail in a sectional view shows the bricklayers and joiners how the building is to be constructed. It will explain what materials are to be used and how the various components fit together. The Building Control Department will look carefully at these drawings to determine whether the structure is sound. Sections can be taken through any part of the building from the roof to the foundations.

Sections show:
- the materials used: brick, engineering block, hardwood, softwood, concrete, insulation board and damp-proof membranes
- construction details (how the various materials fit together)
- wall construction: brick and blockwork or brick and timber framed
- dimensions (especially heights and wall thickness)
- floor and ground levels inside and outside the house
- the design of the foundations and floor
- the design of the eaves
- the type, thickness and position of insulating materials
- the scale of the drawing.

The scale is normally **1:20**.

For you to do

Identify materials 'a' to 'd' on this sectional view. See page 133 for a list of common building symbols. The solution is on page 221.

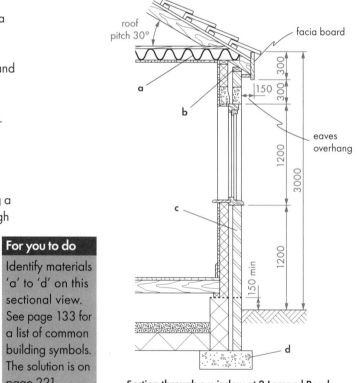

Section through a window at 2 Lomond Road
scale 1:20

Rendered illustrations

Marketing the property for sale or for renting is a vital part of new building developments. The marketing team use glossy brochures and leaflets that will promote the houses and apartments effectively. These promotional documents will include illustrations of the proposed houses and floor plans showing the main room dimensions.

To maximize the impact and realism, illustrations may be fully rendered and shown in mature surroundings; trees and shrubs are often included. The drawings can be computer generated or manually done. These illustrations can be either 2D or pictorial, often in perspective to maximize realism.

Promotional graphics will show:
- external views of the building
- coloured and rendered views that are easily understood and appeal to the consumer
- simplified floor plans enabling the consumer to determine which size of house will best suit the family's needs
- a new property in pleasant, mature surroundings; trees and shrubs can be 'painted in'
- text that explains the benefits of a particular property but does not get bogged down in technical detail
- prices.

The illustrations may not be printed to scale but the proportions will be accurate.

Worked example

A new kitchen extension is being added to a small bungalow at 2 Lomond Road. The extension is being built onto the back of the house.

Architect's preliminary sketches

The architect has made site visits to discuss the project with the owners and to take measurements and produce **preliminary sketches**. The sketches produced include pictorial views, a site plan, a floor plan and a one-point perspective view.

Additionally, the architect's team has sourced a section through a window of the original house. The construction details of the new extension should match the original dimensions. A location plan has been downloaded and the extension added. The architect has also made notes and recorded dimensions that will be required to complete the drawings in the project set.

Your task is to draw:
- a site plan to a scale 1:200
- a floor plan to a scale 1:50
- the rear elevation and end elevation to the right to a scale 1:100.

**Location Plan
scale 1:1250**

Problem solving tips

Of the seven types of drawing in the project set you will normally be asked to draw only **2D site plans**, **floor plans** and **elevations**. These will not be difficult or complex. However, scaling is always required and, because the information you need comes from several different sources, they can be time-consuming to draw.

You will have to interpret each of the other drawing types – location plans and sections, etc – to find the information you need to complete drawings. Other drawing styles used by architects include planometric and perspective drawing. These styles are covered elsewhere in this book.

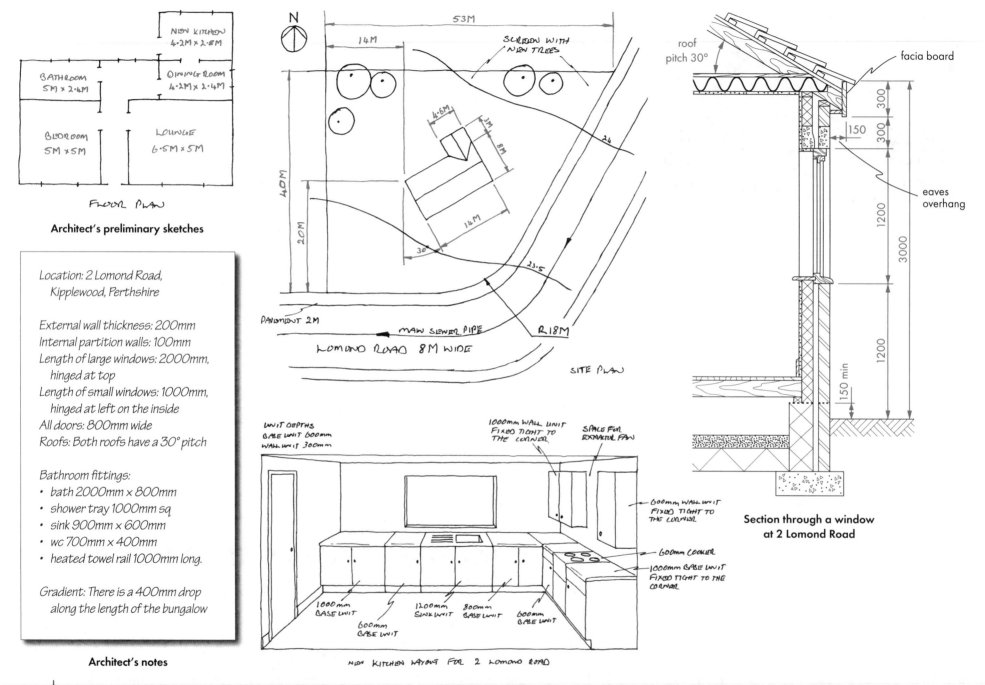

Architect's preliminary sketches

Location: 2 Lomond Road,
Kipplewood, Perthshire

External wall thickness: 200mm
Internal partition walls: 100mm
Length of large windows: 2000mm,
hinged at top
Length of small windows: 1000mm,
hinged at left on the inside
All doors: 800mm wide
Roofs: Both roofs have a 30° pitch

Bathroom fittings:
• bath 2000mm x 800mm
• shower tray 1000mm sq
• sink 900mm x 600mm
• wc 700mm x 400mm
• heated towel rail 1000mm long.

Gradient: There is a 400mm drop
along the length of the bungalow

Architect's notes

Section through a window at 2 Lomond Road

Worked example

Draw a site plan to a scale of 1:200.

Include:

- a 1m wide access path around the building
- a 1m wide path from the front door to Lomond Road
- waste removal pipes to the sewer in Lomond Road
- three new trees to provide privacy from the right of way.

1 Draw the site boundary

- Study the preliminary sketches.
- Scale the length and breadth 1:200.
- Draw the boundary outline.

Scaling 1:200

Boundary lines:

Length: $53M \div 200 \Rightarrow \dfrac{53000}{200} = 265$

Breadth: $40M \div 200 \Rightarrow \dfrac{40000}{200} = 200$

Radius: $18M \div 200 \Rightarrow \dfrac{18000}{200} = 90$

2 Draw the bungalow outline

- Scale the relevant dimensions.
- Position the left corner.
- Draw the outline.

Scaling 1:200

Position of bungalow:

Length: $14M \div 200 \Rightarrow \dfrac{14000}{200} = 70$

Breadth: $20M \div 200 \Rightarrow \dfrac{20000}{200} = 100$

Bungalow dimensions:

Length: $14M \div 200 \Rightarrow \dfrac{14000}{200} = 70$

Breadth: $8M \div 200 \Rightarrow \dfrac{8000}{200} = 40$

New extension dimensions:

Length: $4,6 \div 200 \Rightarrow \dfrac{4600}{200} = 23$

Breadth: $3M \div 200 \Rightarrow \dfrac{3000}{200} = 15$

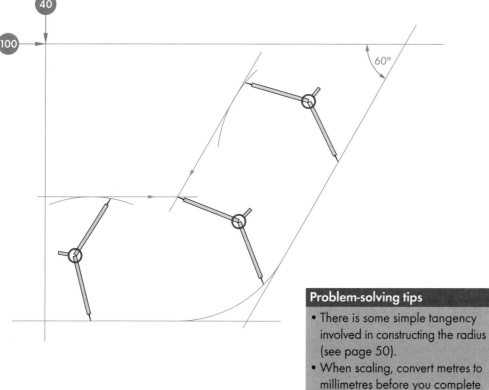

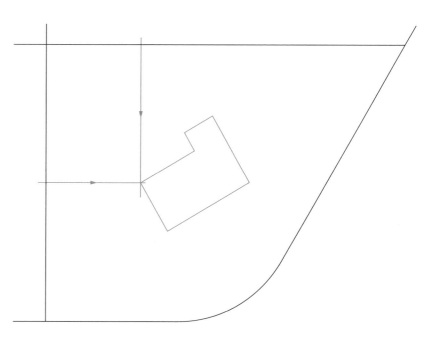

Problem-solving tips

- There is some simple tangency involved in constructing the radius (see page 50).
- When scaling, convert metres to millimetres before you complete the calculation.

CONSTRUCTION DRAWINGS

3 Draw the roof

- Scale the height to the eaves.
- Project an end elevation construction including a gable of the new extension. (This enables you to find the ridge of the new roof.)
- Project back to find the line of intersection of the two roofs.

4 Draw the paving, road and waste pipes

- Scale the relevant sizes.
- Use the architect's notes and the floor plan to calculate the position of the front door.
- Draw the access paths.
- Waste pipes are taken from the kitchen and bathroom. (The pipes must run downhill.)
- Add a rodding eye to allow access to clear any blockage at the junction outside the kitchen.
- Include a man hole for access wherever there is a change of direction or a joint.
- The waste pipe should meet the sewer at an angle that aids the flow of the sewer waste (down hill).
- Draw the road and pavement.

5 Draw the trees, direction symbol and boundary lines, and firm in
- Use the correct BS symbols (see page 133) to draw in existing trees. Use your own judgement to position them.
- Add new trees in the positions shown.
- Add a north arrow.
- Firm in the two boundary lines using chain lines.
- Firm in the rest of the drawing and add the title.

Worked example

Draw a floor plan to a scale of 1:50.

Include:
- the kitchen layout as described
- the bathroom fixtures and fittings
- a ceiling light and switches in each room
- two twin power sockets in each area except the bathroom.

1 Draw the outline of the walls
- Study the floor plan preliminary sketch and the architect's notes.
- Scale the lengths and breadths 1:50.
- Draw the outline of the walls.
- Scale the external wall thickness.
- Add this thickness to the **inside** of the external walls.

Scaling 1:50

External sizes

Bungalow:

Length: $14M \div 50 \Rightarrow \dfrac{14000}{50} = 280$

Breadth: $8M \div 50 \Rightarrow \dfrac{8000}{50} = 160$

New extension:

Length: $4,6M \div 50 \Rightarrow \dfrac{4600}{50} = 92$

Breadth: $3M \div 50 \Rightarrow \dfrac{3000}{50} = 60$

Wall thickness:

External wall thickness: $200 \div 50 = 4$

**Site Plan
scale 1:200**

80

50

CONSTRUCTION DRAWINGS

2 Draw the internal partition walls

- Scale the internal walls.
- Scale room dimensions from the preliminary sketch. (Remember these are 'inside' sizes.)
- Carefully mark out and draw the internal walls.

Scaling 1:50

Internal walls: $100 \div 50 = 2$

Interior room sizes:

Lounge: $6,5M \div 50 \times 5M \div 50$
$$\Rightarrow \frac{6500}{50} \times \frac{5000}{50} = 130 \times 100$$

Bedroom: $5M \div 50 \times 5M \div 50$
$$\Rightarrow \frac{5000}{50} \times \frac{5000}{50} = 100 \times 100$$

Bathroom: $5M \div 50 \times 2,4M \div 50$
$$\Rightarrow \frac{5000}{50} \times \frac{2400}{50} = 100 \times 48$$

Dining room: $4,2M \div 50 \times 2,4M \div 50$
$$\Rightarrow \frac{4200}{50} \times \frac{2400}{50} = 84 \times 48$$

3 Draw the doors and windows

- Scale door and window sizes.
- Study preliminaries to locate the large and small windows.
- The windows are positioned in the centre of each wall on the inside.
- Doors are positioned approximately according to preliminary plan.
- Mark out and draw the doors and windows using the correct BS symbols (see page 133).

Scaling 1:50

Doors: $800 \div 50 = 16$

Windows (large): $2M \div 50 \Rightarrow \dfrac{2000}{50} = 40$

Windows (small): $1M \div 50 \Rightarrow \dfrac{1000}{50} = 20$

4 Draw the kitchen units

- Study the preliminary kitchen sketch.
- Scale the dimensions of the kitchen units.
- Draw the units using the correct BS symbol for the sinktop (see page 133).
- Design suitable symbol for cooker.
- Add an extractor fan using the correct BS symbol.

Scaling 1: 50

Kitchen units:

Depth of base units: $600 \div 50 = 12$

Depth of wall units: $300 \div 50 = 6$

Length of units:

$\qquad 1200 \div 50 = 24$

$\qquad 1000 \div 50 = 20$

$\qquad 800 \div 50 = 16$

$\qquad 600 \div 50 = 12$

6 Draw the lights, switches and sockets, and firm in

- Look up BS symbols for each item (see page 133).
- Draw lamp symbol in the centre of each room.
- Position the light switches close to, but not behind, doors. Some lights need two switches.
- Draw the switches and wiring routes (use a broken line).
- Twin sockets may be positioned near corners at opposite sides of a room.
- Add the room name and inside room dimensions to each room.
- Firm in the drawing and add the title.

5 Plan and draw the bathroom fittings

- Scale each fitting, see architect's notes.
- Look up the correct BS symbols for each fitting (see page 133).
- Plan the layout. There can be many solutions here, but try to think about the practicality of the layout.
- Draw the bathroom fittings.

Scaling 1:50

Bathroom fittings:

Bath: $\dfrac{2000}{50} \times \dfrac{800}{50} = 40 \times 16$

Shower tray: $1000 \, sq \div 50 = 20 \, sq$

Sink: $\dfrac{900}{50} \times \dfrac{600}{50} = 18 \times 12$

W.C.: $\dfrac{700}{50} \times \dfrac{400}{50} = 14 \times 8$

Towel rail: $1000 \div 50 = 20 \, long$

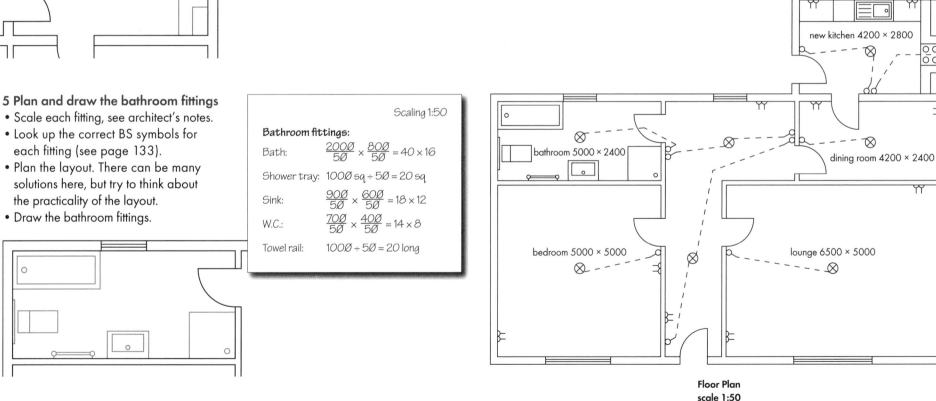

new kitchen 4200 × 2800

bathroom 5000 × 2400

dining room 4200 × 2400

bedroom 5000 × 5000

lounge 6500 × 5000

Floor Plan
scale 1:50

Worked example

Draw to a scale of 1:100:
- the rear elevation
- the end elevation to the right.

Include:
- windows, door and damp-proof course (DPC)
- window and door frames
- a 400mm ground drop along the length of the bungalow.

Ignore the overhang at the eaves. Show the facia board at the eaves.

1 Draw the gable
- Study the architect's notes and the site plan preliminary sketch.
- Scale the main dimensions of the bungalow.
- Draw the gable of the main part of the bungalow.
- Project the heights across and draw the rear of the bungalow.

Scaling 1:100

Bungalow:

Breadth: $8M \div 100 \Rightarrow \frac{8000}{100} = 80$

Height to roof at the eaves: $3M \div 100 \Rightarrow \frac{3000}{100} = 30$

Length: $14M \div 100 \Rightarrow \frac{14000}{100} = 140$

40 120

2 Draw the new kitchen extension
- Study the preliminary site plan to determine the direction of the slope.
- Scale the change in ground level.
- Draw the sloping ground level.
- Draw the gable of the new kitchen extension.
- Project the heights of the new extension across to the end elevation.
- Project the new ground levels across to the end elevation.

Scaling 1:100

New extension:

Breadth: $4,6M \div 100 \Rightarrow \frac{4600}{100} = 46$

Length: $3M \div 100 \Rightarrow \frac{3000}{100} = 30$

Change in ground level: $400 \div 100 = 4$

Notice the different ground levels of the extension and the main building.

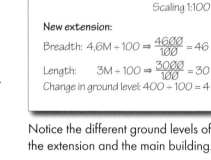

3 Draw the windows and door
- Scale window and door dimensions.
- Study the section drawing for window heights and scale them.
- Draw window in the centre of the new extension gable.
- Study the preliminary floor plan and architect's notes and calculate the positions of the two small windows. These should be in the centres of the bathroom and hall respectively when viewed from the inside.
- Study the architect's notes and add hinge symbols to the windows.
- Draw the door – estimate the position from the floor plan. The height should be the same as the windows.

Scaling 1:100

Windows

Height to sill: $1200 \div 100 = 12$
Height of windows: $1200 \div 100 = 12$
Length of large windows: $2000 \div 100 = 20$
Length of small windows: $1000 \div 100 = 10$
Measurement to the centre of the bathroom wall:

(external wall + 2500) ÷ 100

$\Rightarrow \frac{250 + 2500}{100} = \frac{2750}{100} = 27,5$

Space between bathroom and hall windows measured from floor plan:

$3,55M \div 100 \Rightarrow \frac{3550}{100} = 35,5$

4 Draw the facia board and DPC, and firm in
- Study the architect's notes and sectional view.
- Scale facia board breadth and DPC height. (The damp-proof course is usually set at 150mm above ground level.)
- Firm in the drawing and add titles.

Scaling 1:100

Min height of DPC: $150 \div 100 = 1,5$
Depth of facia board under the roof: $300 \div 100 = 3$

Rear Elevation
scale 1:100

End Elevation

Construction drawing symbols and conventions

The following symbols and conventions have been standardized by the **British Standards Institution** (BSI). Such symbols and conventions are used on building or construction drawings to:
- simplify the drawing process
- ensure a common understanding of these symbols and what they represent
- ensure there is consistency, no matter where the drawings are produced or where the building is erected.

All users – architects, structural engineers, surveyors, electricians, builders, plumbers and joiners – share a common understanding of these symbols which are now recorded in **BS 8888** and are in the process of being accepted as worldwide standards.

You will need to make reference to them in order to complete your building drawings. You may also be asked questions about them in your exam. If you are asked to include them in a drawing you will be shown a selection to choose from. You should try to become familiar with the symbols below so that you can recognize and use them in the final exam.

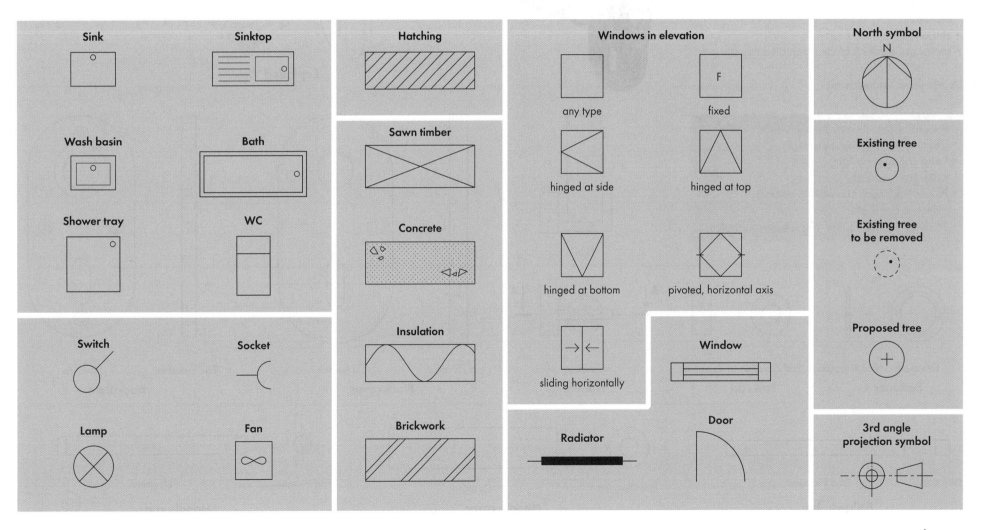

ORTHOGRAPHIC SKETCHING

Orthographic sketching

An important element of freehand sketching is the ability to sketch objects orthographically. Possessing this skill allows the product designer to communicate ideas effectively to clients. It is a method of sketching that requires a disciplined approach.

Worked example

Orthographic views of the components of a door handle are shown. Sketch in good proportion:

• elevation
• end elevation
• sectional view A–A of the assembled components.

Do not show hidden detail.

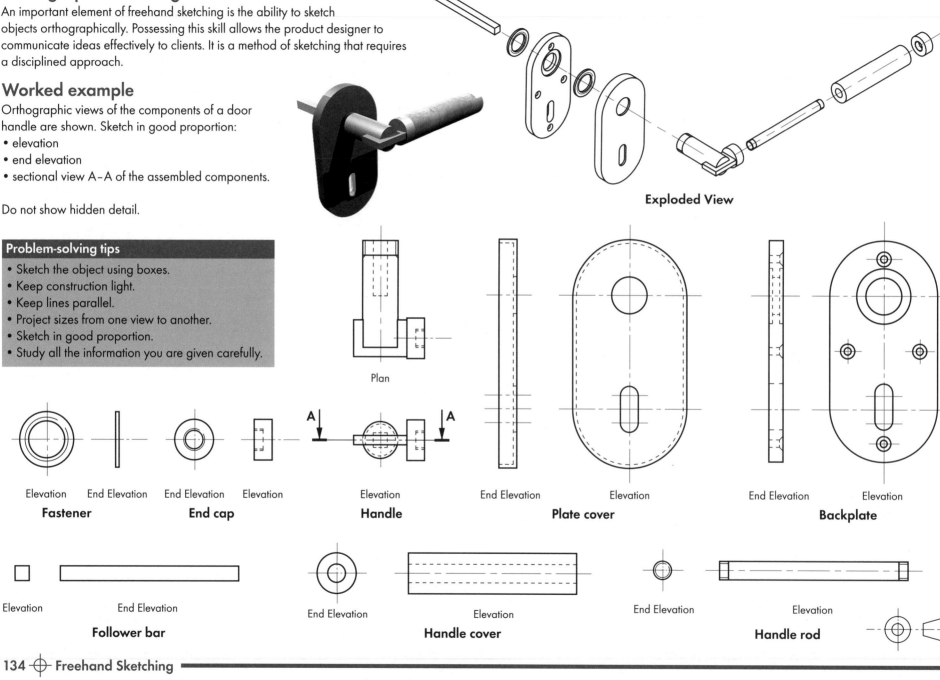

Exploded View

Plan

Elevation · End Elevation
Fastener

End Elevation · Elevation
End cap

Elevation
Handle

End Elevation · Elevation
Plate cover

End Elevation · Elevation
Backplate

Elevation · End Elevation
Follower bar

End Elevation · Elevation
Handle cover

End Elevation · Elevation
Handle rod

1 Sketch the plate cover
- Construct the crate of the plate cover.
- Sketch construction lines for the semi-circles at each end.

2 Sketch the handle and key hole
- Sketch the semi-circular arcs at each end.
- Construct the circle for the handle.
- Construct the key hole.
- Sketch in the circle and arcs.

3 Sketch the handle assembly
- Construct the crates for the assembly of the handle, handle cover and the end cap, working from the centre of the circle in the plate cover.
- Firm in the outlines.
- Add the cutting plane A–A. This passes horizontally through the centre of the handle.

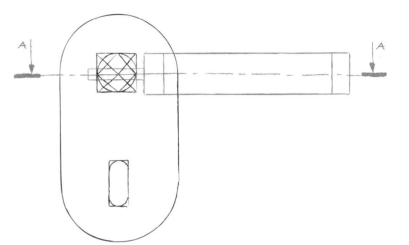

Problem-solving tips

- Start with the view that is most easily recognised (in this case the elevation); it will be easier to establish accurate proportions.
- Begin with the component that governs the size of the assembly – often the largest one.
- To construct the crate, you need to consider the crate's proportions (height compared to length). You should also consider the size of the crate, and ensure that you leave enough space to fit the end elevation and plan on the page.

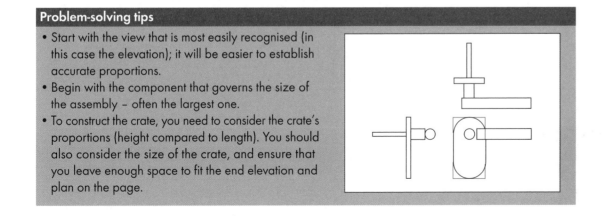

ORTHOGRAPHIC SKETCHING

4 Project the elevation and sketch the sectional plan
- Project the lengths upwards.
- Construct each part in turn. (Check the proportions of each part on the detail drawings.)
- Firm in the detail that is made visible by the sectioning.

5 Add cross hatching
- Add screw threads and cross hatch each component. Alter the spacing and direction to define each area.
- Do not hatch the fasteners, handle rod or follower bar.

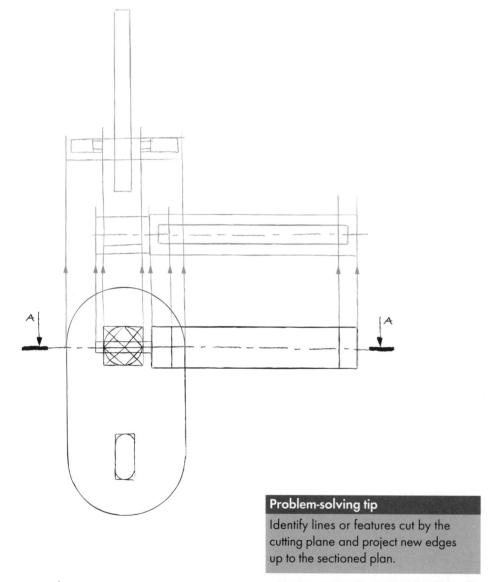

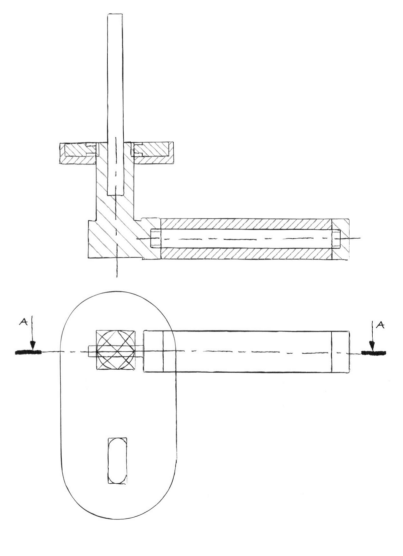

> **Problem-solving tip**
> Identify lines or features cut by the cutting plane and project new edges up to the sectioned plan.

6 Project the elevation and sketch the end elevation

- Project heights across to the end elevation.
- Construct each part individually. Take care with proportion.

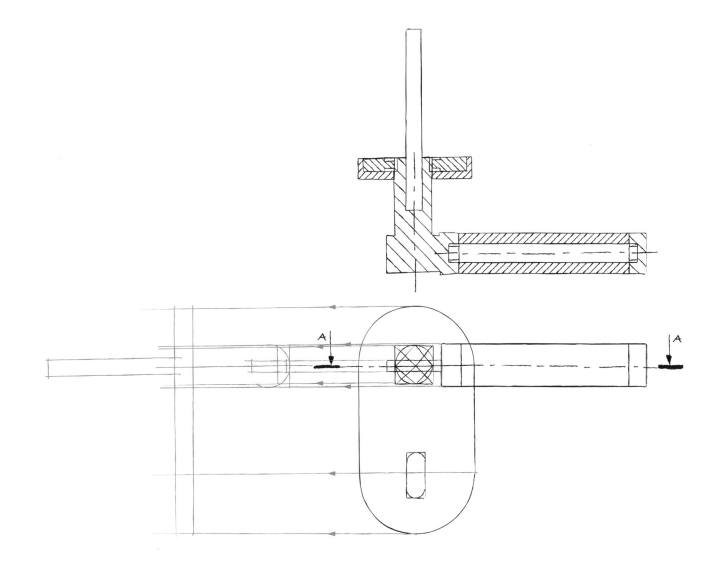

ORTHOGRAPHIC SKETCHING

7 Firm in the outlines
• Add detail to each part.
• Firm in outlines and centre lines.
• Title the views.

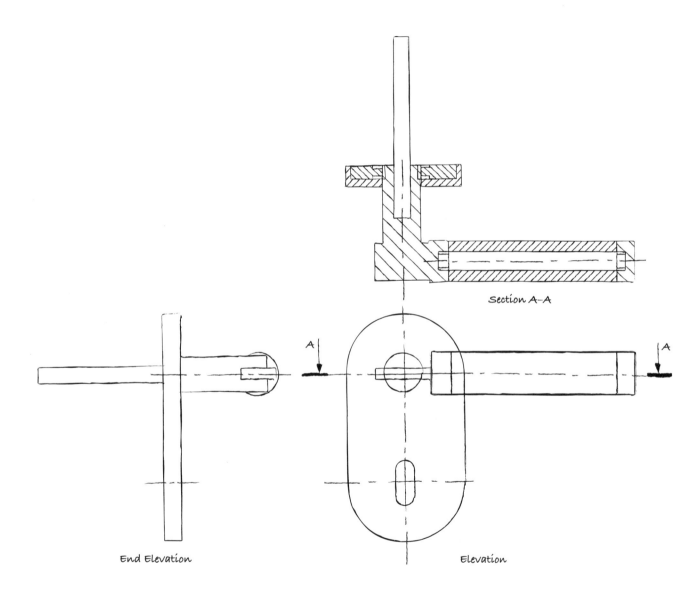

Section A–A

End Elevation

Elevation

Perspective sketching

Perspective sketching is a form of sketching that is used by architects, designers and illustrators to afford their sketches a greater sense of realism and depth. The ability to sketch objects in perspective is a vital skill in graphic communication. Mastering this skill allows effective communication of ideas between the designer and client.

Placement of the vanishing points

If a sketch is to fill the page, it is sometimes necessary to place the vanishing points off the page, estimating their position on the horizon line. This enables a large sketch to be made without distortion. Sketching using these remote vanishing points is a useful skill and requires a good eye for perspective.

When the vanishing points are placed within the page, a large sketch becomes distorted. It is important to reduce the size of the sketch when this method is used.

Placement of the leading vertical edge

The position of the leading (closest) vertical edge dictates the angle the object is viewed at.
- Placing the leading edge high (above the horizon) will reveal the bottom of the object.
- Placing the leading edge low (below the horizon) will show the top of the object.
- A leading edge placed mid-horizon will show neither top nor bottom.

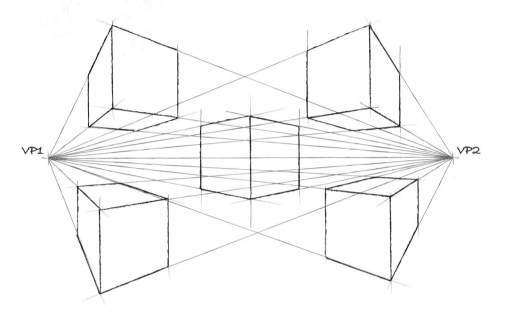

- Positioning the leading edge exactly mid-way between the vanishing points shows equal views of the two sides.
- Moving the leading edge across the horizon line shows more of one side and less of the other.

Decide on the face you want to see most clearly and position the leading edge accordingly.

PERSPECTIVE SKETCHING

Use crates to build sketches

Any object, regardless of its complexity, can be sketched. The key is to simplify the object by crating each feature. Consider the overall proportions of a feature (length × breadth × height) and sketch a crate that will fit the feature. Continue crating each feature until you reach the desired level of detail.

Size

Consider the size you want the finished sketch to be before you sketch the first crate. Too small a size will result in difficulties when detail is added.

Proportion

Proportional accuracy is vital to achieving a realistic sketch. When sketching, proportion has to be judged; it cannot be measured. You must train your eye to recognise the correct proportions. One way to approach this is to compare lengths, breadths and heights and make adjustments as you see fit until the correct proportions are achieved. Where possible you can also look for opportunities to divide crates up into equal sections such as halves, thirds, quarters, etc.

1

2

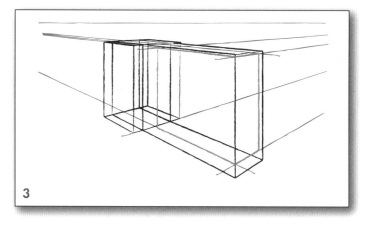

3

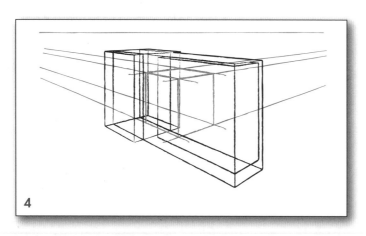

4

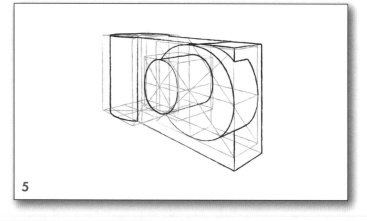

5

One point perspective sketching

One point perspective sketching is a method of sketching that is simple to construct and understand. It is commonly used by illustrators, architects and interior designers to give a realistic impression of interior spaces. It uses a single vanishing point, positioned on the horizon line. The impression of perspective is given by projecting the depths of objects or spaces back to the vanishing point.

Worked example

An architectural firm has produced a design for the interior living space for a modern home. A pictorial drawing (with cutaway section revealing the interior space and lighting recess in the ceiling) and orthographic views are given. To further aid the consultation process, they require a set of drawings that can be more easily understood by the client.

Sketch in good proportion a one point perspective view in the direction of arrow **1** to show the interior of the room.

lighting recess

Cut-away of the interior

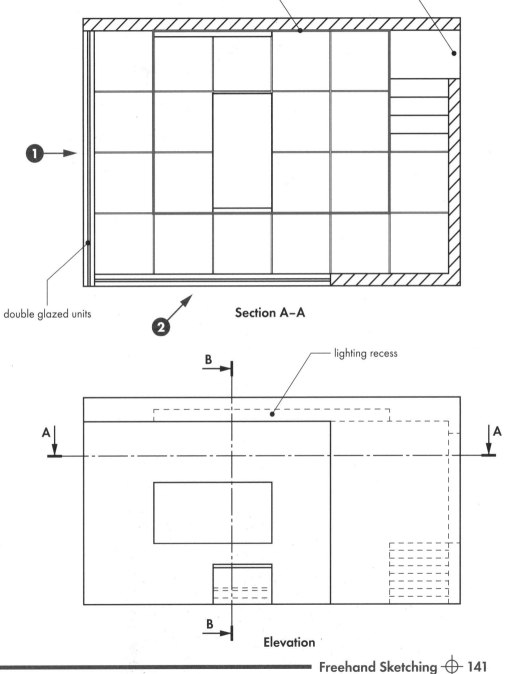

lighting recess

doorway

double glazed units

1

2

Section A–A

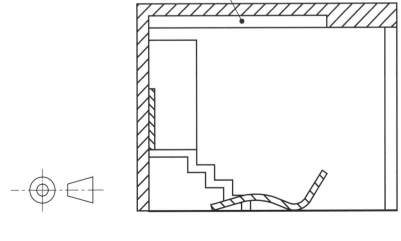

lighting recess

Section B–B

B

A

A

lighting recess

B

Elevation

ONE-POINT PERSPECTIVE SKETCHING

1 Sketch the vanishing point
- Position the horizon line approximately one third down from the top of the page and place the vanishing point half way along.

2 Sketch the back wall
- Sketch the back wall of the room. (Consider the height of the room first: position the back wall relative to the horizon line, with one third of the height of the room above it and two thirds below.)
- Sketch the width of the room, putting half on either side of the vanishing point. (Consider how this size compares proportionally with the height of the room.)

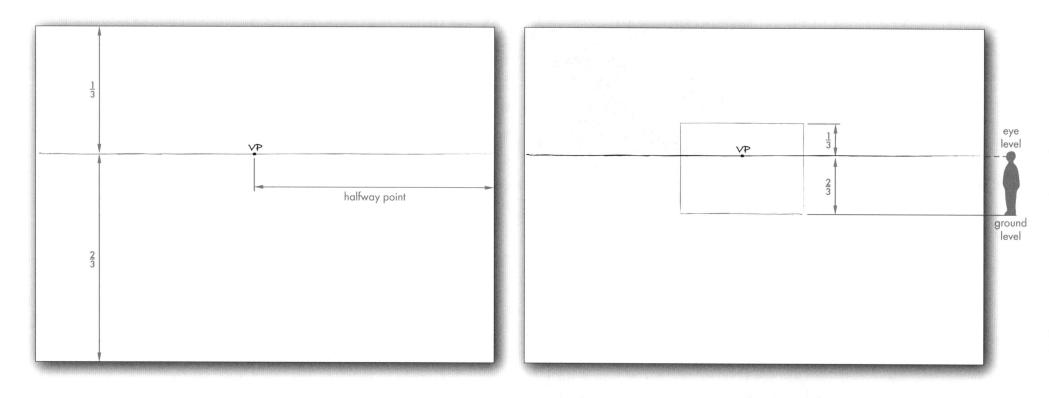

Problem-solving tips
- It is important that the sketch of the back wall is not too big. Space must be left for the floor, side walls and ceiling.
- The position of the vanishing point on the back wall is critical to the success and realism of the finished sketch. Too high or low a position will give an unrealistic view point. For interior views, the horizon line should generally be at a standing viewer's eye level.

3 Sketch the floor, ceiling and side walls
- Sketch lines from the vanishing point out to the four corners of the back wall and beyond. (Lines that disappear into or come out from the vanishing point are known as vanishing lines.)

4 Sketch the floor tiles
- Sketch the near edge of the floor. Take care with proportion. Remember the depth is affected by foreshortening.
- Divide the near edge into four and project vanishing lines.
- Divide the floor into six rows of tiles. Foreshortening makes each row narrower than the previous. Sketch a few 'trial lines' until you achieve a floor you are happy with.

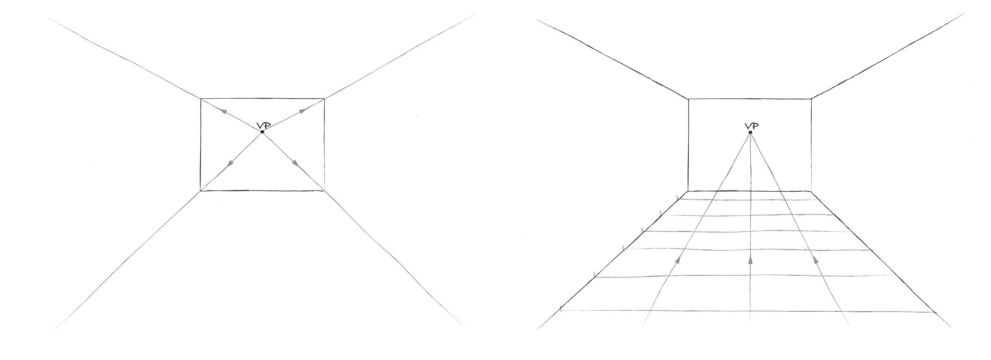

Problem-solving tip
The tiled floor will be used as a guide when aligning and spacing out the other features in the room, and is therefore constructed at this early stage.

ONE-POINT PERSPECTIVE SKETCHING

5 Sketch the thickness of one wall
- Use the floor tiles as a guide to sketch a vertical line from floor to ceiling.
- Add thickness to the wall and sketch vanishing lines outwards to give the top and bottom edges of the window.

6 Sketch the ceiling and lighting recess
- Using the floor tiles as a guide, project construction lines up the side and back wall until they meet the ceiling.
- Use these points (circled) to construct the lighting recess.
- Project this shape upwards to create the lighting recess.

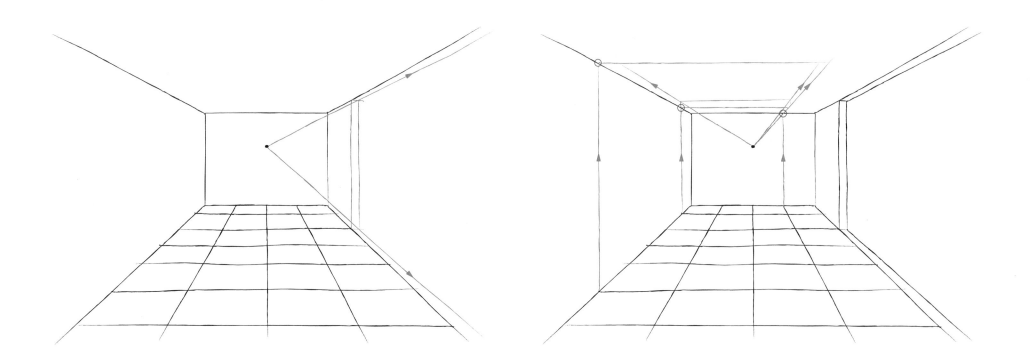

7 Sketch the door and landing
- In good proportion, sketch the door shape on the back wall.
- On the back wall, set out the diagonal line from the bottom corner of the door to the floor to define the incline of the stairs.
- Sketch vanishing lines through the three points on the back wall.
- Sketch the landing and front of the slope. (Use the tiled floor as a guide.)

8 Sketch the stairs
- Divide the sloping line on the back wall into four equal spaces.
- Add vertical and horizontal lines to give the outline of the stairs.

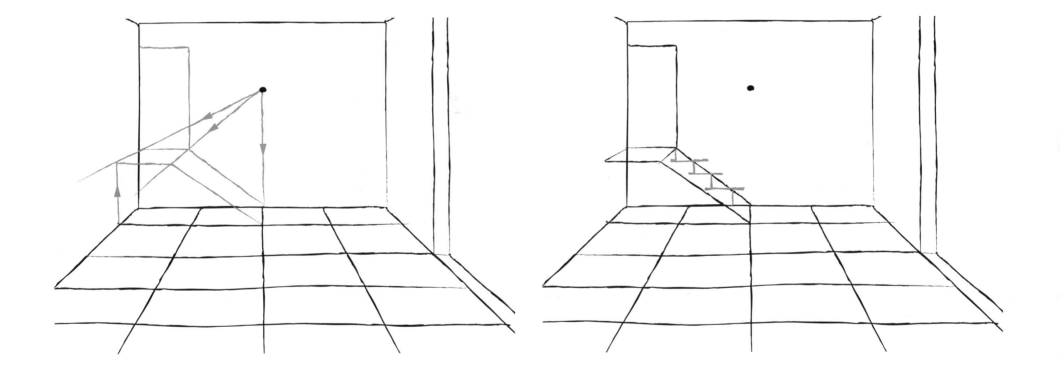

9 Sketch the stairs

- Sketch vanishing lines that pass through the corners of the stairs.
- Construct horizontal and vertical lines to define the front edge of the stairs.

10 Complete the stairs

- Add thickness to the near edge of the stairs and landing.

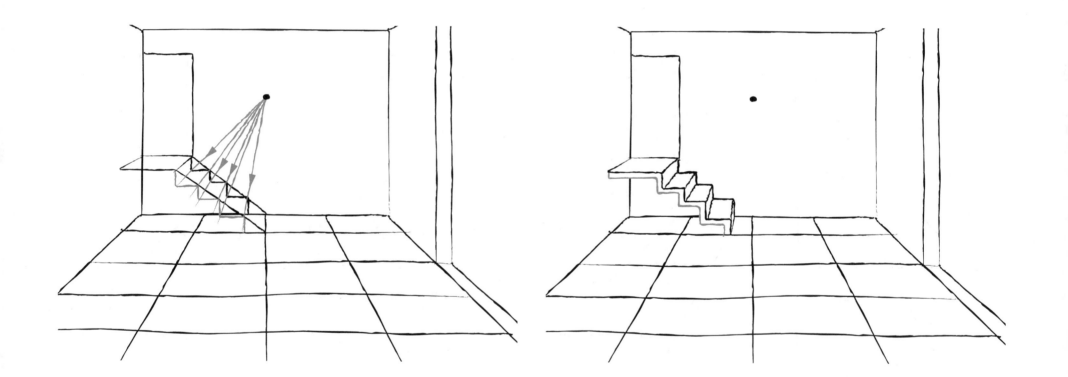

11 Sketch the wall feature
- Sketch the shape of the wall feature on the left-hand wall. (Use the floor tiles, the height of the stair landing and the eye level/horizon line as guides – key projection points are circled.)
- Add thickness to the wall feature.
- Add the front surface of the wall feature.

12 Sketch the crate and side profile of the lounger
- Sketch the base of the crate for the lounger using the floor tiles as a guide.
- Project the four corners upwards. (Key projection points are circled.)
- Draw the near side of the crate, then project vanishing lines back from its top corners and add the back edge.
- Sketch the profile of the lounger, ensuring that it touches the extremities of the rectangle as shown.

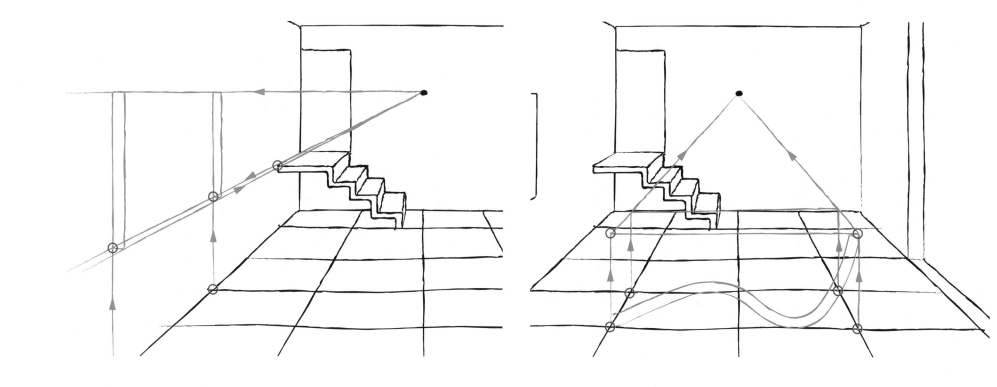

13 Sketch the back profile of the lounger

• Sketch the back profile of the lounger on the back surface of the crate. (The profile should touch the extremities of the rectangle in the same way as the first profile did.)

• Connect the visible edges between the two profiles.

14 Firm in all visible edges

• Firm in all the visible edges of the objects and the interior of the room.

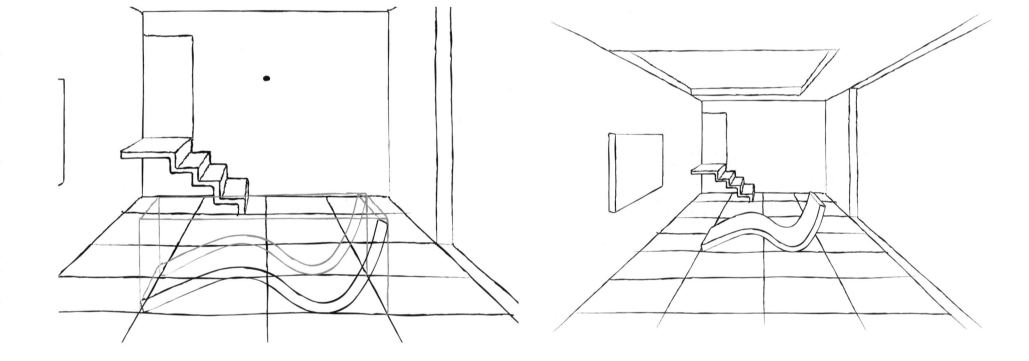

Two point perspective sketching (room interior)

Two point perspective sketching is a style of sketching favoured by architects, interior designers and illustrators to give their sketches of interior spaces a greater sense of realism. It uses two vanishing points placed on the horizon line. The impression of depth is created by projecting the lengths and breadths of objects or spaces back to the vanishing points.

Worked example

The interior living space of a modern home shown on page 141 is to be drawn in a way that can be more easily understood by the client.

Sketch in good proportion a two point perspective view in the direction of arrow **2** to show the interior of the room.

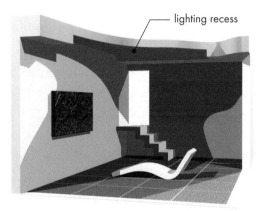

Cut-away of the interior

1 Sketch the back corner of the room

• Sketch the horizon line approximately one third down from the top of the page and position the vanishing points at each end.
• Sketch the back corner of the room where the back and side wall meet.
• Mark the height of the room with one-third of the height placed above the horizon line and two-thirds below.

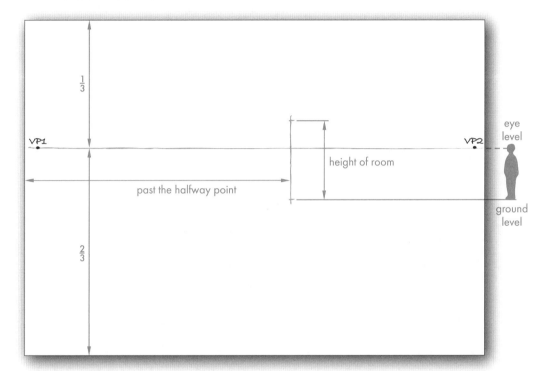

Problem-solving tips

• Placing the vanishing points in the correct position is critical to the success and realism of the finished sketch. Too high or low a position can give a distorted view point.
• When setting out the back corner it is vital that the height is correct. This governs how near or far the room appears to the viewer. If it is too large the resultant sketch does not leave enough drawing space for the walls, floor and ceiling.
• Consider also the shape and proportion of the room. Generally if a room is square, the position of the back corner should be placed centrally along the horizon line. In this particular case the room is rectangular and so we must place the back corner off-centre to allow us to include the floor and walls in the finished sketch.

2 Sketch the back and left hand walls
- Sketch vanishing lines from both vanishing points through the top and bottom of the back corner.
- Sketch verticals to establish the length of each wall. (Take care with proportion.)

3 Sketch the floor tiles
- Set out the spacing for the floor tiles along the bottom edges of the walls. Remember that this spacing is affected by foreshortening and the spacing will decrease as it moves further away from the viewer.
- Sketch vanishing lines through the tile marks and across the floor.

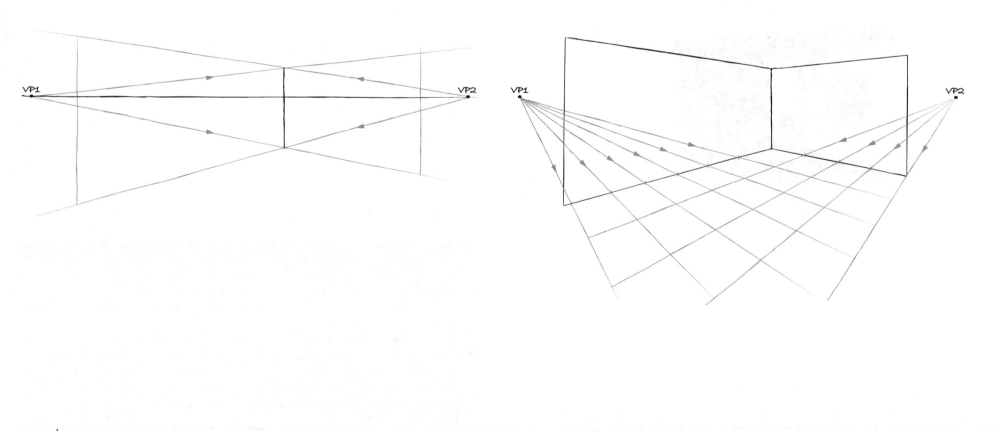

4 Add thickness to the walls
- Sketch vertical lines on the outside of the right-hand wall.
- Sketch vanishing lines through the circled points to establish the outside of the walls and the top and bottom edges of the windows.
- Add a vertical line to the left hand wall to give it thickness.

5 Sketch the lighting recess
- To mark the position of the recess, sketch construction lines up the side and back wall until they meet the ceiling. (Use the spacing of the floor tiles as a guide, as shown.)
- Sketch vanishing lines through these marks (circled).
- Project this shape vertically to create the lighting recess.

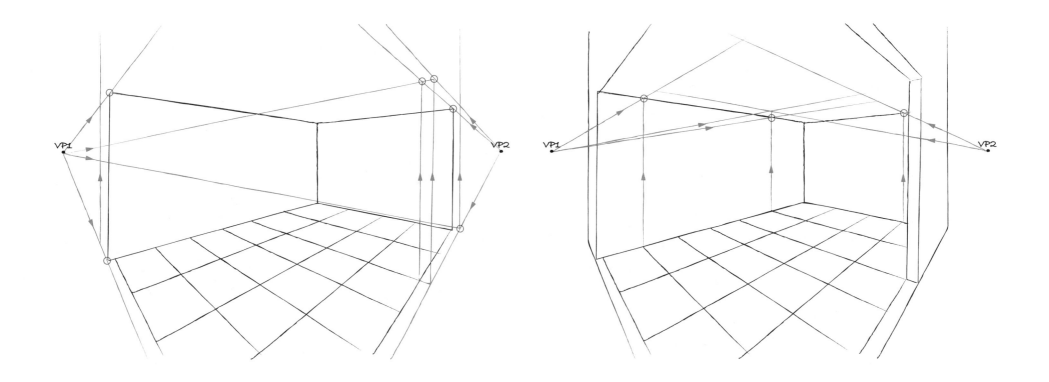

6 Construct the doorway and stairs

- Sketch the door on the back wall. Take care with proportion and use vanishing lines at the top and bottom.
- On the back wall sketch a sloping construction line for the stairs.
- Project vanishing lines to create the landing.
- Project another vanishing line to establish the depth of the landing (use a single tile spacing).
- Sketch the front slope of the stairs.

7 Set out the spacing for the stairs

- Set out the stairs by dividing the sloping line on the back wall into four equal parts.
- Project all three points back to VP1.
- Project vertical lines down from these points to give the outline of the steps.

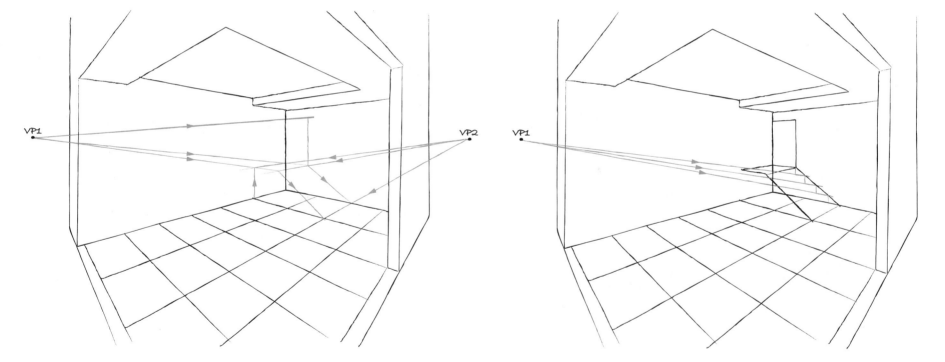

8 Construct the top edges of the stairs
- Project vanishing lines through the stairs.
- Construct the side of the stairs using the vanishing lines as a guide.

9 Add thickness to the stairs
- Add vertical lines and vanishing lines to create the thickness of the stairs.

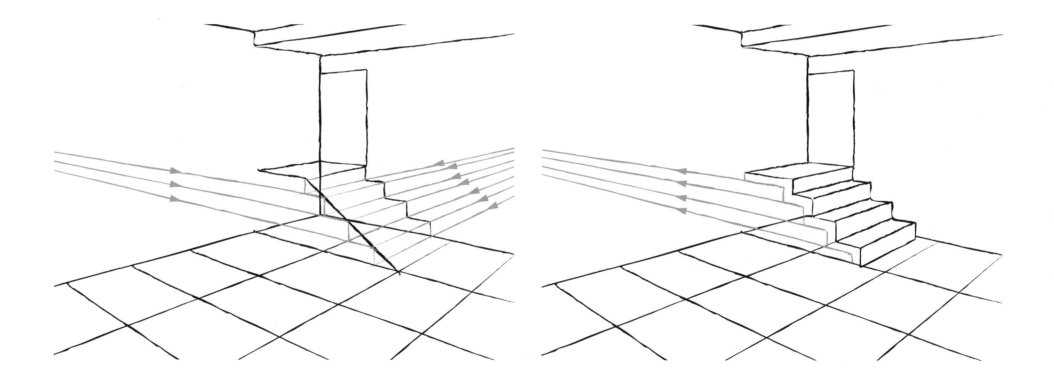

TWO POINT PERSPECTIVE SKETCHING (ROOM INTERIOR)

10 Sketch the wall feature
- Use the spacing of the floor tiles, the height of the stair landing and the eye level to set out the shape of the wall feature.
- Project vanishing lines from VP1 through the corners of the shape.
- Add a thickness to create the front of the wall feature.

11 Sketch the crate and side profile of the lounger
- Using the floor tiles as a guide, project four vertical lines and mark the height on the leading edge.
- Project vanishing lines from this height to complete the crate.
- On the front surface of the crate, sketch in the side profile of the lounger.

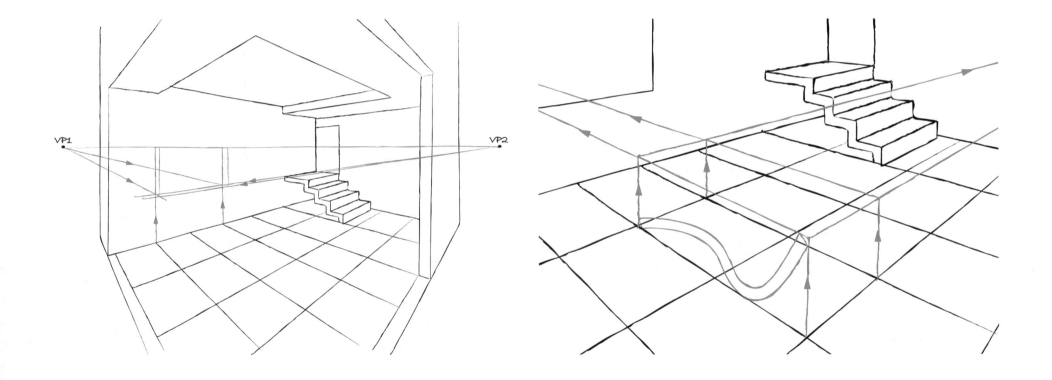

12 Complete the lounger

- Sketch vanishing lines to form the visible edges of the lounger.
- Sketch the side profile of the lounger in good proportion on the back surface of the crate.

13 Firm in all visible edges

- Carefully firm in all the visible edges of the objects within the sketch.

Two point perspective sketching (product)

Two point perspective sketching is a common style of sketching used by illustrators, designers and architects to give their sketches greater realism. This style of sketching allows objects or buildings to be drawn at any angle and from a range of view points.

Worked example

Orthographic drawings for a new cordless answerphone system have been produced. A pictorial sketch is required to present the idea to the client.

Sketch a two point perspective view of the product in good proportion with corner X as the bottom corner.

Problem-solving tips
• Build up the sketch using crates.
• Sketch in good proportion.
• Keep construction lines light.
• Do not use drawing aids – keep it entirely freehand.

Plan

Elevation

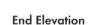

End Elevation

1 Establish the vanishing points

- Sketch the horizon line approximately one-third down the page. Mark vanishing points on each end of the horizon line.
- Sketch the leading edge of the crate. To do this, first consider the faces you wish to see and the shape and proportion of the object. In this case, the crate of the object is a cuboid. Position the leading edge of the crate to allow us to see more of the front surface.
- Sketch a vertical line through the horizon line to give the leading edge. Set the height of the crate by marking in positions for the top and bottom of the crate on the vertical line.

Problem-solving tips

We want to give the impression that we are viewing from slightly above the product, so the crate extends just above the horizon line. When setting out the leading edge of the crate, it is vital that the height is correct. The height of this line governs how near or distant the object appears to the viewer. If it is too large the sketch fills the page. This can distort the finished sketch as the sense of perspective is exaggerated.

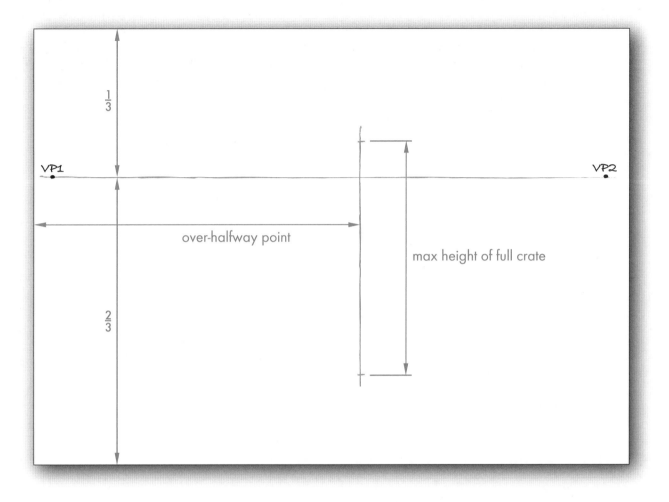

TWO POINT PERSPECTIVE SKETCHING (PRODUCT)

2 Set out the crate
- Project lines from the top and bottom of the leading edge to the vanishing points.
- Add vertical lines to either side of the leading edge, to complete the front surface and side of the crate. Consider the proportions of each surface (length compared to height).
- Remember that these faces will be affected by foreshortening and should be adjusted to give the correct proportions of the crate.

3 Set out the base of the answerphone
- Set out the height of the base of the answerphone by marking in a suitable height on the leading edge of the crate.
- Project lines back from this height to the vanishing points.
- Project the back edges where these lines meet the verticals.

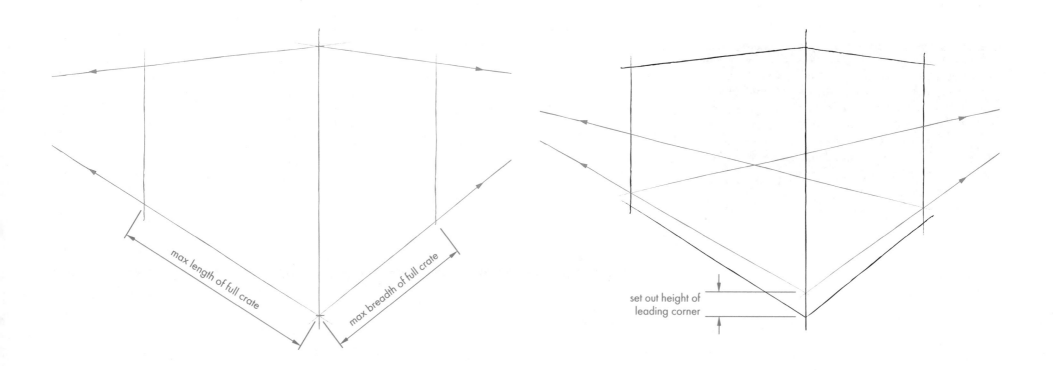

max length of full crate

max breadth of full crate

set out height of leading corner

4 Crate the handset and cradle

- Construct the crate that will contain the handset and cradle. Remember to consider the proportions again. Set out the crate by constructing the shape of the floor of the crate first and projecting vertically from the four new corners. Note that the crate overlaps the front of the answerphone base.
- Complete the top surface of the crate, taking care to use the vanishing points.

5 Construct the side profile

- Construct the side profile of the handset and cradle on the side of the crate.
- Project lines back to VP1 from the visible corners of this profile and add the back line to give its thickness.

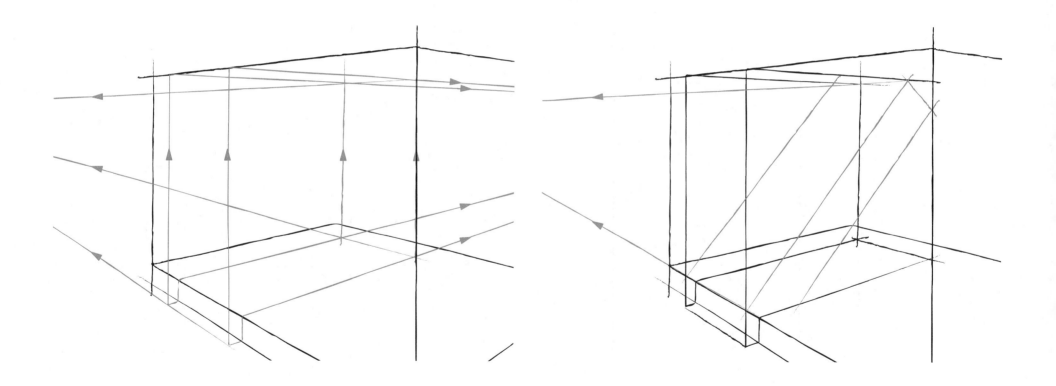

6 Add detail to the phone

- Sketch a line approximately halfway up the side of the crate to define the top of the cradle and project it back to VP1.
- Round the front edge of the cradle. A line that rounds slightly towards the bottom is also added to the side profile.
- Add detail to the handset on the angled surface.
- Add thickness to the handset.

7 Set out detail on the base

- On the top surface of the base, construct a square for the speaker holes.
- Draw diagonals and centre lines in the square.
- Construct boxes for the menu buttons. (Take care to maintain good proportion and accurate position.)

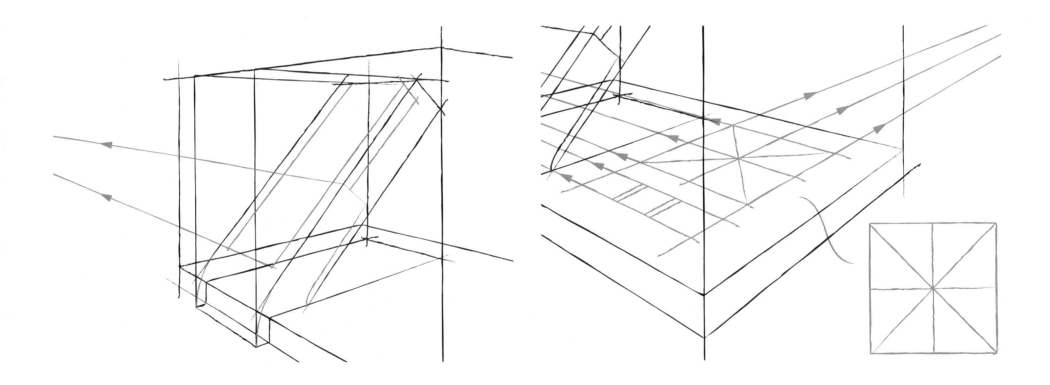

8 Construct the perspective circle
• Divide the diagonals into quarters as shown and sketch in the circle.
• Add detail to the menu buttons by rounding off the two outer edges.

9 Complete the speaker phone and menu buttons
• Add the outer ring of speaker holes. (Use the construction work already done.)
• Add the inside ring of holes and the centre hole.
• Add height to the menu buttons.

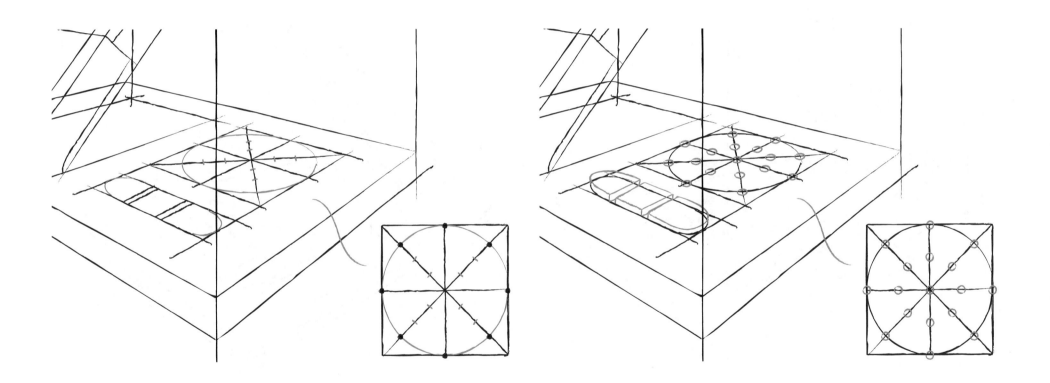

10 Add detail to the base, cradle and handset

• Round off the corners of the answerphone base, cradle and handset.
• Add the screen detail and the three holes at the top of the handset.
• Add the split line where the top and bottom parts of the base meet.

11 Firm in

• Firm in all the visible edges of the answerphone. (Do not remove your construction lines.)

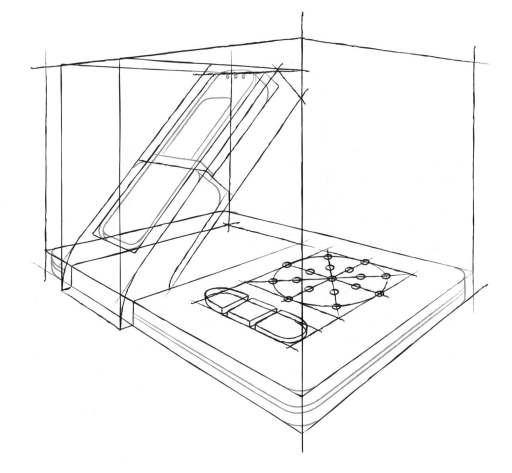

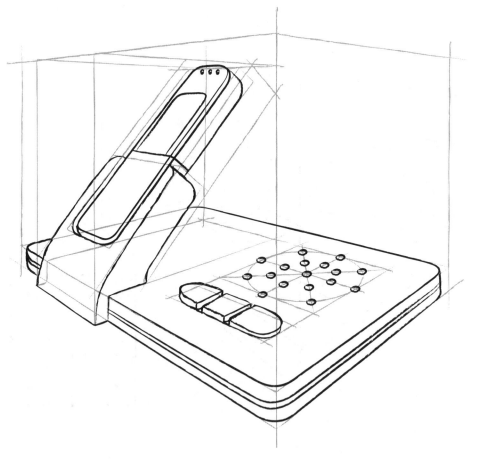

Illustration and presentation techniques

There are many different ways in which colour, tone and texture can be applied to drawings to make them appear more realistic. The rendering medium and the style in which it is applied can create different effects on the finished graphic.

Spirit markers

Spirit markers are widely used in design and illustrations, and are particularly well suited to the illustration of technical objects. They can be used to lay down large areas of flat tone and are particularly good at simulating plastic, metal and glass surfaces.

There are two main methods of applying colour from spirit markers to create different textural effects:
• strike through
• blocking in.

The **strike through** technique is often used to produce a very loose style of graphic. It can give the impression of movement or reflections on a glossy surface. It is particularly useful when rendering objects that have a single colour.

The **blocking in** technique is more formal in style and often used on more complex graphics where there are a number of different components and/or colours.

Most graphics rendered using spirit markers require additional detailing with coloured pencils. The use of the marker pen is, in most cases, only the foundation of the graphic. The graphic will then have highlights and shadows added to sharpen the image. The ability to execute this stage effectively adds realism and is a key skill that a graphic artist must possess.

Remember to plan your graphics before starting any work. Any graphics that you intend to render using spirit based markers need to be produced on **bleed-proof** paper. This paper has a special coating on one side that stops the marker pen ink from bleeding from one area to another. It is vital that you use bleed-proof paper if you want to get the best quality finished graphic.

Worked example

A hand-operated sports pump has been designed and the proposal presented to the client.

Four different graphics are shown here to demonstrate the different effects that can be created using spirit markers and coloured pencils. The graphics are similar in style to those you will have to produce in your Thematic Presentation.

Use this section as a guide and apply the techniques demonstrated here to your own illustrations of another product.

Marker pen rendering – strike through

Here we use an orthographic sketch of the base of the pump and add colour using spirit based markers to create a realistic view of the object. The strike through technique has been used here to create the impression of reflective surfaces.

The key to this technique is confidence. Apply the pen with confidence and you are halfway to creating a dynamic, striking graphic.

1 Sketch the basic outline of the base
- Use a 2H pencil to construct the plan view of the base of the pump.

2 Apply the base tone
- Working from the top left to the bottom right, use the chisel tip of a cool grey (4T) marker to apply random sweeps of colour across the outline.
- When the marker has dried, complete the process again, trying to keep the sweeps random in direction and varying the angle slightly.
- Allow the marker to dry and then work from the bottom right to approximately half-way up the graphic. Ensure the darker tones are on the bottom right side of the graphic.

3 Apply flat tone
- Use the same marker pen to apply flat tone to the recessed surfaces. These will reflect less light because they are further from the light source.

TIP

Try to leave areas of white paper exposed. This will create reflective highlights on the illustration.

TIP

Use the bullet tip of the pen in the narrow areas. Apply the shadows freehand but work carefully, using the outlines as a guide.

4 Apply shadow

Imagine the light source is coming from the top left – shadows will be cast in the grooves and recesses.

- Use the bullet point of a cool grey (6T) pen to add areas of dark tone where the shadows would be cast.

5 Block in the background

- Use the chisel tip of a black marker pen to apply flat tone to the outside of the graphic. This helps push the graphic forward and allows you to clean up the outside edge of the object.

6 Add highlights and shadows

Use good quality black and white rendering pencils to add highlights and shadow to the graphic.

- Pick out the edges that face top or left with the white pencil. (Make highlights as bright as possible.)
- Darken shadows with the black pencil. (Take care to build the tone gradually.)

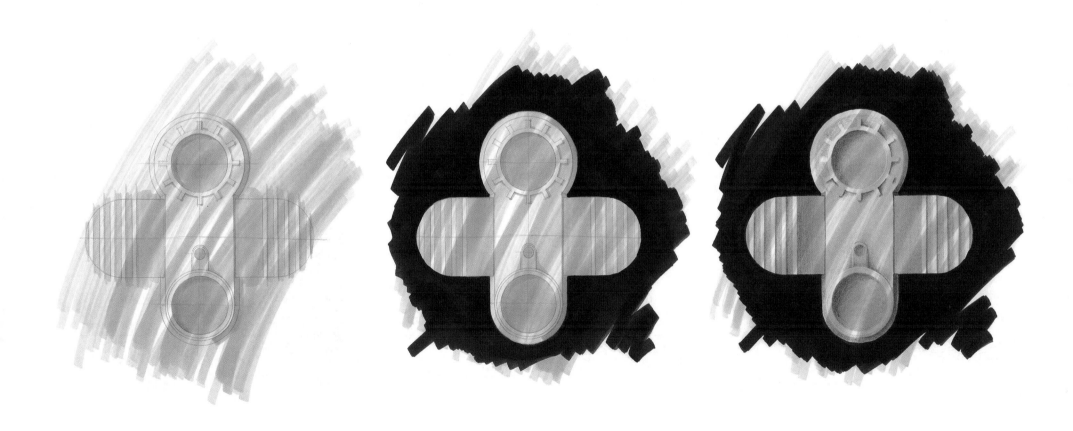

Marker pen – blocking in

Here a two point perspective sketch of the body of the pump is to be rendered using a blocking in technique. This type of graphic is more formal in style and enables different areas of colour to be applied to the graphic.

The key to this technique is accuracy and pace. The marker must be applied at a steady pace, taking care not to pause as this will cause the marker to 'bleed' ink into the paper.

1 Sketch the outline of the pump body
• Use a 2H pencil to sketch a pictorial view of the pump body.

2 Block in the yellow cylinder and blue screen
• Use the chisel tip of an orange marker to apply flat tone to the cylindrical part of the pump. Pen strokes should be vertical and pass through the top of the graphic. Leave areas of white space to act as highlights.
• Allow the marker pen to dry, then apply more orange marker pen to the outside edges. This will deepen the tone and start to give the cylinder a 3D appearance without the need for pencil work.
• Use the bullet tip of a light blue marker pen to apply flat tone to the screen on the pump. This is fiddly work and needs careful attention.

3 Block in the body of the pump
• Use the chisel tip of a light grey marker pen to apply flat tone to the body of the pump. Follow the outline of the shape first and then fill the inside. It is vital here that you keep the pen moving; any pauses will result in a patchy finish.
• If the finish is patchy, repeat the 'blocking in' process again. This will darken the tone but should help create an even surface finish.

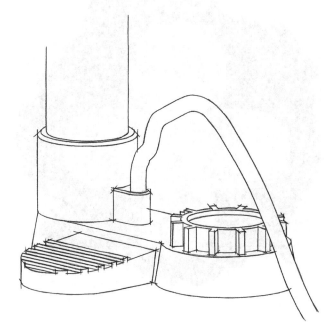

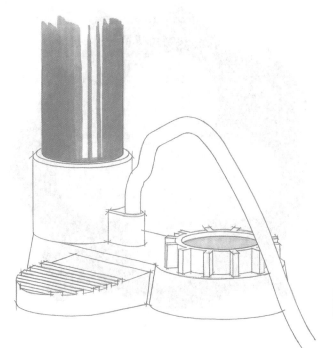

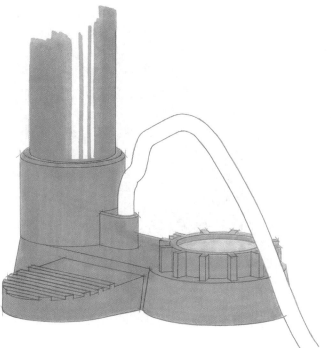

4 Add tonal scale

- Use the chisel tip of the same marker pen to add graded tone to the body of the pump.

5 Block in the flexible rubber pipe

- Use the chisel tip of a black marker pen to apply flat tone to the flexible rubber pipe on the pump. It is vital here to keep the pen moving as any pauses will result in a patchy finish.

6 Add highlights and shadows

- Use good quality black and white rendering pencils to add highlights and shadow to the grey and black sections of the graphic.
- Use a good quality dark orange pencil to add shadow to the cylindrical part of the pump.

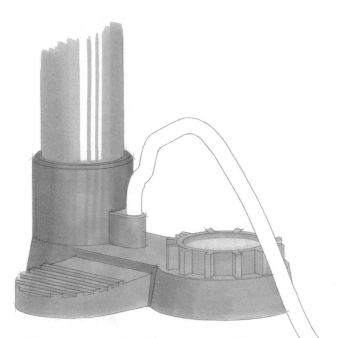

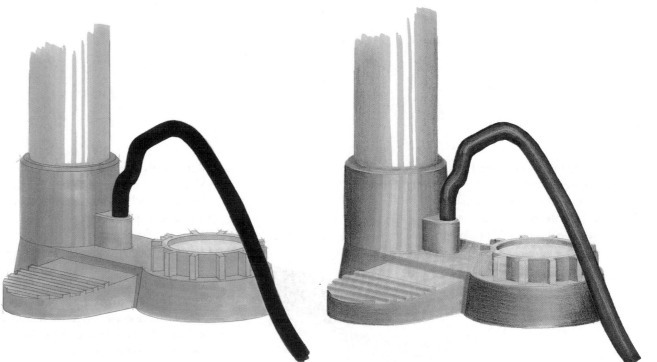

Marker pen – desert scape

The desert scape technique is used to represent highly polished metal surfaces. These surfaces reflect their surroundings and would normally be very difficult to recreate. The desert scape technique places the object in a theoretical desert, where the surroundings are relatively simple to recreate. There are three main areas of colour: blue sky tone, neutral earth tones and a dark horizon line.

1 Sketch the outline of the adaptor
• Use a 2H pencil to sketch an enlarged view of the metal adaptor on the end of the pump, including the shadow.

2 Block in the sky tones
• Use the chisel tip of a blue marker pen to apply flat tone to the adaptor. Pen strokes should run towards the vanishing point and stay within the outline of the graphic. Leave areas of white space to act as a highlight just above the centre.
• Allow the marker pen to dry, then apply more blue marker pen to the top of the adaptor. This will deepen the tone and give the cylinder a 3D appearance, reducing the need for pencil work later on.

3 Block in the earth tones
• Use the chisel tip of a yellow marker pen to apply flat tone to the adaptor. Once again, pen strokes should run towards the vanishing point and stay within the outline of the graphic. Leave areas of white space to act as a highlight just below the centre.
• Allow the marker pen to dry, then apply more yellow marker pen to the bottom and end faces of the adaptor.

4 Block in the shadow and flexible rubber pipe
• Use the chisel tip of a light grey marker pen to apply flat tone to the area of shadow.
• Use the chisel tip of a black marker pen to apply flat tone to the flexible rubber pipe.

5 Add highlights and shadows
• Use a good quality white rendering pencil to add highlights and shadow to the flexible rubber pipe.
• Use a good quality black pencil to add to the shadow just below the adaptor.
• Use good quality dark yellow and blue coloured pencils to deepen and blend the tone around the outside edges and the end face of the adaptor.
• Use a very sharp, good quality brown pencil to add the horizon line just above the centre of the adaptor. The horizon line should also be marked on the end face of the adaptor, projected towards the vanishing point.

Pencil rendering

The two point perspective view of the handle of the pump is to be rendered using coloured pencils. Texture and tone should be applied to create a realistic wood grain and finish.

TIPS

- Remember, in your Thematic Presentation you must produce these graphics freehand. You will be penalised if you use any drawing aids to construct your graphic.
- The key to all of the stages used to create this type of graphic is to build up the tone gradually. This will let you spot any errors before it is too late.

1 Sketch the outline of the handle

- Use a light brown coloured pencil to sketch the outline of the handle. Try to keep this as light as possible and use the tip of the pencil.

2 Apply a yellow base colour

- Use the side of the pencil lead to apply a yellow graded base tone to the graphic. Try to keep this as light as possible and build up the tone gradually.

3 Increase the depth of tone

Imagine the light source is coming from over your left shoulder.

- Use the side of an orange pencil to apply darker tone to the outer edges of the cylinder, becoming lighter towards the middle. Work from dark to light, easing the pressure on your pencil as you go.
- Use the same technique to apply graded tone to the chamfered edges.

4 Increase the depth of tone further

- Use a brown pencil to apply a darker tone to the handle. This should add depth to the graphic.
- Darken the tone on the underside of the handle as this is in shadow.
- Darken the tone to the end of the handle.

5 Introduce texture

Here the aim is to create an illustration that represents wood. It does not have to be an exact duplication of wood, as long as it looks realistic.

- Use the point of a brown pencil to add the rings (end grain) on the end of the handle.
- Create grain patterns along the main body of the handle, but remember to keep things simple.

Graphic design elements and principles

The purpose of graphic design is to create documents and publications that have visual impact and hold the attention of the viewer or reader. To achieve visual impact, graphic designers refer to a list of important guidelines called **design elements and principles**.

Design elements

Design elements can be thought of as the essential building blocks of successful graphic design. It is essential for a graphic designer to understand how to use design elements and how to combine them for the best possible effect.

Line

Lines (or **rules**) are used to **divide up** a layout or **connect** elements in a layout. Lines can vary in thickness and be coloured. Underlining words can emphasise a point.

Shape

Creative use of **shape** can help sustain reader interest. Shape can also help organise a page by separating items and making the layout easier to follow. Shapes can be categorised as natural, geometric or abstract.

Texture

Texture can be considered in two ways. **Physical texture** is provided by the the coarseness or smoothness of paper. **Visual texture** is the pattern in images such as the pattern of tree bark in a photograph. Both forms can be employed to create moods and add richness to a graphic display. Blocks of text can also create texture and can provide visual balance in a layout.

Size

The relationship between items in a graphic layout can be emphasised by **size**. Often the most important item in a layout will be the biggest. This is done to create a dominant focal point. Text is also used in this way – headings generally use a bigger font size than body copy while sub-headings fall in between.

Colour

Perhaps the most effective visual element on a page, **colour** is used to create moods and stimulate emotions. This is essential to the graphic designer when a product or service is being marketed. Colour combinations are useful in creating a corporate identity that the public will remember. Harmonious colours will bring unity to a graphic layout while contrasting colours will create drama.

Value

Value deals with the use of **colour tones** in a layout. Darker tones have a higher value. Setting dark tones against light tones creates contrast and makes a graphic display more dramatic.

Mass

All items in a layout have **mass**. A bold heading has a greater mass than a small sub-heading. Blocks of text also have mass. Lines and colour fills add mass but thin lines can bring a formal elegance to a layout while heavy blocks of colour can represent fun and frivolity.

Design principles

The principles of design refer to the way elements are assembled and to the overall composition of the designed pages. Design principles can vary according to fashion – a magazine design from 40 years ago would be quite different to a current magazine design. Different design principles can also be used for different purposes – an insurance company would probably want its document to look quite different to flyers for a sports club, so the designers would use different sets of design principles.

Balance

One way of looking at visual **balance** is to consider a page on which the layout of items is symmetrical, so that items are equally spaced around the centre. The layout would feel stable, strong and conservative. Companies like banks and building societies often favour this formal style. A layout that is asymmetrical can bring contrast, movement, excitement and variety to a layout. This informality can also create a more relaxed style. Modern design often favours an asymmetrical layout.

Contrast

Creating **contrast** by introducing elements (colours, font styles and shapes) that are opposites or are very different will increase the visual impact of a piece. The use of contrast will give your publication an eye-catching quality.

Emphasis/Dominance

There will be items in your layout that need to be given greater **emphasis** than other items, such as headings, sub-headings and graphics. These items can be made to **dominate** the page by making fonts bigger or bold or underlined, or by displaying them against a background.

Rhythm

Creating the feeling of movement by repeating elements can help a layout to flow. **Rhythm** can direct the reader and make the layout easier to understand.

Proximity/Unity

Careful positioning of related elements in close **proximity** can make a publication easier to follow and understand. Positioning items close together can create **unity**. Unity can also be achieved with the appropriate use of colour throughout different parts of a publication.

Alignment

DTP allows you to **align** elements (text, graphics and lines etc) anywhere on the page. The placing of these elements should be deliberate, not random. The aim is to connect the elements visually to achieve a neat, structured look.

White space

Leaving areas of a layout free from text and graphics creates **white space** that allows the eye to rest. Wide areas of head space, foot space and margins can provide this. White space can also create focus by directing the reader's eye to graphics or text nearby.

Flow

A graphic designer uses layout to help the text and graphics **flow** by leading the eye through a page. We are conditioned to read from the top left to bottom right. A magazine cover normally has the title at the top, a photograph in the middle and a contents list down one side or along the bottom. The layout makes use of emphasis and flow to grab browsers and entice them into the magazine.

Analysis of design elements and principles

It is important to understand how design elements and principles are used in graphic design. The following page looks at some important elements and principles and explains how they have been used to create a striking double page layout. Analysing displays from magazines and newspapers will help you understand how professional graphic designers create exciting layouts.

White space
White space doesn't have to be white. The large expanse of black around the title focuses the eye there and creates an impression of drama and sophistication. The white space to the top right helps balance the layout and emphasises the photographs below. Both white spaces allow the eye to rest and make the layout less busy and more luxurious. This impression is important to the magazine's target market.

Contrast (fonts)
The title is a serif font and the body font is sans serif (see page 184), creating **contrast**.

Visual unity
The start of the article is **emphasised** by the title while the drop capital **tells** readers where to start reading.

Contrast (tone/colour)
Contrast is applied here through lightly toned pictures and a very dark background. Pink and green also add eye-catching contrast.

Visual unity
Visual unity is achieved through the use of green. It appears in the title, in sub-headings and in the eye makeup on some of the photographs. The reader sub-consciously connects these features through colour. Overlapping pictures also creates unity and adds depth to the layout.

Contrast (shapes)
Shapes here are mainly square but the close up shots of female faces are curved and contoured, creating **contrast**. The columns of body text are left aligned and leave an uneven edge on the right to break up the square elements on the page.

Use of line
The use of **line** emphasises the clean vertical lines in the layout. It also provides an opportunity to introduce the pink accent colour.

Contrast (layout)
The cluster of photographs in the bottom right creates **contrast** with the neat, organised layout on the rest of the page.

Eye Beauty

Think you know everything about eye make-up?

Some eye make-up don'-dos are really obvious – frosty blue shadow is one, extending eyeliner past the corner of the eye à la Cleopatra is another. Follow these easy tips to avoid common eyesores.
· Limit deeper-coloured eye shadows to the eyelid.
· Use lighter coloured shadows on the brow bone.
· For a casual but polished look, sweep one shade from your lashes to your brow bone.
· Use cream shadows sparingly, as the colours tend to be very vivid.
· Eye gloss is the newest trend. It can add a pretty, sheer shine to lids, but don't try it unless you know you can carry it off. If applied incorrectly, eye gloss can look greasy and garish.
· When applying powder eyeliners, first run the applicator brush under cold water. Then apply it wet for a more intense colour.
· White, pink and yellow eyeliner pencils tend to make the eye look open and brighter. The colour blue counteracts redness, and black will give you a sultry look.
· In order to apply eyeliner easily, manufacturers sometimes make it so creamy that it doesn't stay on well. Instead, use a matching eye shadow or powder liner to set your creamy eyeliner.

Keeping those eyes bright
A balanced diet contributes to general well-being – but vitamin A is most directly associated with eyes as it helps you see better in dim light. You'll find it in dairy products, oily fish and liver, as well as vegetables like spinach and carrots. If you're pregnant, consult your doctor before taking vitamin A supplements.

Tension often shows first in the muscles around your eyes. If you work with computers or have to concentrate for long periods, try to remember to give your eyes a rest. Look up, shifting your gaze and blink regularly. Optrex Eye Wash with Eye Bath or Optrex Refreshing Drops will help soothe discomfort.

Dirt, smoke, dust and sun can harm your eyes. Don't forget to wear protective glasses to shield your eyes when you do any DIY jobs. And while sunshine definitely gives us all a boost, it's important to protect your eyes from UV light. Choose sunglasses that conform to British standard BS 2724, which means they'll filter out 90% of the sun's dangerous rays.

Make sure you drink plenty of water; it helps keep eyes hydrated and feeling fresh.

Harsh lighting, central heating and air conditioning can also leave your eyes sore and irritated. Why not carry a bottle of Optrex Dry Eyes eye drops for fast, effective relief? Keep an Optrex Soothing Disposable Eye Mask in the fridge to instantly cool, soothe and refresh tired eyes. Place the mask over them, pressing down gently across your eyelids and temples. With the mask in position, relax for 10 minutes or so, preferably in a darkened room.

It's a good idea to have an eye test every year to pick up on any problems.

A final tip for eyes? A good night's sleep!

Make-up overload
Make-up is meant to enhance, not overwhelm your features. But how do you tell if you're a little, well, overzealous in the application department? If any of these telltale signs apply to you, it's time to opt for a lighter hand.

The Magic's in the eye make-up.

Options for building an eye design are almost too numerous to list. The basic concept is to shade the eye to accent its shape, or to change its shape by using a progression of light to dark colours across the eye, blending one over the other so that you can't see where one stops and another starts. Here you can follow, step by step, how to use one eye shadow or several different eye shadows to create a well-blended, classic eye-makeup design. Even for the most formal eye-makeup design, four different colours should be plenty. Whether you use one, two, three, or four different eye shadows, they become a full design when worn with eyeliner, temple contour and mascara.

One Colour design
This design blends one soft, subtle colour all over the eye area, from the lashes to just under the eyebrow, with no patches of skin showing through. You should not wear only a splash of colour over the eyelid and ignore the rest of the eye area.

Application
When applying a single colour, first place it from the lashes to the crease using a brush such as Paula's Choice large round shadow brush or a shadow softening brush. Make sure that you do not extend the colour into the inside corner of the eye (off the lid area) or out beyond the lid onto the temple. Also be certain there are no patches of skin showing through on the lid next to the eyelashes. The entire lid at this point is one solid colour. Next, place the colour from the crease up to the brow, following the entire length of the eyebrow from the nose out to the temple area. Avoid leaving a hard edge at the back (outside) corner of the eye where the eye shadow stops. If desired, use a brush such as Paula's Choice soft blending brush. This will create subtlety and a soft highlight under the eyebrow. Because the eye shadow for the one- colour eye-makeup design is so soft and subtle, blending and application is quite easy. The best colours for this design include light tan, neutral taupe, beige, pale mauve, brown, pale grey, light golden brown, camel and light auburn. Whatever the colour, it should definitely not be obvious.

PAGE 6/October 2008/BURBLE · WWW.BURBLE.CO.UK · WWW.BURBLE.CO.UK · PAGE 7/October 2008/BURBLE

Colour
Colour is important here. The subtle pastel tones of the faces contrasts with the severe black background. Pink appears in other parts of the layout and creates a strong contrast with the green text.

Alignment
Alignment is crucial to this clean sharp layout. The paragraphs on the right-hand page are accurately aligned to create a crisp vertical line and the photo and text on the left-hand page are accurately aligned and neat.

Rhythm and flow
Rhythm is created by the green sub-headings and by the double spacing between paragraphs. Both techniques create a visual **flow** that leads the reader through the layout.

Computer-aided drawing and design

Developments in CAD applications in recent years have revolutionised the way the design, manufacturing and construction industries work. Computer-aided drawing and design (CAD) is now used in all areas of engineering and construction.

CAD software is both a design and a graphics tool. Employed by architects and designers in the design of new buildings and products, it also replaces the drawing board when drawings are needed to guide the production of products and the construction of buildings.

You should be familiar with the following terms:
- **CAD:** computer-aided design/drawing/draughting
- **CAG:** computer-aided graphics
- **CAM:** computer-aided manufacture
- **CADAM:** computer-aided design and manufacture.

A typical desktop computer specification

Computers are being improved constantly. Modern desktop machines are faster and have more storage capacity than those of a few years ago and can run more sophisticated software. What currently seems a high specification will soon become outdated due to advances in technology and manufacturing capability. At the time this book was produced, typical features of modern desktop machines include:
- 2·2 GHz processor
- 3 gigabytes (GB) of random access memory (RAM)
- 320 GB hard drive storage space
- 128 MB video/graphics card
- Dolby Digital sound card
- DVD and CD rewriter
- memory card reader
- multiple USB ports for connecting peripherals
- modem and fast broadband internet connection
- anti-virus protection
- 19-inch high-resolution flat screen monitor
- QWERTY keyboard.

Considerations prior to buying a CAD system

Before investing in a CAD/CAG system there are several issues a company should consider.

Types of software used

Firstly, consideration must be given to the type of software that is required. The software must support the type of work the company is involved in. For example, an engineering company that makes components for the car industry would require either a 2D or 3D CAD package. Other software such as DTP or illustration software would be unnecessary.

Type of computer system

Secondly, the company must consider the system's requirements. Will a large network need to be installed, or can the office use a series of individual workstations or laptops to allow staff to use the software? Many modern software packages are designed to work best as part of large networks. Space is saved by storing essential files centrally, allowing individual users to tap into these files when required.

If the company has a large bank of library components or uses a CAD/CAM setup, there is a strong case for investing in a large scale network to allow all areas of design, planning and production to be linked. This enables fast communication between all parties and makes it easy to track the progress of any of the projects.

Flexibility

Finally, all companies must consider flexibility prior to any investment. Software quickly becomes outdated and any investment in hardware must stand the test of time. Also, many companies are diversifying as a means of breaking into new markets. Software and hardware should support diversification in the future.

Benefits of CAD in industry

Standardisation

CAD applications can be set to work to a number of recognised standards (e.g. BSI, ISO), allowing work to be produced in one continent for use in another. In-house styles can be set, giving all the work produced a corporate identity.

Speed and quality

There is a high initial outlay by the company, not only for hardware and software, but also for training/recruiting skilled draughtsmen. This outlay will soon be recouped, however, as the speed at which CAD drawings can be produced is far greater than traditional production methods. The quality of the finished printed product is also higher.

Ease of modification

Modifications can be made to drawings quickly and accurately, allowing savings to be made in monetary terms as well as time.

Storage and retrieval

CAD drawings can be stored in digital format on hard drives, CD-ROMs, DVD-ROMs and computer networks. This takes up far less space than paper copies and allows the drawings to be reprinted as many times as required, quickly and accurately without deterioration in quality.

Ease of formatting and scaling

Drawing scale and orientation can be changed quickly and easily. Enlarged details can be shown without the need for the drawing to be recreated from scratch.

The use of library components

See page 174 to read about the use of library components.

Use of layers

See page 175 to read about the use of layers.

2D COMPUTER-AIDED DESIGN

2D computer-aided design

2D CAD software became popular in the 1980s as a replacement for manual drawing methods. It is used by architects, designers and engineers to produce fully dimensioned orthographic production drawings.

Advantages of 2D CAD

The introduction of 2D CAD software brought many advantages including:
- improved speed of drawing
- ease of modification and correction
- improved quality and accuracy of output
- ease of storage and retrieval
- linking with manufacturing machinery in CAD/CAM production processes
- ensuring that drawing standards such as BS 8888 are used consistently
- setting drawings to any given scale.

TIP

These advantages also apply to 3D CAD modelling software.

Features of 2D CAD software

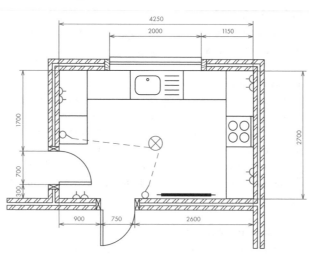

CAD library

A CAD library of standard parts or components enables the user to store pre-drawn icons for use on any number of drawings. These icons are often pre-installed as part of the CAD application but can be drawn in-house and updated as designs change. The CAD library saves time and effort by enabling the architect or engineer to select icons from a palette or menu and drop them into composite drawings.

An architect may use hundreds of library parts and will normally insert them using a customised graphics tablet. Interior designers use library parts to create interiors 'on-screen' to allow discussion with clients.

Common library parts include:
- building drawing parts such as doors, windows and plumbing and electrical fittings
- standard engineering components such as nut & bolts, screws, washers and springs
- electronic symbols for circuit diagrams such as batteries, resistors, capacitors and switches.

For example, the kitchen extension design shown here makes use of several standard library components:

- **architectural fixtures**

 Window Door

- **kitchen fixtures**

 Cooker Sinktop

 Base units Radiator

- **electrical fixtures**

 Sockets Switches Light fitting

- **landscape materials**

 Brick wall Tree Paving slab

Layers

CAD software enables drawings to be built up in a series of layers. Different drawing features are allocated to separate layers e.g. dimensions, construction lines, text and outlines. Layers are like clear film overlays that can be switched on or off to control the parts of a drawing to be viewed.

Layers provide several benefits:
- Drawings can be built up in stages and are easier to manage.
- Several versions can be printed, each with different layers visible.
- Printing selected layers makes the drawing easier to understand.
- Careful selection of layers allows printed information appropriate to the user, giving architects and engineers greater control over what tradespeople and clients will see.

The floor plan below shows a drawing for a new kitchen extension. All the layers are visible and consequently the floor plan is cluttered and difficult to understand.

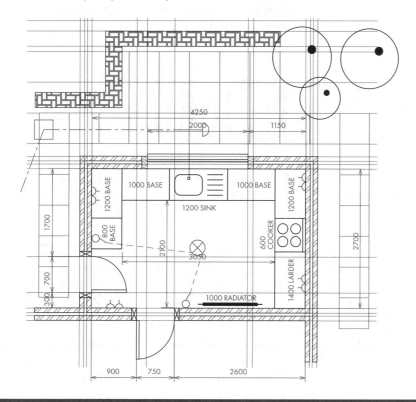

The following drawings demonstrate a typical composition of layers in an architectural drawing:

- **Layer 1** includes carefully placed construction lines to enable the architect to draw the foundations and position the walls.

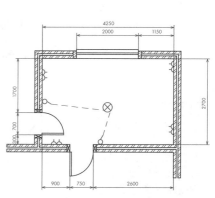

- **Layer 2** shows walls, window and doors. The dimensions and electrical fittings are required by the builder and electrician.

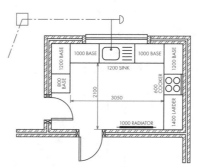

- **Layer 3** shows the kitchen units, appliances and drainage pipes. The kitchen fitter and plumber will use this layer.

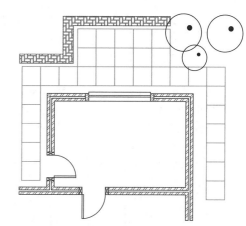

- **Layer 4** sets out the landscaping to the rear. This work may be sub-contracted and the landscaper will require a plan.

2D COMPUTER-AIDED DESIGN

Other CAD commands
In addition to layers and libraries, there are many other CAD commands you should familiarise yourself with. This page describes the most important ones.

Arc/Box/Circle draws arcs, boxes and circles quickly and accurately.

Auto-dimensioning automatically calculates and adds dimensions to BSI standards.

Box array Ring array

Box array/Ring array creates multiple copies of objects in rectangular or circular arrangements.

Break Extend

Break removes a section from the middle of a line.
Extend makes a line longer.

Chamfer Fillet

Chamfer and **fillet** create angled (chamfered) and rounded (filleted) corners.

Change units selects the units of measurement used within the drawing.

Copy duplicates objects without having to redraw them each time.

Distort/Rubber banding allows you to pull/stretch one end of an object or line.

Ortho Isometric

Grid displays an on-screen grid of specified spacing to allow accurate drawing.

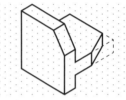

Grid lock/Snap attaches the end points of lines to the grid/specified snap spacing.

Ungrouped Grouped

Group combines separate objects together so that they are handled as one.

Line types selects BSI line types used in CAD drawings.

Mirror creates a mirror image copy of an object about a specified axis.

Move selects objects and repositions them on the drawing.

Ortho restricts lines to vertical or horizontal directions only.

Original Panned

Pan moves the on-screen view without zooming in or out.

Part erasing/Trim removes parts of objects specified by the user.

Pattern fill inserts a range of line patterns to specified areas within objects.

Rotate turns the object to any given angle about a given point.

0.5

Scale enlarges or reduces the size of objects.

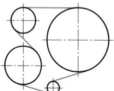

Tangent connects circles and lines at tangents, quickly and accurately.

Original Modified Undone

Undo reverses the last command to restore the drawing to its previous state.

Original Zoomed

Zoom enlarges the on-screen view to allow small details to be easily seen.

3D computer-aided design

3D modelling software allows designers and architects to create 3D computer generated models of their designs that would have previously been produced from materials such

as polystyrene, clay or card. Component parts are created using various modelling techniques and assembled to form the final model.

Computer generated models have revolutionised the design process, allowing designers to assign physical properties to onscreen models and assess their validity. Designers can now create presentations using animation techniques and present these to clients

without the need for building costly and time consuming models. Once final designs have been agreed, data from the 3D models can be up loaded to a **Computer Aided Manufacture** (**CAM**) system and the individual components manufactured in the knowledge that they will fit together and will function as a complete product.

Benefits of 3D modelling

3D computer modelling has many advantages over traditional forms of modelling:
- Models can be produced quickly and accurately.
- Models can be modified quickly and easily
- Models can be used to test the structural properties of the product. This can help reduce the time taken in the testing and development stage of the product and can result in huge financial savings.
- Models and their data can be sent via the internet quickly and without cost, allowing clients to view progress during the design process.
- Models take up very little storage space compared to traditional built models.
- A wide range of surface finishes can be applied with ease.
- Models can be used as part of simulations and animations for discussion with clients.

It's important to remember that products are made up of assembled parts. If one part is changed, it may be necessary to change other parts if the product is to function as required. Modelling software makes it easy to produce modified parts.

Types of 3D modelling

There are three types of 3D models: **wire frame**, **surface** and **solid**. These modelling types share common features:
- Models are virtual entities within the computer's memory and can be viewed from any angle.
- Models are constructed using a system of X, Y and Z co-ordinates.
- The software allows orthographic views of the model to be generated automatically.
- The data can also be used in a CAD/CAM setup to manufacture the product.

Wire frame models

Wire frame models are created by specifying the edges of a physical object where surfaces meet, or by connecting corners of an object using straight lines or curves.

Wire frame models are relatively simple to construct. This makes them suitable for complex 3D models which might require significant computing power. Surface textures and rendering can be added to the wire frame to give a solid appearance.

Orthographic views and drawings can be projected from wire frame models. Hidden line removal can make complex models easier to understand. Wire frame modelling is particularly well suited to and widely used in CAD/CAM systems for programming tool paths for DNC (Direct Numerical Control) machine tools.

Surface models

A surface is created from a line which is extruded or revolved and given a thickness. Surface models replicate products made from sheet materials such as steel and aluminium and products with hollow plastic casings.

Surface modelling was initially developed by the automotive and aerospace industries, but is now routinely used in all design disciplines.

3D COMPUTER-AIDED DESIGN

Two common methods used in surface modelling applications are:

- **lofting:** a series of profiles are generated and swept, or lofted, to create a 3D surface

- **deforming:** direct creation of a curved surface by the manipulation of control points.

Surface modelling is most commonly used in two fields:

- creating functional surfaces that also have to look good, such as kitchen appliances and car bodies
- technically complex surfaces for components such as turbine blades and other fluid dynamic engineered components.

Solid models

These models are commonly built by **lofting**, **extruding**, **revolving** or **sweeping** 2D shapes (sketches) into solid 3D forms. Modern software comes with a built-in palette of common solid forms known as solid primitives. This is effectively a library of 3D forms and can be customised to include forms and parts needed by the user.

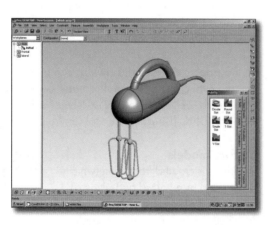

Revolve

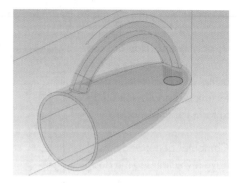

In the above example, **revolve** has been used to create the shell of a whisk. The wall profile (shown in red) was drawn and revolved around its axis (shown in green). This allows the modeller to create the resulting **solid of revolution**.

Extrude

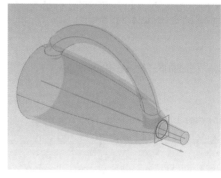

Extrude has been used here to add the detail at the rear of the whisk. The profile (shown in red) was drawn and then pulled along its axis. This example also applies a taper to the extrusion, making it narrower.

Sweep

In this example, the handle has been added using the **sweep** command. The profile (shown in red) was drawn and then swept along the path (shown in green).

Loft

Here a **loft** has been used to create the free-flowing solid model of a blender attachment. Six circles (shown in red) were drawn on six different horizontal planes and a loft created between each of the circles. The loft feature is used to create a smooth transition between different profiles, blending them seamlessly in one continuous path.

Computer-aided illustration

While there are many different types of illustration software on the market, they all serve the same purpose: to add colour, tone and texture to computer graphics in order to create a realistic image.

Features of 2D illustration

Learn and remember the main illustration software features.

Import and export

CAD drawings, scanned sketches and digital photographs can be imported into illustration software so that they can be traced to produce editable objects. Finished graphics can be exported for placing into DTP documents.

Drawing tools

Drawing tools enable the user to create a wide range of editable shapes. **Line**, **circle** and **box** tools allow easy creation of simple geometric shapes. The **Bezier tool** can be used to draw complex freehand curves and shapes.

Once an object has been created, it can be selected and further manipulated using the **move**, **copy**, **scale**, **rotate** and **mirror** tools.

Drawing tools can be used to create new illustrations completely from scratch, or to trace existing images that have been imported for reference. Illustration software often includes an **auto-trace tool** to speed up the tracing of imported artwork.

Colour mixing tools

Colour mixing tools enable the illustrator to create any number of colours and apply them to areas of the illustration.

Fill styles

Applying different colour fill styles can be enough to render a CAD line drawing effectively.

- **Plain fill styles** can be lightened or darkened to render flat sided objects.

- **Linear fill styles** can be used to suggest shiny surfaces with reflections or shadows. When combined they can render items such as concave buttons effectively.

- **Cylindrical fill styles** produce graded tones for rendering curved surfaces.

- **Blends** can create 3D effects by grading tones across several flat surfaces. The blend is created between the original two elements as shown.

- **Textures** can add extra realism if the software supports this.

2D illustration example

A promotional graphic for an electronic gizmo is being prepared using a CAD line drawing as reference.

Import the original CAD line drawing

A line drawing is imported into the illustration software from a CAD package.

Trace the outlines to create closed shapes

The line drawing is traced using drawing tools, effectively creating another drawing within the illustration package. Use the Bezier tool to stretch and shape lines to match curves on the CAD drawing. The aim is to produce a drawing consisting of closed shapes (around 20 in this case).

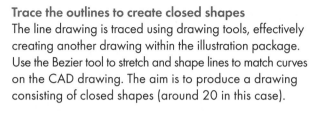

Add colour fills

The closed shapes of the new drawing are filled with colour.

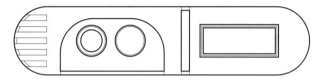

Add gradient fills, blends and textures

Linear and cylindrical fill styles create a three-dimensional appearance on curved surfaces. Blends are used on the body and the domed button to create rounded edges.

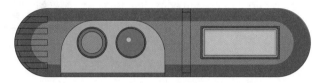

Remove the original outlines

Finally, the black outlines are removed and the original CAD line drawing is deleted to leave a realistic looking CAG illustration. This illustration is now ready for use in promotional documents.

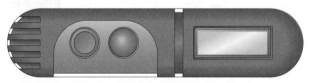

Surface rendering software

Surface rendering software can create sophisticated surface rendering effects by attaching materials colours and textures to a 3D model. The model is then lit by carefully chosen light sources which create striking shadows and highlights. The software computes the form of the object and generates fill styles accordingly. These fill styles are bitmap images that are wrapped to the surface of the 3D model.

Features of surface rendering software

- **Colour** can be adjusted on the model to suit the user's needs. Pre-set colours or colours that are mixed by the user are attached to the model.

- **Materials** are attached to the model to replicate 'real materials' like plastics, metals, stone, wood and glass etc. The materials are bitmap images tiled and wrapped to the surface of the model. Scale and colour can be altered to improve realism.

- **Custom materials**, though more fanciful and dramatic than the standard materials, are handled and applied in exactly the same way. The user can also scan and add materials to the palette.

- **Light sources** can be directed, and the intensity set to emphasise shadows and highlights.

- **Backgrounds** and **surfaces** can be added to improve visual impact. The addition of a surface grounds the model and provides context, which in turn adds to the realism of the finished presentation.

- **Multiple light sources** can be added to create shadow and highlight. The number of lights, their type and their position can be selected from menus or created by the user.

- **Environments** can enhance the realism of the model. The components are built and assembled with the same 3D software used to create the model. The environment should be scaled to a relevant size. These are like film sets, where it really only matters what is seen on camera. A well executed environment draws the viewer into the scene and helps sell the product.

The final illustration brings the selection of materials, colours and light sources together in the environment. Once these are chosen, the final view is determined: consider the model and which view will create the best visual effect. Also consider how it can be framed using the other elements in the environment. This whole process is very much like a photographer composing a picture.

Animation and simulation

Animation

The use of computers and 3D modelling software have revolutionised animation. What was previously an expensive, time consuming and labour intensive manual process is now a fully digital process and part of the thriving computer graphics industry.

Computer animation is now routinely used by advertisers and film makers as an effective way of promoting products and creating exciting and realistic action, while the entire computer games industry relies on 3D animation software. On-screen animation is now easy to produce and faster processors enable smooth, real time movement, vivid graphics and control of the action by the gamer.

Benefits of animation in promotional graphics
- It improves realism: photorealistic images provide a quality that was not previously achievable.
- On-screen movement grabs the viewer's attention.
- It enables the creation of impossible action and stunts.
- It can be cheaper than shooting film with actors.
- It is much quicker to produce than manual animation.

Walk-through animation
Larger construction projects, such as shopping malls, schools and hotels, often use walk-through models as part of the marketing process. Users navigate through the 3D model as if they were inside the building. Such models are often interactive; direction is controlled by the user.

Simulation

Weather maps on television represent the output of simulation programmes that predict the weather days in advance. Engineers and architects also make use of simulation software to predict events and test the design and strength of structures like skyscrapers and bridges before they are built. The screen shots on the right show a typical simulation that tests the design and load bearing capacity of a proposed new bridge. Simulation software often incorporates animation.

Benefits of computer simulation
- Dangerous events or tests can be carried out safely.
- Realistic training programmes can be used to train pilots, etc.
- It is much cheaper than the 'real event'.
- It allows accurate predictions to be made.

Simulation example
- The new bridge design is constructed using the simulation software.

- The bridge is load-tested by the lorry passing over it. If the bridge fails it collapses and the engineer must re-calculate his design.

- The revised design flexes but withstands the load (stress points are highlighted in colour). The software now helps the engineer to calculate the exact dimensions required for the beams and will even cost the materials.

Desktop publishing

Desktop publishing (DTP) is the process of designing newspapers, magazines, books, leaflets, booklets, and reports on a desktop computer. The industry that produces these items is the **publishing industry**. Designing the structure and format of the publication and the layout of each page is the job of the **graphic designer**, while the process of creating the publication on paper is **printing**.

The history of printing

Until recently, publications were produced using a labour intensive, mechanical printing process. A typesetter selected individual metal letters (types) and assembled lines of type on a 'composing stick'. The 'sticks' were arranged as text columns in a galley and the rows were spaced with strips of lead (hence the term leading). Once complete, the type was inked and paper was pressed on top of the galley. Over the years, the development of new printing technologies such as rotary presses and offset lithography (a high quality printing method used in high volume publications such as newspapers and magazines) has greatly improved the quality and speed of the printing process.

The introduction in the 1980s of powerful desktop computers and WIMP (Windows, Icons, Menus and Pointing device) interfaces has revolutionised the design and preparation of documents for reproduction. Slow and costly manual typesetting processes have been replaced by fast, flexible DTP software, which allows text and images to be quickly and easily imported and arranged to create exciting designs. Camera-ready artwork – used to develop lithographic printing plates for high-volume production– can be outputted directly from the computer. 'Plateless' digital printing technologies such as high-quality colour laser printers make low-volume publications fast and economical to produce.

Benefits of DTP

DTP provides a number of benefits to publishers and graphic designers:
• Design work and publication time is greatly reduced as designers can create standardized layouts to be used time and again.
• Text and graphics can be imported from a variety of sources and locations around the world.
• Text and graphics can be positioned accurately using grid and snap, scale, rotate and crop functions.
• The proposed layout can be sent electronically to the editor or client for approval prior to printing.
• Modifications can be made easily and quickly.
• Once approved, the final layout can be sent for printing electronically with little or no time wasted in pre-production.

The client also benefits from the designer's use of DTP software:
• The speed and quality of production are important to clients.
• Designers can quickly produce high quality visuals for presentation to the client.
• Visuals can be sent for approval electronically, saving time.
• The client's modifications can be made quickly and easily.

DTP hardware

A typical DTP system would comprise a **desktop computer** (publishing companies use more powerful computer workstations) and a range of **input** and **output devices**.

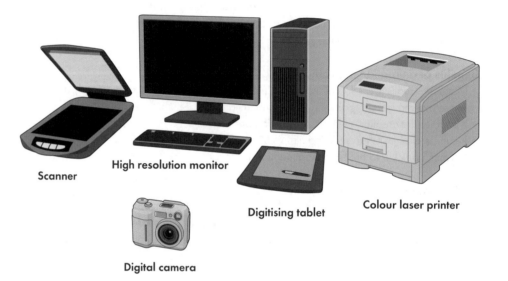

Scanner

High resolution monitor

Digital camera

Digitising tablet

Colour laser printer

For input, the following devices might be used:
• a **scanner** to create electronic copies of existing text and graphics
• a **digitising tablet** to 'point and pick' from a menu or create pictures
• a **digital camera** to take digital images for use in the publication.

For output:
• a **colour laser printer** for proofing (checking) and short runs
• an **ultra high resolution monitor** with a large screen. Publishers will use screens that display double page layouts actual size.

In addition, a **modem** provides both input and output for sending and receiving material from remote locations.

DTP software

DTP software has many features that enable the graphic designer to create exciting page layouts. There are a large number of software packages on the market, including:

- **image editing applications** for manipulating digital photographs and scanned artwork
- **drawing applications** for producing high quality line-based illustrations
- **page layout applications** for assembling text and images into finished documents ready for printing.

These applications offer the following important features.

Colour fills

Colour fills provide background colours, textures and fill effects that enhance publications and websites.

Plain fills **Graded fills** **Textured fills**

Colour editing tools

Colour editing tools give the graphic designer the choice of thousands of colours, tints and shades. A **colour mixing palette** enables graphic designers to mix their own colours.

Effective use of colour is vital in graphic design. It can be used to communicate a variety of moods to different target markets. Large companies have carefully chosen corporate colour schemes that help identify the organisation to the public. These appear on all of the company's publications and websites.

Drawing tools

Many publications and websites need original artwork, which can range from simple boxes with colour fills to very complex drawings. Drawing tools enable these graphics to be produced and integrated into page layouts.

Picture and photo editing

Graphics play an important role in DTP. They can be used to illustrate an article or enliven a layout. **Cropping** images to reduce unwanted background or to remove the background completely are common editing features.

Dave MacLeod on the third ascent of Leo Houlding's 1999 classic route *Trauma* overlooking the Nant Peris pass in North Wales. After eight years without a repeat, *Trauma* was climbed three times in three months in the spring and summer of 2007.

Grids and guidelines

Grids and guidelines improve the accuracy of positioning and alignment of elements. **Snap to grid** and **snap to guideline** functions make it easier to produce accurate layouts.

Columns

A **column** structure can make a publication or webpage easier to read. Columns also help improve alignment and page layout.

Cropped images can create a variety of shapes that provide a contrast with the rectangular structure of the page. A cropped graphic can be positioned close to or within the body copy so that the text can be wrapped around it. Cropping gives the graphic designer a great range of creative options and can help bring an article to life.

Layers

Layers give the graphic designer more control over the page layout. Headers and footers may be stored on one layer and the body text on another. The use of layers is especially useful in an international market where different languages can be stored on separate layers and added to different versions as required.

Layer 3: images
Layer 2: body text
Layer 1: header/footer

Frames

Text and pictures are contained in **frames** so they can be moved around independently of one another. This enables creative layouts to be designed. Handles allow selected frames to be resized and reshaped.

Headers and footers

Headers and **footers** run through the publication and contain information that repeats from one page to another, such as the publication's name, section headings, topic titles and page numbers.

header

footer

Text

Text may be put to many different uses in a publication, and the different uses need different typographic treatments. **Headings** and **titles** introduce an article while **sub-headings** break the article down into smaller chunks. **Captions** explain a photo or graphic and **pull-quotes** draw the reader into an article. **Headers** and **footers** give additional information about the publication or section. The main body of text is called **body type** or **body copy**.

Typeface (font style)

Fonts come in **serif** and **sans serif** styles. Serifs are the decorative features at the end of strokes of letters, numbers and symbols.

serifs

Serif fonts tend to create a formal, serious look. They are often used for body copy in newspapers and magazines.

Sans serif fonts lack the decorative features and tend to give a less formal, more modern look. For example, this book is set in Futura, a sans serif font.

Graphic designers can create contrast by using a sans serif font for headings and a serif font for body copy.

There are modern fonts in script, handwriting and fun styles that should never be used in body copy. They are fine for invitations, compliments slips and cards where the text is kept to a minimum and the line spacing (leading) can be increased.

Examples of each font style are shown below.

Times Garamond Palatino	Arial Tahoma Verdana	*Brush Script* **Impact** **STENCIL**
Serif fonts	**Sans serif fonts**	**Fun fonts**

Choice of font style is down to readability and the target audience of the publication. it is best not to use too many fonts in a publication. Headings, sub-headings and captions should be different to your body copy fonts. When in doubt, use a sans serif font for headings and sub-headings and a serif font for body copy.

Text formatting

- Text size is measured in **points**. Headings require large, bold sizes. Body copy is smaller.

18 point bold text

10 point regular text

- **Kerning** is used to avoid unsightly gaps between certain pairs of characters, particularly those with sloping uprights and overhangs. Most fonts contain extra information ('kerning tables') that DTP software can use to kern text automatically.

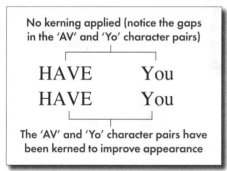

No kerning applied (notice the gaps in the 'AV' and 'Yo' character pairs)

HAVE You
HAVE You

The 'AV' and 'Yo' character pairs have been kerned to improve appearance

- **Bullet points** are visual aids and are excellent when listing facts or items.

- Trains are safe.
- Planes are quick.
- Boats are an experience.

- **Leading** is the vertical space between lines. (For example, this book uses 10·5pt body text with 12·5pt leading.)

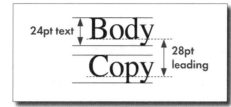

24pt text ↕ Body
Copy ↕ 28pt leading

- **Tracking** uniformly alters the spacing between letters. For example, tighter tracking can help to increase the mass or impact of a heading, while looser tracking might be used to expand a line of text to fit the width of a text frame.

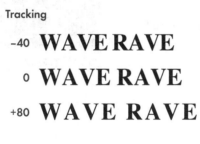

Tracking

−40 **WAVE RAVE**

0 **WAVE RAVE**

+80 **WAVE RAVE**

- An **indent** creates a visual start to a new paragraph.

Yachts are the preferred mode of transport of the rich, the successful and the powerful.
 A popular destination for the rich and famous is St. Barthelemy, a chic, tranquil island in the West Indies.

- A **drop capital** signifies the start of an article and indents the body copy adjacent to the drop capital.

Yachts are the preferred mode of transport of the rich, the successful and the powerful. They are the epitome of style.

- **Left-aligned text** creates a visually strong line and can make a document look more sophisticated. It is the most commonly used style. It looks less formal than right alignment.

Yachts are the preferred mode of transport of the rich, the successful and the powerful. They are the epitome of style.

- **Justified text** creates clean vertical lines on both sides. It gives text a strong visual shape and saves space but it can create unwanted hyphenation and exaggerated word spacing.

Yachts are the preferred mode of transport of the rich, the successful and the powerful. They are the epitome of style.

- **Text wrapping** allows text to be placed on the page around a piece of artwork. The example here shows a cropped image which has text wrapped round it.

- A **hanging indent** uses a drop capital but indents the rest of the column underneath.

Yachts are the preferred mode of transport of the rich, the successful and the powerful. They are the epitome of style.

- **Right-aligned text** can look sophisticated and is often useful for captions and sub-headings. It can also provide alignment with a photograph or the right-hand edge of a page.

Yachts are the preferred mode of transport of the rich, the successful and the powerful. They are the epitome of style.

- **Centred text** creates a symmetrical column of text but should be used sparingly. It can look dull, it is difficult to read and lacks a strong visual line.

Yachts are the preferred mode of transport of the rich, the successful and the powerful. They are the epitome of style.

Yachts are the preferred mode of transport of the rich, the successful and the powerful. They are the epitome of style.

Master page and grids

In a publication such as a magazine, the design and layout of each page may be different. However, the structure of each page is often based on a **master page**. Once the preliminary design work has been done a master page is drawn up using DTP software. At this stage the structure establishes features such as **margin widths** and **header** and **footer** spaces that will be constant throughout the publication.

Grids

Graphic layout on the computer normally begins with a **square grid**. This can be squares or dots. A **grid snap** feature ensures accuracy when the master page is set up.

A non-printing column structure (shown here in blue) is built on top of the square grid. This structure provides a **master grid**, or **template**, for all the pages in the magazine. The square grid can be switched off to improve clarity.

Flexibility

The structure of the master page needs to be flexible so that different layouts can be designed.

Guidelines can be dragged in from the top and side ruler bars or pre-set from a menu. They are used to set the individual structure of the page and set out columns, headings, sub-headings, graphics, photos and captions.

Printing page

The printing page will be bigger than the final publication size. Publications such as magazines and newspapers are printed on oversized paper, then trimmed to the final page size. This allows printers to print right to the edge of the page (**bleeds**). **Crop marks** indicate where the printing page should be cut. Inside this edge is the printing area.

The finished page is split into four colour layers: cyan, magenta, yellow and black. A printing plate is made for each of the four colours. The four plates are then printed on top of each other to give a full-colour page. **Register marks** are used to ensure the plates are aligned accurately.

Printing page

Bleed

Register mark

Crop mark

Printing area — Final page size — Non-printing area

Double page layout

The double page layout on the following page demonstrates a number of the common DTP design features that make modern publications visual and vibrant. Note the column structure, titles, headers, footers, margins and gutters that are common to most non-fiction publications such as magazines and newspapers. You need to be familiar with these features and use them to good effect in the promotional graphics section of your Thematic Presentation.

Header
In this example a **running header** is shown, so called because it appears on every page in this section of the publication.

Bleed
The main picture bleeds off the page at the top and left edge. This creates a modern, informal feel to the page.

Colour fill
Text boxes can be filled with colour to create harmony or contrast. The two plain blue fills used here harmonise with the blues in the main picture and contrast with the reds used elsewhere.

Column rule
The column rule sharpens the lines on the page, giving the layout a more formal look. In this case it also separates the main article from the interview with the lead singer.

Reverse
The colour of the body text is black. The colour of text in this sub-heading has been reversed and set on a darker colour fill. The reverse creates contrast and gives the page visual interest.

Headline
The headline introduces the article and usually appears at the top of the page. Bold fonts and tight tracking are used to create emphasis. The reverse text on a blue colour fill gives this snappy title visual impact and helps draw the reader into the article.

Heading
This second heading introduces a separate part of the article.

Tilt
The picture is tilted a little to catch the reader's attention and to create an informal modern feel that appeals to the youthful target market.

Drop capital
A larger first letter signals the start of the article.

Caption
Gives additional information about the photograph.

Hanging indent
The body copy has been stepped in away from the text frame, creating more white space.

Sub-headings
Sub-headings break up a large block of body copy and create a visual rhythm on the page.

Column
The body text is arranged in columns to restrict the width of the lines. It makes the text easier to read and helps create a visual structure that sets the tone of the page. Columns are often, but not always, the same width.

Page number (folio)
Page numbers normally appear in the footer.

Pull quote
This is selected body copy, enlarged and emboldened or coloured. It draws the reader into the article and is often a controversial or lively quote. The oval shape creates contrast with the box shapes on the page.

Gutter (alley)
This narrow space separates columns. It contributes white space to a layout and helps to de-clutter a page.

Cropped image
The image has had the background removed. This creates a more interesting shape.

Text wrap
The text wraps, or flows, around the cropped image. It brings an informal modern feel to the page.

Footer
The footer can contain a variety of information. It is not normally relevant to the article but to the publication itself.

NEW MUSIC

CRAZY TIMES DOWN AT
COSTELLO MUSIC

"Maybe it's something in the water in Glasgow; the Clyde isn't short of its own legends."

You might have heard that Glasgow's Fratellis are a bit glam. Round their way, it's all space hoppers, spangles and coveted Bolan seven-inches (that they might be able to swap for something from 1972-era Bowie). In Fratelliland, there are no iPods, no MP3s and YouTube is an adhesive for push-bike puncture repairs. They are shamelessly retro, yes, but don't think that means they have no original ideas.

For a start, theirs is a brilliantly old-school/new-tricks take on the classic last-gang-in-town myth. To qualify, a band must be 'proper mates' with a collective history, look cool when standing around street corners, and share a certain style and Musketeer philosophy. In short, they're 'us', and everyone else will always be 'them'. The Clash crowned it and since then it's been a sprint through Happy Mondays, The Strokes and, of course, The Libertines.

The Fratellis' nod to the Ramones in all taking the same surname and brandishing it like a badge immediately exudes cool. Like The Libs they have concocted hyperreal back-stories – car crashes, mystical oddball – which are immediately more interesting than whatever the truth might be. The last time a rock band arrived out of the blue so fully-formed was when Franz Ferdinand – haircuts, uniforms, artwork, videos, lyrics and interview techniques all carefully conceived – were sprung upon us. Maybe it's something in the water in Glasgow; the Clyde isn't short of its own legends.

But despite landing as a complete package, there is nothing cynically contrived about The Fratellis. They look like they sweat rock'n'roll. It's not just the big hair, skinny jeans, shades and sulky poses – they're wound up by a genuine love for the music and its history and their desperation to be part of it all. It's a natural fanboy response, it informs everything they say or do and it feels as natural as learning to walk. The 'fros and the pouts are important, and seriously seductive,

but don't worry – the tunes match up. 'Costello Music' tears along, fuelled by relentless youthful glee and Jon's scratchy vocal – part-Bolan, part-Caledonian Pete. Light and shade isn't the point with The Fratellis, they just make a merry and unpretentious noise. Think the energy and cheekiness of the first Supergrass record ramped up, multiplied and wearing darker denim.

In other hands, 'Henrietta' – a tale of an older woman stalker – would be clunky and bogus. Here it's a believable, racy air-punching chantalong, all chopping guitars and upbeats where 'cola' rhymes with 'gondola'. The swapping of 'I said/she said' lyrics ('Country Boys And City Girls') carries echoes of the trials of Pete & Carl – as does the idea of girls who might be boys, which bubbles through a few tunes. There's constant wide-eyed innocent wonderment about chasing girls, especially the ones just out of reach. When Jon sings "I love the way you city girls dress/Even though your head's in a mess," he sounds half-excited, half-terrified. Things really start to go T-Rex on the double-tracking entry to 'Chelsea Dagger' and it's pretty glam-tastic from there on in, especially on the brilliant 'Vince The Loveable', by which time you know you're listening to one of the albums of the year. It might be 13 tracks long, but there's no flab here.

Still, there have been doubts voiced about the authenticity of the trio for a number of reasons. They only played their first gig last March, they were signed to Island with what appeared to be indecent haste and a number of high profile producers were parachuted in to work on the album (like Tony 'Beck' Hoffer). The band were also sent to LA to complete it. It's much like Jet three years ago – there is a similar amount of hype and money behind The Fratellis. And the real pressure starts now. The band are about to headline the 02 NME Rock'n'Roll Riot Tour. In the past headline acts have included Razorlight and Kaiser Chiefs, so there's quite a mark to live up to.

But who cares about any of that? Yes, the Jet comparison stands up – but only because the Fratellis have delivered a brilliantly retro album that relies on the past for inspiration, but has the hips and attitude of 2006. They are what Dirty Pretty Things would like to be.

Right now, their bouncing glamorama feels like the most important album you could own. 'Costello Music' will wrestle with 'Empire' for your soul over the next few weeks. Do yourself a favour and sign it over to the Glaswegian trio now.

It is my belief that this band are going to be huge and I recommend that you tune in now while they are still in your neck of the woods. Trust me, I'm a doctor.
Paul McNamee

NEW MUSIC

The F to S of the Fratellis...

Bassist Barry Fratelli spells out what it means to be a Fratelli

The F is for 'Fanbase'.
"We knew we needed a fanbase. We thought we'd better treat them the best we can and give them a load of free stuff, so we've started the Budhill Singles Club via our website where you can get a bunch of mp3s, acoustic versions and stuff. We sent out a pre-printed CD: it's a blank CDR but the sleeve is all printed up so you can download the tracks and have your own official packaging for it. We've got plenty of obsessive fans. I've been sent some weird stuff, but we don't need to talk about that. You're better off not knowing."

The R is for 'Rock Clichés' (and how to avoid them).
"We're not the 'UK's rowdiest act', as a certain magazine has called us. I don't even drink any more. I hate getting tarred with a certain brush because someone has been too lazy to realise we're not just some rubbish band singing about Albion. Take that how you will. If you listen to bands you can normally tell who their influences are, but not with us. I'm a mod at heart really."

The band during their UK tour

The A is for 'Anger Management'.
"I get fed up with arrogant Englishmen making snidey remarks about the Scottish. Someone called me a 'Sweaty Sock' yesterday [Cockney rhyming slang for 'Jock']. It's bad manners."

The T is for 'Teacher's Pet'.
"There were a few cool teachers at my school, man. You want some names? My French teacher for one, she was pure brilliant. Ooh la la. Let's not go any further into that."

The E is for 'Envy'.
"I get envious of lots of things. Other guys trying to pull your bird. [Eh? - Ed] But I'm not envious of any other bands. There's no point. You spend years thinking about how cool you're going to make yourself look but then you just end up being yourself."

L is for 'The Lurios' and 'Little Baby Fratellis'...
"There was another band called the Fratellis, who are now called The Lurios, and we were rather uncomfortably on the same bill as them last Wednesday night. There have been a few stern emails sent back and forth, but as soon as we got signed we drafted a heavy letter to their lawyer. It's all legal and above board. Basically the first band to get signed gets the name, so we won! Our MySpace site is called 'Little Baby Fratellis' because there's also an American Fratelli, who play Mexican rock'n'roll stuff. Which is another headache!"

The I is for 'Idols'.
"I had a picture of the guys from 'The Dukes Of Hazzard' on my wall when I was a kid. Then I changed it to Axl Rose. If you want to listen to bands, go back a bit further man. Go to the 70s. Go to the 60s and work your way up, and if you've not found anything by then you're not listening hard enough."

The Fratellis debut album 'Costello Music' is currently available in all good stores.

page 4 www.shoegazemagazine.com October 08 October 08 www.shoegazemagazine.com page 5

INPUT AND OUTPUT DEVICES

Input and output devices

Computer aided design work involves the use of a range of input and output devices. Input devices are used to generate data to be used by the design application software. Output devices are used to view the output of the software.

Input devices

The **mouse** is used to control the cursor in most WIMP software systems and is widely used in graphics applications. Modern mice use beams of light to detect movement and allow multiple input via a series of buttons and scroll wheels.

The **QWERTY keyboard** is the primary input device for inputting numbers and text. It contains a large number of push button switches that send an electrical signal to the CPU. The keys on a QWERTY keyboard are laid out in the same positions as those on the original mechanical typewriters.

Digital cameras record photographic images in a digital format. These images are easily stored, edited and manipulated once copied on to a computer system. The digital files are stored in the camera's memory or on a removable memory card.

Modern digital cameras can also record moving pictures and sound. These files are often very large and require lots of memory.

3D digitisers record the X, Y and Z coordinates of real objects. The object is placed within a workspace and contact is made at various points on the objects surface using a light or sound sensor, robotic instrument or pen. The more points of contact that are taken, the more accurate the 3D computer model will be.

Flatbed scanners are used to convert hard copies of printed or drawn work into digital format. These digital files can be manipulated using graphics packages. Typed text can be scanned using OCR (Optical Character Recognition) and saved as text files for editing in word processing applications.

Graphics tablets are used in the graphics and engineering industries to quickly and accurately input information. The tablet has electrical sensors to monitor the position of a stylus or puck, allowing graphics tablets to be used to sketch drawings, trace hard copies of line drawings and add library parts to CAD drawings.

Joysticks are commonly used within the computer games industry and also within many robotic applications for fine control of moving parts. Many modern joysticks or joypads use double handed devices for controlling a series of complex inter-related movements: one hand may be used to control the movement of the actual device, while the other hand is used to control the view point from which the user sees the device.

Output devices

Monitors (VDUs) are the primary output devices used to display interaction between users and computer systems. Modern monitors provide clear, accurate and detailed representations of work produced by computer applications. Old style CRT type monitors consumed large amounts of energy and have been replaced in recent years with more economical LCD monitors.

Inkjet printers are available to suit paper size A4 to A0 and are commonly used to print text and graphics. The print is sprayed onto the paper using a series of different coloured jets. The colours are applied in various combinations to produce a high number of different colours and tones. Print quality is usually very good, although some full colour images can tend to flood the paper with ink causing it to wrinkle.

Laser printers are used to produce high quality text and graphics. Print is applied by fusing electrostatically charged toner (powder) to the paper. The resolution of modern colour printers can be as high as 1200dpi, giving photographic quality output. The running costs are lower than those of inkjet printers although the initial cost is considerably more.

Drum plotters are used to plot **large scale line drawings** such as building and engineering drawings. The paper is supplied on a roll and moves back and forth along the X axis while the pen moves along the Y axis.

Flatbed plotters are very similar to drum plotters, but are limited by the size of the paper that can be mounted on the bed. The paper remains stationary and the pen moves in both the X and the Y axis. Flatbed plotters use a number of different coloured pens which are changed automatically to produce line drawings. Both flatbed and drum plotters are commonly used in the engineering industry, although laser and inkjet printers are now replacing flatbed plotters.

Laser plotters have been developed by integrating the technology from existing drum plotters and laser printers. They provide high resolution plots of large scale drawings. Laser plotters combine the best qualities of both pen plotters and laser printers.

Data projectors are used to project an on-screen image onto a much bigger screen to allow a larger audience to view the information. Data projectors are widely used in industry when giving presentations and also in schools where they have become a common means of presenting information.

Thematic Presentation: introduction

The **Thematic Presentation** is a theme-based project that lets you demonstrate your skills over a wide range of graphic styles and techniques. The theme can be an everyday object, or a leisure activity. However, it is usually best to keep things simple by choosing a common object or product. The Thematic Presentation represents 30% of the course mark, so doing well in this project makes a significant contribution to your success in the course.

You will approach the Thematic Presentation using the same graphic skills that are used in industry when a product is designed, manufactured and promoted. The Thematic Presentation comprises three sections known as the **3Ps**:

- **Preliminary graphics** are design sketches and manual illustrations of the type produced by designers and architects early in a project. They should be manually produced and freehand (without the use of drawing instruments).
- **Production drawings** are fully dimensioned orthographic and pictorial CAD drawings. These drawings would be produced by design engineers and architects prior to manufacture or construction.
- **Promotional graphics** are CAG illustrations and promotional publications such as brochures, booklets and posters, etc. These publications are used to promote a product or a business in the marketplace.

Selection of a suitable product

The focus of your thematic presentation is most likely to be a product. Choose this product carefully. It should have at least three components and, ideally, should dismantle. Electronic products with lots of buttons, like mobile phones and cameras, can be difficult to dismantle and can be very complex internally. It may be better to look for mechanical products with moving parts that can be dismantled or can be easily studied and measured without dismantling.

There is a wide range of household goods which you could consider:

- Look in the kitchen for items such as a tin opener, corkscrew, garlic press or wine bottle stopper.
- Toy boxes often contain suitable products like vehicles, Lego figures, construction toys.
- Tool boxes and garages may turn up suitable tools such as pliers, small vices and clamps.
- Musical equipment includes guitar effects pedals, drum pedal, guitar stand and guitar tuner.
- Shops like Ikea and other DIY stores have lots of cheaper mechanical items that would be suitable.

Discuss your choice of product with your teacher before you begin.

Assessment

A total of 60 marks are available for the Thematic Presentation, allocated as shown:

Preliminary graphics	Marks
Orthographic freehand sketches	4
Pictorial freehand sketches	4
Manual illustrations	4
Thumbnails and roughs	4
Presentation visuals	4
Total	**20**

Production drawings	Marks
Orthographic drawings	6
Annotation	2
Pictorial line drawing	6
Technical detail	6
Total	**20**

Promotional graphics	Marks
CAG illustration	6
DTP text and layout	6
DTP technical quality and complexity	4
Additional promotional graphics	4
Total	**20**

You have until the end of March to complete your Thematic Presentation. However, you will spend only about 1 ¼ hours per week working on it in class. Any additional time you spend on the project will be time well spent – plan your work to meet your teacher's deadlines.

The following pages show examples of each section in the Thematic Presentation. In each example full marks have been achieved. Remember, the Thematic Presentation is an individual piece of work and it is important that you discuss your project with your teacher to make sure that you are producing the correct range of material.

PRELIMINARY GRAPHICS: ORTHOGRAPHIC FREEHAND SKETCHES ──

Preliminary graphics: orthographic freehand sketches

The product selected here is a garlic press. It has seven components and while it cannot be fully dismantled, each component can be examined and measured. Once you have selected a product, you need to analyse it. Examine it closely, and work out how the components fit together. If there are any moving parts, find out why they need to move and how the design of the components enables this. Finally take accurate measurements of each component. These measurements will be added to your orthographic sketches as dimensions.

You are producing preliminary sketches followed by production drawings which would be used to manufacture the components and assemble them into the finished product. You should dismantle the product as far as possible and produce sketches of each component. Your sketches must be in good proportion, fully dimensioned and conform to British Standards.

The orthographic freehand sketches required for your Thematic Presentation should include **component sketches** and **assembly sketches**.

Component sketches

Planning
- Break your product down into its component parts.
- Consider how many related views you need to fully describe each part.
- Plan the layout of the views for each component on the page leaving sufficient space for dimensioning.
- Consider the content, size and location of the title block.

Completion
- Set out the area for each of the components and the title block.
- Lightly construct the main view of each component using the crate method.
- Project lines to construct the related views.
- Add detail and dimensions to the components.
- Title each component and its related views.
- Complete the title block.
- Enhance the presentation of the sketches using fine line pen, spirit marker and colour pencil.

Construction of the components using the crate method

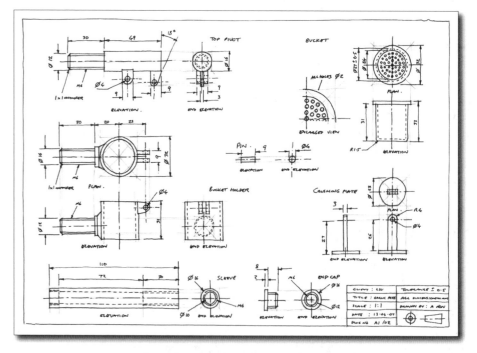

Completed page prior to enhancing

Assessment checklist

Use this checklist as a guide to assess the marks that your component drawings will attract. Your drawings should demonstrate:
- orthographic **freehand sketching** (no use of instruments or tracings)
- **good proportion**
- **visual quality**
- a range of **technical detail**

- two or more **dimensioned, related views**
- **sufficient dimensioning** to allow creation of CAD graphics
- **three types of dimensioning**
- use of **datum lines**
- a variety of **line types**
- appropriate **annotation**.

Three types of dimensioning
A variety of dimensioning types are clearly and correctly shown, including **linear**, **angular**, **radial**, **diametric** and **annotated dimensions**.

Variety of line types
A variety of line types have been shown throughout the orthographic sketches, including **outlines**, **centre lines** and **hidden detail lines**.

Visual quality
The sketches demonstrate **visual quality**. They are neat and accurate, and the line quality is excellent. They have also been enhanced appropriately. All final lines, dimensions and annotations have been picked out with a fine line pen and the sketches have a thick outline or silhouette to make them stand out on the page. Spirit marker and coloured pencil have been used to emphasise the sketches.

Appropriate annotation
The **correct titles** of the related orthographic views and the **names** of each component are shown.

Freehand sketching
The page clearly shows that orthographic freehand sketching has been used. Initial construction is still visible and it is obvious that no instruments or tracings have been used.

Good proportion
The sketches demonstrate **good proportion**. To be successful when tackling this aspect of freehand sketching you must look at your product carefully and match its proportions accurately.

Dimensioned related views
The page contains two or more **dimensioned, related views**. In practice you should dimension all related views to make the task of producing CAD drawings as easy as possible.

Technical detail
The **enlarged/partial** view makes it easier to view the detail and contributes to the range of technical detail.

Datum lines
Dimensioning uses a datum line appropriately to simplify the dimensioning and make it easier to read.

Sufficient dimensioning
All orthographic views are suitably dimensioned and are in accordance with British Standard conventions.

Appropriate annotation
Appropriate information relating to the drawing has been included in the title block. This should be seen as planning ahead for the title block in the production drawings.

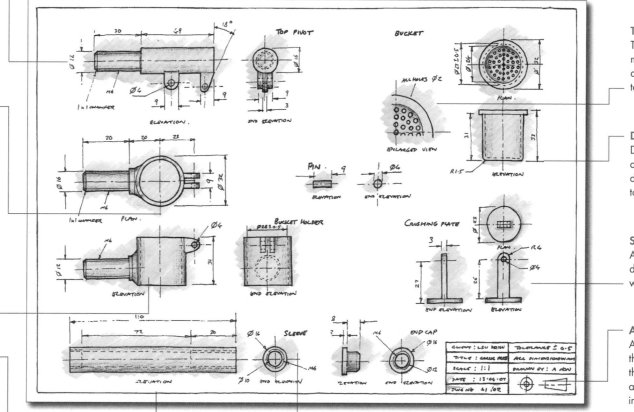

Final page showing enhanced graphics

Assembly sketches

In addition to the freehand component sketches, you should complete orthographic **assembly sketches** of the product.

The component and assembly sketches are part of the same topic and the 4 marks for the orthographic freehand sketches are shared between them.

The assembly sketches are used to show how the components fit together and guide the CAD work in terms of how the finished graphic will appear. These sketches should also demonstrate visual quality, good proportion and show technical detail.

Planning

- Assemble the component parts of your product.
- Consider how many related views you need to fully describe the product.
- Consider which views require technical detail and what form this will take.
- Plan the layout of the views on the page.
- Consider the content, size and location of the title block.

Completion

- Set out the area for each of the views and the title block.
- Lightly construct the main view using the crate method.
- Project lines to construct the related views.
- Add detail to the assembly's components.
- Title each view.
- Complete the title block.
- Enhance the presentation of the sketches using fine line pen, spirit marker and colour pencil.

Construction of the components using the crate method

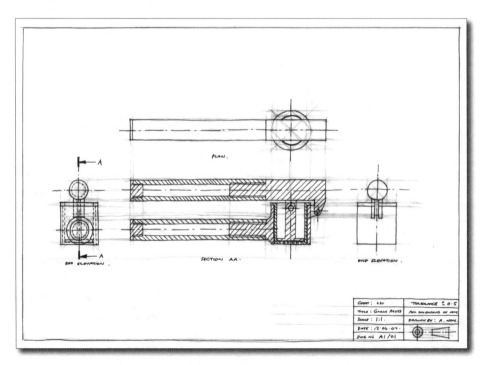

Completed page prior to enhancing

Preliminary graphics: orthographic freehand sketches	Marks
Analytical orthographic freehand sketches including: • related orthographic views • technical detail (full, part and stepped sections, exploded views, assembly details, scaled views, cutaways, auxiliary views, details of moving parts) • full dimensions (three types, from linear, angular, diametric and radial) • dimensional tolerances • datum lines • appropriate line types • annotation	**4**

Assessment checklist

Use this checklist as a guide to assess the marks that your assembly drawings will attract. Your drawings should demonstrate:
• orthographic **freehand sketching** (no use of instruments or tracings)
• **good proportion**
• **visual quality**
• a range of **technical detail**
• a variety of **line types**
• **appropriate annotation**.

Visual quality
The sketches all demonstrate **visual quality**. They are neat, proportionally accurate, and the line quality is excellent. They have also been enhanced appropriately. All final lines and annotations have been picked out with a fine line pen, and the sketches have a thick outline or silhouette line to make them stand out on the page. Spirit marker and coloured pencil have been used to emphasise the sketches and introduce tone.

Technical detail
The **sectional view** makes it easier to understand the product and contributes to the range of technical detail.

Variety of line types
A variety of line types have been shown throughout the related views, including **outlines**, **centre lines**, **cutting planes**, **cross-hatching** and **hidden detail lines**.

Freehand sketching
All the sketches must be completed freehand, without the use of instruments or tracing aids.

Good proportion
The sketches all demonstrate **good proportion**. To be successful when tackling this aspect of freehand sketching you must study your product carefully and match its proportions accurately.

Appropriate annotation
The **correct titles** of all the related orthographic views are shown.

Appropriate annotation
Appropriate information relating to the drawing has been included in the title block. This should be seen as planning ahead for the title block in the production drawings.

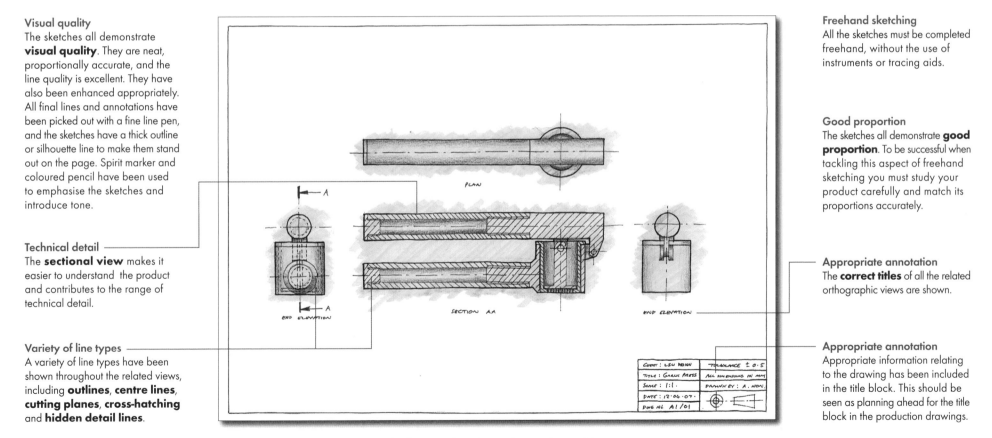

Final page showing enhanced graphics

Preliminary graphics: pictorial freehand sketches

Pictorial sketching is an excellent way of analysing the product that your Thematic Presentation is based on. It's an opportunity to demonstrate your sketching ability. These sketches are intended to replicate the sketches a designer would create when a new product is designed. However, you are not designing a product. Instead, you are analysing an existing product.

You can use any of the accepted pictorial styles but the examples here are all in perspective. This brings realism to the sketches and can create a dynamic, almost 3D effect, on the page. Develop your skills in one and two point perspective sketching (see pages 139–162). If the perspective is good and the proportions are accurate, your sketches will come to life.

These analytical preliminary sketches should build on your knowledge of the product already gained through your orthographic sketching:
• Examine each of the components and how they are assembled.
• Identify moving parts and the mechanisms that enable the movement.
• Explore any interesting features your product may have.

Annotations should be added to explain technical aspects or the thoughts you have about how the product looks or functions. You will need to plan the sketches to ensure you are creating a range of technical detail (see the assessment box). This will add complexity and improve your chances of picking up all 4 marks.

Planning
• Quick thumbnail sketches will help you resolve a number of different issues:
• Take some time to plan the views you will use.
• Select the technical detail you want to include.
• Plan the approximate size of each sketch and its position on the page. (This planning page will be discarded later.)

Construction
• Construction lines will help you to establish good proportions:
• Consider the product as a series of geometric forms.
• Start by constructing the biggest component.
• Build the sketch up, adding the remaining parts or features one-by-one.
• Trust your eye to keep the proportion accurate and the perspective strong.

Preliminary graphics: pictorial freehand sketches	Marks
Pictorial, analytical freehand, line sketches in:	**4**

Pictorial, analytical freehand, line sketches in:
- perspective
- isometric
- planometric
- oblique

Exploring a theme, product or component. Showing details such as:
- full, part and stepped sections
- exploded views
- assembly details
- details of moving parts
- cut-aways
- auxiliary views

Assessment checklist

These pictorial sketches are worth 4 marks and the marks are awarded where:
- the **quality** of sketching is good
- there is **technical detail**
- the work is sufficiently **complex**.

Remember!

Your pictorial sketches must be freehand. You cannot use drawing instruments or straight edges. Proportion is important. Your sketches need to match the proportions of the product. Take care when estimating the proportions; accurate construction work will help.

Technical detail
The exploded view helps explain how various components assemble.

Complexity
The sketches are sufficiently complex to merit marks at this level.

Quality
There are four separate sketches on the page and, in each case, the **quality of perspective** is very good, **proportions are accurate** and the **complexity is appropriate** to higher level. In addition the **line quality** is very good.

Technical detail
The **part-section** allows the viewer to see into the assembly. The choice of technical detail is appropriate.

Technical detail
Moving parts can be shown and their movement explained graphically. Arrows may also be used to describe the direction of movement.

Annotations
Annotations are added to provide additional information.

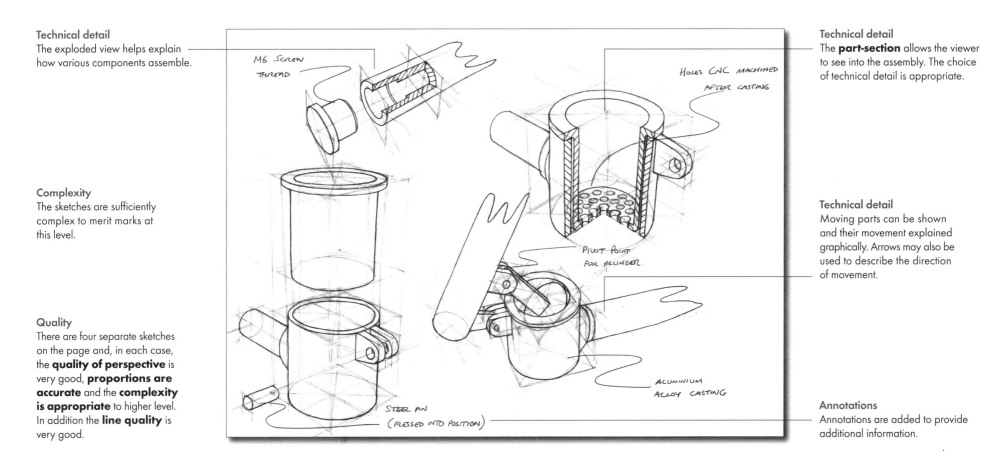

M6 SCREW THREAD

HOLES CNC MACHINED AFTER CASTING

PIVOT POINT FOR PLUNGER.

ALUMINIUM ALLOY CASTING

STEEL PIN (PRESSED INTO POSITION)

Preliminary graphics: rendered manual illustrations

Rendered manual illustrations give you the opportunity to show your skills in manual illustration techniques using pencils and marker pens. Pastels and other manual media can also be used.

Planning

By the time you get to this stage, you should be fully familiar with your chosen product. Decide on the types of technical detail you will use to illustrate the product. This example shows orthographic and perspective sketching as well as sectional and exploded sketches, and focuses on specific areas by enlarging small details.

These sketches need to be planned and set out to make best use of the page. Select the mediums you will work with. This example uses spirit marker pens, coloured and 2H pencils, and fine line pens. The sequence of steps on these three pages will help you plan your own illustrations.

Sketch freehand outlines

- This graphic work is analytical. Try to get into the head of the designer – what would he or she have explored when the product was being designed?
- Try to vary the styles of sketching from orthographic to perspective.
- Careful selection of technical detail will help add complexity to your work.
- Focus on important features of the product such as assembly details, moving parts and functional details.
- If you are working with marker pens, use good quality bleed-proof paper.

Preliminary graphics: rendered manual illustrations	Marks
Rendered analytical freehand sketches in colour or monochrome to show: • tonal scale on flat and curved surfaces • highlights • shadows • texture on: • pictorial or orthographic sketches • technical detail from full and stepped sections, details of moving parts, cut-aways and auxiliary sketches	4

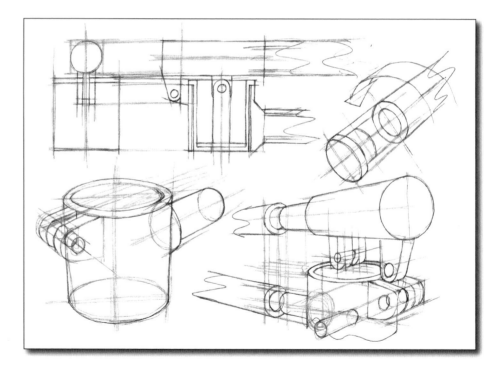

Blocking in

- Flat marker pen tone can be applied.
- Use good quality bleed-proof paper.
- Work quickly to create a smooth even texture.
- If the first coat is patchy, go over it again to even it out.
- Work freehand using the wide chisel tip whenever you can.
- Remember to re-seal the pen whenever you put it down.
- Decide where your light source is coming from. Edges or surfaces facing towards the light source will be highlighted and those facing away will be in shade.
- Some darker tones can be added with the marker pen at this stage. Add another coat to the areas that will be facing away from the light source.

See pages 163–168 for more information on using marker pens.

Add highlights, shadows and detail

- Use best quality white rendering pencils to pick out highlights. Be bold here.
- Black rendering pencils are used to create shade. Be careful not to overdo the darker areas.
- Use a graded tone on curved surfaces.

Problem-solving tips

- The strike-through technique is useful on orthographic sketches and objects that have single colours. It is quick and useful when a reflective surface is needed.
- Blocking in with marker pens gives flat tones which can have detail added with rendering pencils.
- Coloured pencils are versatile and extremely useful when wood grain textures are required. Crisp highlights can be left on curved surfaces.

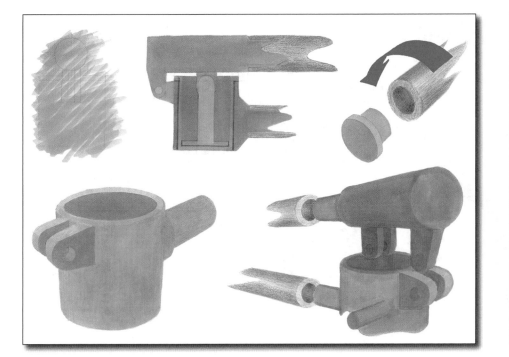

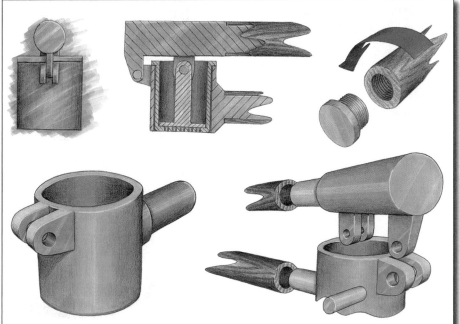

Enhance the presentation
Presentation of ideas can be crucial when a designer wants to sell a new idea. Try enhancing your illustrations in the same way.

Assessment checklist

Use this checklist as a guide to assess the marks that your rendered illustrations will attract. Your drawings should demonstrate:
- tonal scale on flat and curved surfaces
- highlights
- shadows
- texture

on:
- pictorial or orthographic sketches
- technical detail from full, part and stepped sections, details of moving parts, cut-aways and auxiliary sketches.

Assessment is based on the complexity and visual quality of the techniques listed.

Drop shadow
The **drop shadow** suggests depth and makes the graphic stand out.

Flashbar
The **flashbar** creates a simple background and helps unify the page, creating visual impact.

Thick outline
The **thick outline** gives emphasis to the shape.

Black halo
The **black halo** grounds the graphic, making it appear more substantial.

Annotation
The **annotation** helps to explain product details.

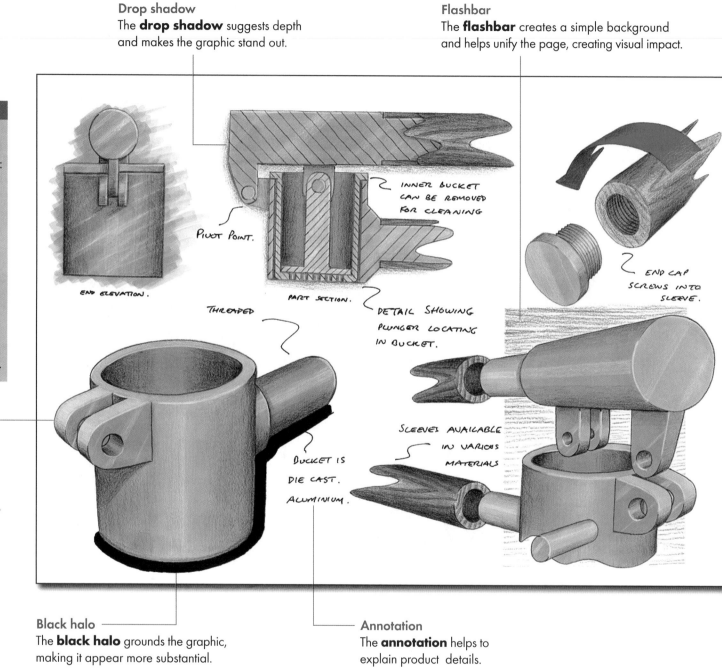

END ELEVATION.

PIVOT POINT.

PART SECTION.

INNER BUCKET CAN BE REMOVED FOR CLEANING

DETAIL SHOWING PLUNGER LOCATING IN BUCKET.

END CAP SCREWS INTO SLEEVE.

THREADED

BUCKET IS DIE CAST. ALUMINIUM.

SLEEVES AVAILABLE IN VARIOUS MATERIALS

Production drawings: using 3D modelling software

The use of 3D modelling software is becoming common and is an effective way to complete your production drawings. It is a very different approach from using a 2D CAD package. Each component is built separately and then assembled to form the finished product. Orthographic production drawings can be projected from individual 3D components and from the assembly. If you are using a 2D CAD package, pages 203–204 will take you through the main steps in the process.

3D computer models are built using a range of modelling techniques (see pages 177–178). All the modelling techniques involve taking 2D information (sometimes referred to as a sketch) and then manipulating it to generate 3D solid features or forms.

Producing the 2D sketches requires accuracy and drawing skills but success depends on the user's problem-solving ability. The user must decide which modelling technique to use and how to construct the 3D model.

These two pages show one approach to completing production drawings using 3D modelling software. Key features of the software are highlighted, and examples show how components are built before assembly.

Production drawings	Marks
Related orthographic drawings, including: • a variety of line types • dimensions • curved surfaces • technical complexity • visual quality	6
Annotation	2
Pictorial line drawings of the assembled item and visual quality	6
Two examples of technical detail, such as: • full, part or stepped sections • exploded views • assembly details • scaled views • details of moving parts	6
Total	**20**

The extrusion command

The **extrusion** command creates solid features by creating volume from a 2D sketch. This is an effective method of producing forms with a uniform cross section. This is probably the most widely used of all the 3D modelling commands and is an important element in this stage of the thematic presentation.

Combining commands

When constructing sketches, it is important to use the full range of editing commands to make the work both quicker and easier to complete. In this case the **duplicate** command was used to produce a circular array of holes. The **extrude** command has then been used again to subtract the material from the bucket.

PRODUCTION DRAWINGS: USING 3D MODELLING SOFTWARE

The revolve command

The **revolve** command creates solid features by creating volume around a centre axis. This is an effective way of producing complex forms from a few simple elements. In this case, creating a sketch and axis allowed the bucket for the garlic press to be formed in one go rather than using a series of separate time-consuming commands.

The mirror command

The mirror command can be used when adding repeated features within a component. This command is an effective method of creating exact copies of features that are the mirror image of the original. This process saves time and is more accurate and much easier than repeating the original process again.

Creating an assembly

Completed components are brought together in an assembly.
- Fix one component in place and assemble the remaining components in the same sequence you would use to manually assemble the product.
- Ensure components that fit together are made accurately. Inaccuracy can lead to problems in assembly and will be visible in the production drawings.

Complete the production drawing

Orthographic and pictorial views of the assembled or individual component parts can be generated in an engineering drawing. These views can then be manipulated to show technical detail such as sectioned or enlarged views. Dimensions, annotations, centre lines and graphics are then added to complete the production drawing.

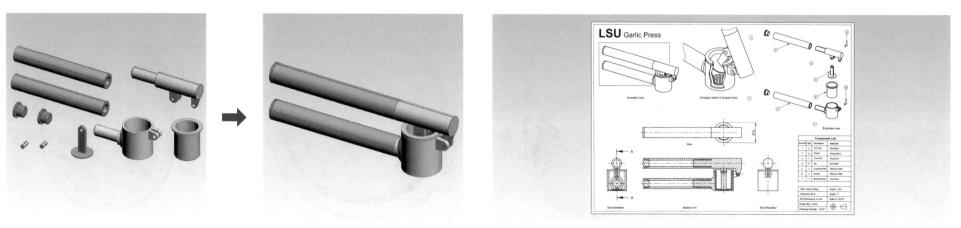

Production drawings: computer-aided drawings

Your completed production drawings are worth 20 marks. The marks are awarded for both the component drawings (shown on this page) and the assembly drawings (shown on page 202).

Component drawings

The component drawings on this page are fully dimensioned. Study the component and assembly drawings and the notes that explain where marks are gained.

Assessment checklist

Use this checklist as a guide to assess the marks your production drawings will attract. Your drawings should include:
- related orthographic drawings
- annotation
- pictorial line drawings
- technical detail
- full dimensioning.

Related orthographic drawings
A variety of dimension styles are used.

Annotation
The correct titles of the orthographic views are shown.

Related orthographic drawings
As a 3D modelling package has been used, the related orthographic views have been generated from the model and do not contain wire frame or facets.

Related orthographic drawings
Both parallel and chain dimensioning are used and the dimensions are placed to aid clarity.

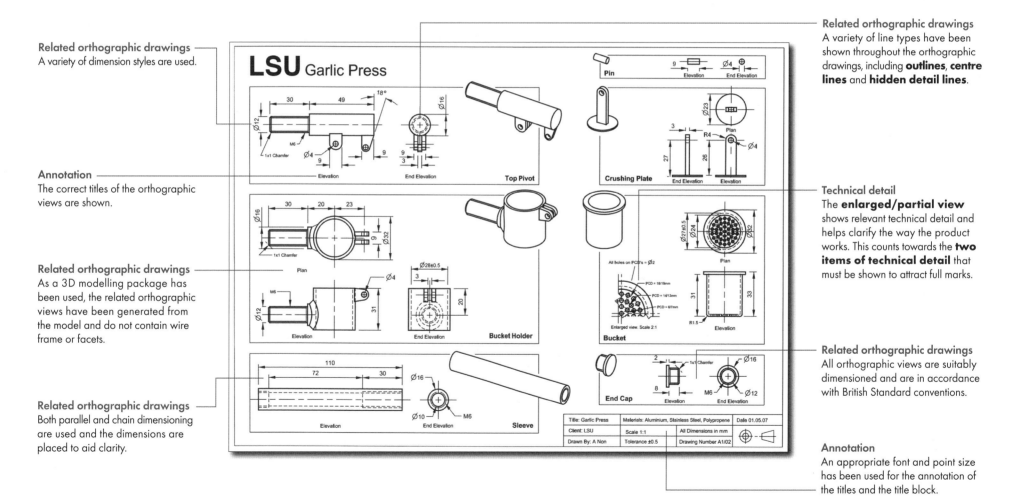

Related orthographic drawings
A variety of line types have been shown throughout the orthographic drawings, including **outlines**, **centre lines** and **hidden detail lines**.

Technical detail
The **enlarged/partial view** shows relevant technical detail and helps clarify the way the product works. This counts towards the **two items of technical detail** that must be shown to attract full marks.

Related orthographic drawings
All orthographic views are suitably dimensioned and are in accordance with British Standard conventions.

Annotation
An appropriate font and point size has been used for the annotation of the titles and the title block.

PRODUCTION DRAWINGS: COMPUTER-AIDED DRAWINGS

Assembly drawings

The orthographic assembly drawings can be combined with the pictorial drawings if there is enough space. The complexity and accuracy of the drawings are crucial, but other factors, such as neatness and clarity, good layout, and conformance to British Standards are just as important.

Technical detail
The **enlarged/cutaway view** demonstrates a sufficient degree of technical complexity and counts towards the **two items of technical detail** that must be shown to attract full marks.

Annotation
All the views are clearly and correctly labelled to help identification of the parts and improve clarity.

Pictorial line drawings
The pictorial views have been suitably laid out. Scale, position and spacing have been considered and applied.

Pictorial line drawings
This is a clear pictorial view of the item. Isometric, oblique, planometric or perspective views can be used in these instances.

Related orthographic drawings
Related orthographic drawings are shown in 3rd angle projection.

Related orthographic drawings
A variety of line types have been shown throughout the orthographic drawings, including **outlines**, **centre lines** and **hidden detail lines**.

Technical detail
A **full section view** has been used to show the internal details of the assembled product. Part or stepped sections could also be used.

Technical detail
An **exploded view** which shows the appropriate level of technical detail has been used. This gives more information about the product such as assembly details. Items are clearly labelled and relate to the component list.

Annotation
A component list of the item has been produced to help identification of the parts and improve clarity.

Annotation
A personalised title block has been produced. (Pre-drawn templates are not acceptable.)

Annotation
The scale of the drawing is indicated.

Annotation
The 3rd angle projection symbol is shown.

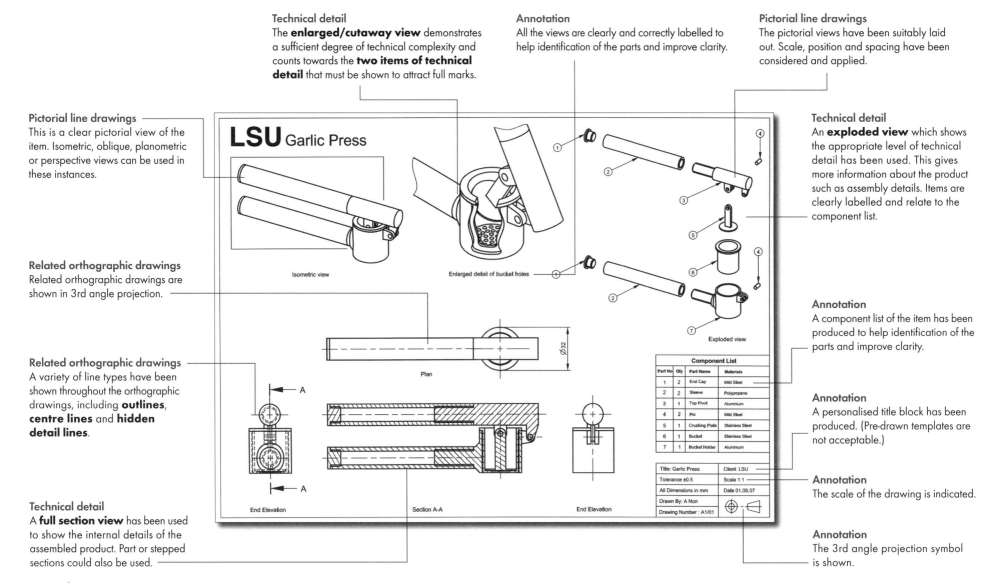

Production drawings: using 2D CAD software

2D CAD software can be used to complete your production drawings. These two pages give advice on how to complete production drawings using this software. Key features of the software are highlighted, and tips suggest how best to approach each stage. In this example technical detail has not been shown (for specific details of this refer to page 202).

Setting up and constructing

- Use **snap** and **grid** to ensure accuracy and make construction easier. Ortho and isometric grids have been used here.
- Use **layers** to separate construction lines, outlines and centre lines.
- Construct the orthographic view that gives the most information first. Project the related views from this.
- Try to re-use lines as much as possible. **Copy** and **paste** can be used to speed up the drawing process.

Adding additional views

- Switch between ortho and isometric grids. Outlines, edges and centre lines can be added to orthographic and pictorial views.
- Maintain your accuracy in positioning lines, but do not try to end them at exact points: lines can be left long and can overlap at this construction stage. Completing your drawings in this way is easier and saves time.
- Once an end elevation is complete, use the **mirror** command to construct the opposite one.

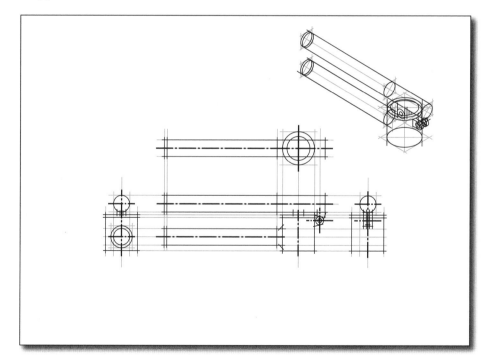

PRODUCTION DRAWINGS: USING 2D CAD SOFTWARE

Tidying up and dimensioning
- Tidy up the drawing by trimming lines that overlap or extend too far.
- Use **trim**, **break** and **extend** commands to manipulate the lines and achieve the desired level of detail and accuracy.
- **Zoom** into the drawing once and use **pan** to move to the part of the drawing you want to edit.
- Add sizes using **auto dimensioning** tools on a separate layer.

Adding annotation
- Remove construction lines simply by switching off the appropriate layer.
- Use **text** tools to add annotation (such as the titles of views) on a new layer.
- Add a title box containing the required information on a new layer.
- Consider the presentation of the page and add a border and a title if desired (remember that this is a production drawing and should be neatly and formally presented).
- Fine tune the layout of the page until you are happy with it.

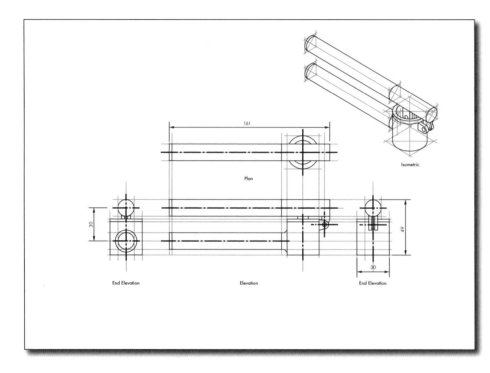

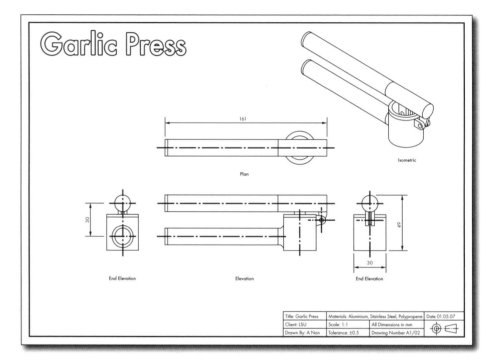

> **TIP**
>
> These two pages only give an overview of what can be achieved using 2D CAD software. Additional complexity and technical detail would be added using the same processes.

Promotional graphics: computer-aided illustration

Having created your production drawings, the next step is to produce computer generated illustrations for use in your promotional documents. There are several ways to do this. The method you will use depends on the software available to you.

This section looks at two methods:
- **attaching materials, textures and colours** to a **3D model** (surface rendering)
- using **illustration paint software** to produce a new illustration.

Promotional graphics: computer-aided illustration	Marks
Using an illustration package on one or more pictorial/orthographic items to show effective use of rendering an assembled drawing or technical detail such as: • full, part and stepped sections • assembly details • exploded views • scaled views including a range of techniques from: • gradients • reflections • shading • highlights and texture	6

Attaching materials, textures and colours to a 3D model

Attaching materials

3D models are enhanced by attaching materials to individual surfaces. These materials take the form of bitmap images applied in a tiled manner (repeated one after the other) until the surface is covered. The software generates fill styles based on the form of the object (curved or flat) to make the scene photo-realistic.

On this example, bitmaps for stainless steel have been attached to the metal parts and bitmaps for wood grain have been attached to the handle. The coloured handles use bitmaps of plastic and colours can be changed.

Changing colours

Colours can be altered to match the final colour scheme of the product or to give more visual impact. In industry, this facility can be useful in discussions with a client, by allowing alternative colour options to be explored before physical samples are made.

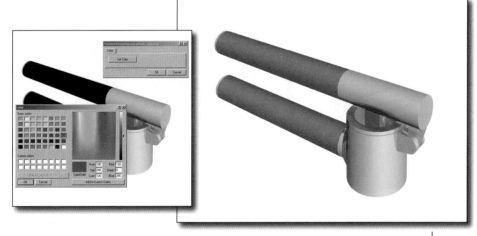

PROMOTIONAL GRAPHICS: COMPUTER-AIDED ILLUSTRATION

Adding backgrounds

The presentation of a 3D model is enhanced by attaching fill styles or bitmap images to the background of the object. This feature is used to visually promote the object. The choice of backgrounds can vary from flat single colour or graduated (as used in this example), to more complex backgrounds taken from photographs or computer generated images.

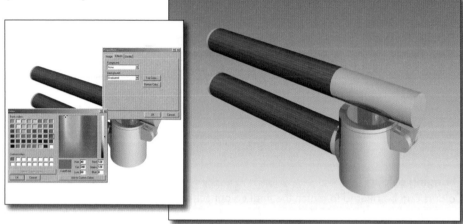

Adding light sources

Light sources are used to enhance the realism and visual impact of the object. Multiple light sources can be used to create stronger highlights and deeper shadows, and to light the object in a favourable way. In this example, the addition of surfaces below or around the object produces shadows or reflections, enhancing the presentation.

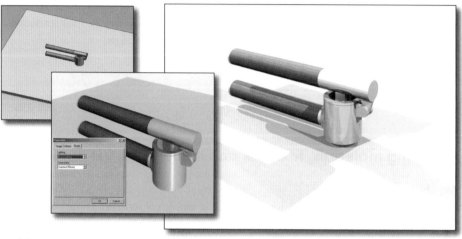

Altering viewpoints / cameras

The viewpoint from which the object is seen can be altered to make it seem more realistic or to create visual impact. The facility can also be used to zoom in to features or details of the product that need enlarged. The choice of camera used can also be changed to suit the user's needs.

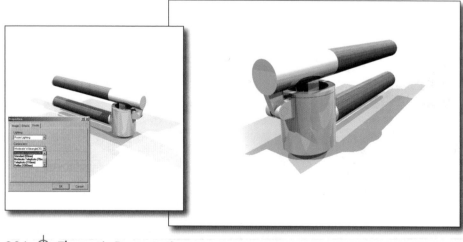

Building an environment

Environments can be built with the same software used to create the 3D model. This grounds and enhances the object and allows different features of the rendering software (exemplified earlier) to be used to best effect. An environment can also place the 3D model in context; here the garlic press is on a kitchen worktop. The environment can be as simple or as complex as required or as time permits.

Attaching decals

Decals are handled in much the same way as materials attached to surfaces of the 3D model, in so much as they are images that are attached to designated surfaces. However, they are singular and are not 'tiled' in the way that materials are. The user has much greater control over their selection and how they are used. Images can be sourced or created by the user, who can also determine their size, location and orientation. The decal here is a bitmap image of the label on the knife block.

Exporting images

Once the desired level of presentation of the 3D model has been achieved, the resultant image can then be exported in a range of different file types. These are then used in specific packages to present the product to a wider audience or client. In this example a range of images of the product will be imported to a desktop publishing package and combined with text and graphics to create a final presentation later in the Thematic Presentation.

Assessment checklist

Use this checklist as a guide to assess the marks your CAG illustration work will attract. Your illustrations should include the effective use of a range of rendering techniques to show:
• gradients
• shading
• reflections
• highlights
• materials
• texture
• two light sources (if using a 3D modelling package)
on:
• pictorial or orthographic item(s)
• an assembled drawing or technical detail.

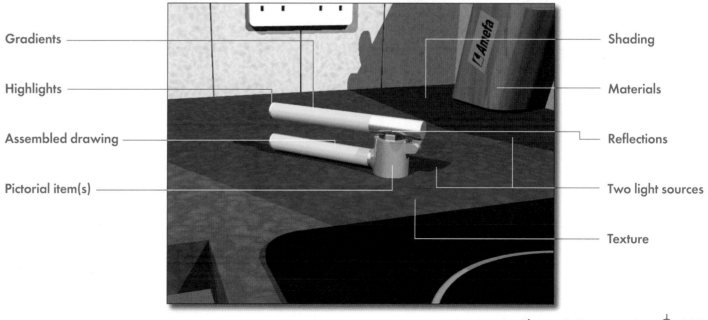

Gradients

Highlights

Assembled drawing

Pictorial item(s)

Shading

Materials

Reflections

Two light sources

Texture

PROMOTIONAL GRAPHICS: COMPUTER-AIDED ILLUSTRATION

Using illustration paint software to produce a new illustration

Exporting the CAD line drawing
Export your CAD line drawing to an illustration package.

Tracing the outlines
Trace the line drawing with the illustration drawing tools. You are effectively creating another drawing using the illustration software.

Making curves
Use the **Bezier tool** to stretch and shape lines to match curves on the CAD drawing.

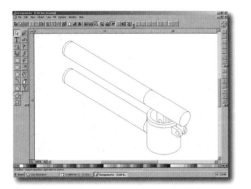

Creating closed shapes
The aim is to produce a drawing consisting of a group of closed shapes. The exploded view below shows the closed shapes that were drawn to create the garlic press illustration.

Colour fills
The enclosed shapes of the new drawing are filled with **colour fills**.

Gradient fills
Gradient fill styles are applied to each area to create tonal change. **Cylindrical**, **linear** and **spherical** fill styles create a 3D appearance on curved surfaces. Textures may be added if the software allows this.

Removing original outlines
Finally, the **black outlines are removed** and the original CAD line drawing is deleted to leave a realistic looking CAG illustration. This illustration is now ready for use in your **promotional documents**.

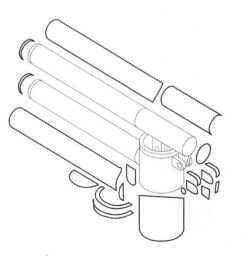

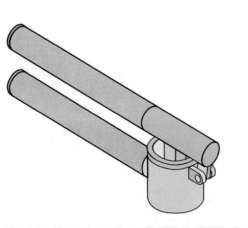

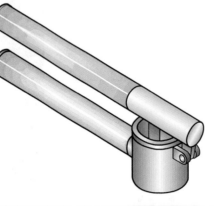

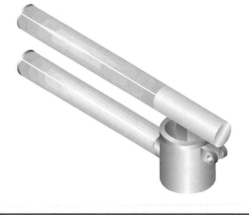

Preliminary graphics: thumbnails and roughs

In addition to the orthographic and pictorial freehand sketches used for planning your production drawings, your preliminary graphics must include planning material for your promotional graphics. This planning material includes **research**, **thumbnails** and **roughs**.

Research

Planning any new document requires research, and for many pieces of work this will be accompanied by a **brief** from a client. In this case study, the client is a manufacturing company with a new product to promote. The design of new documents may be done in-house but most often it will be subcontracted to independent graphic design studios.

The brief will outline the task and give the graphic designer a starting point for research. It is good practice to record the brief for reference. Put yourself in the role of the graphic designer who has been asked to design a range of documents which will be used to promote the product.

> **TIP**
>
> The Thematic Presentation can be completed without this research page, but it will be assessed in the Computer Graphics unit.

Research

Brief: Design a multi-page document to promote the garlic press.

Product name: garlic press
Client: LSU design

Analysis

Target market
- both male and female
- young family, young couples and single independents
- age: mid-20s to late 30s
- lifestyle: style conscious, into gadgets
- income: mid- to high-income

Purpose of the document
- promote the new product
- promote the company
- provide customer support
- inform customers of other items in the product range

Contents of the document
- information about the company and product
- details on product use
- other products in the range
- where to purchase
- company contacts

Format
- single sheet leaflet, 2 sides

Specification
The document must meet the following spec:

Format
Folded brochure to make best use of space on A4 sheet. Fold neatly into a creative package.

Target market
- male and female
- median age 26
- mid- to high-income

Style
Cutting edge graphic design. Needs to be modern with clean sophisticated look.

Colours
Sophisticated contemporary colours – not traditional or too young.

Content
Include:
- company information
- product information
- other products in the range
- contact details

Print restrictions
- full colour, A4
- print run 1000

Colour combinations
Colour combinations must look stylish, sophisticated and modern to stand out in a competitive market.

This colour swatch shows possible combinations:

Fonts
Sans serif fonts are modern and clean. Use these for headings and sub-headings.

Although traditional, serif fonts can be used for body copy.

Logo design
- company name: LSU design
- Try to incorporate contrast in the logo

LSUdesign LSUdesign LSU design

LSU design LSU design Isu DESIGN

Analysis
The graphic designer learns more about the project by breaking it down into smaller parts. The information gathered gives a starting point and helps focus the design work. Use the following list as a guide for your analysis:
- **Who is the document aimed at?** The promotional material may target a certain age group, gender or interest group. These details have to be collated and are known as the **target market demographics**.
- **What is the document's purpose?** Promotional material is used to help market and sell a product or service, and will also promote a company identity.

- **What will be included in the document?** Promotional material will include written information about the product or the company. Graphics may be photographs, illustrations or both. The company will probably have a corporate logo or colour scheme which should be used.
- **What are the printing restrictions?** Printing options include full colour, two colour or black and white. Formats can include posters, leaflets, booklets or newsletters. The print run (number of copies printed) must be specified and a printing budget given.

Specification
From the analysis, the graphic designer writes a design specification for the document. The designer must be clear about the function of the document. Asking the client questions is an essential part of the process, and answers to the questions must be recorded in the specification.

Colour combinations, fonts and logos
Design features such as colours, fonts and logos should be considered at this stage. Any existing client colour schemes must be followed. Use a colour grid like the one shown here to consider colour combinations, tints and shades.

Thumbnails

Thumbnails and working roughs are design sketches which form the starting point for the DTP work. Thumbnails let you record and review your original ideas. Before tackling this stage, it can be useful to collect a range of similar items such as brochures, leaflets and booklets. These will help give you a feel for the medium you are working in. You should also consider the size of paper you will use (which may be determined by the printer you are able to use, and may be restricted to A3 or A4).

Formats

Try out different ways of folding the paper to form a brochure. Use both portrait and landscape formats. Record a variety of design formats on your thumbnails and show where the folds will be positioned.

Thumbnail designs

Your research and specification will give you starting points and help you focus on the style of the brochure. These thumbnail sketches must be sketched freehand. Remember what you have learnt about design elements and principles such as line, contrast, unity, balance, etc. See pages 170–172 if you need to revise these topics.

If you are designing a brochure, you need to consider both sides of the paper.

Add notes to record your thoughts about what you think works and what doesn't. Try different colour combinations.

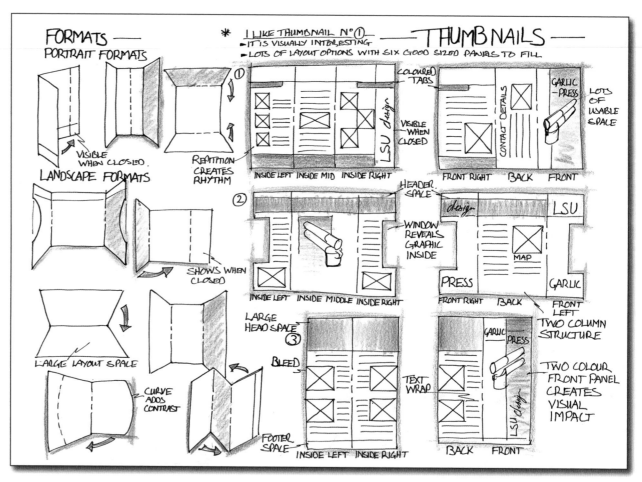

Graphic design symbols

Use the following graphic symbols:

- a column of text is shown as a series of horizontal lines

- a graphic (photograph or illustration) is represented by a box with a diagonal cross.

Structure

Consider the column structure. How many columns on each page? How wide do you want the margins and gutters? How deep should the header and footer spaces be?

Promoting the product and the company

You may find it useful to make a quick sketch of the product you are promoting. This will add realism and give the thumbnails a purpose. Remember, you are promoting the product and the company.

Working roughs

Working roughs let you develop and refine your ideas. The sketches should be larger and include more detail than thumbnails. You can develop one or two ideas. Select your most promising idea/s from the thumbnails and develop them in more detail.

Refining the structure

Sketch out your idea again (freehand) and look more closely at the positioning and structure of columns, margins, gutters, headings, graphics, headers and footers.

Design elements and principles

Make use of design elements and principles such as alignment, contrast, colour, white space and unity. Check the specification again to ensure you are setting the correct tone.

Annotations

Explain your ideas through annotations. You should cover: headings, sub-headings, body text, column structure, headers, footers, gutters, margins, colour and graphics. The end result here should be a design that you can firm up in a presentation visual.

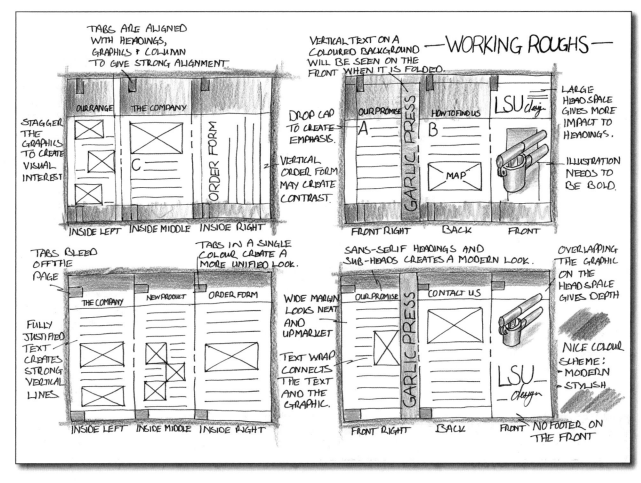

Assessment

If you complete a working roughs page, it will be assessed along with your thumbnails. Together they are worth a total of 4 marks.

Preliminary graphics: thumbnails and roughs	Marks
Annotated sketches to consider: • various concepts • various layouts, to include columns (including multi-columns), graphics and page orientation	4

Preliminary graphics: presentation visuals

The presentation visual is an actual size, manually produced mock-up of the intended document. It gives the graphic designer a preliminary version to discuss with the client. It also helps firm up the structure and is a vital reference tool when the document is being put together at the DTP stage.

Setting out

Measure the position of the folds and, using a drawing board and instruments, draw them on the front and back of a sheet of paper the size you intend your document to be.

Structure

Measure and draw the structure of the document; header, footer, margins and columns.

Graphic item

This course requires that you only complete a single, fully rendered page or panel. Select the panel you want to complete (in this example it is the front panel). Add graphics, text and colour to this panel. The other panels can be part completed with headings and sub-headings shown in full and using symbols for graphics and text.

Annotations

Add notes and dimensions to indicate your decisions about column, margin, gutter, header and footer sizes. State the font styles and font sizes you will use. Indicate your choice of graphics, even if you have not sourced (or produced) them all yet.

Preliminary graphics: presentation visuals	Marks
A single, full-size, accurately drawn visual showing the planned document, including:	
Layout detail: • columns, gutters, margins, headers and footers, accurately measured and drawn • annotation to show dimensions of these layout details	2
Graphic items and text: • a good, fully rendered representation of the intended graphic item • only one fully drawn and rendered page or panel • annotation to show font styles and sizes	2
Total	**4**

graphic items and text

layout detail

Promotional graphics: DTP text and layout

Your promotional graphics must include a **multi-page document**. It is usually best to create multi-page documents using a **master page** to ensure consistency of style and structure.

Setting up a master page

A master page establishes the structure for the document, setting the dimensions for columns, margins, gutters, headers and footers. It is important to set up the master page carefully, using your **presentation visual** as a guide. Follow the steps shown on this page to prepare your own master page.

Grids and guidelines

- Open a blank A4 page (portrait or landscape as required).
- Activate the **grid** on your DTP software.
- Set the grid to an appropriate size. 10mm is normally fine.
- Activate the **snap to grid** function to improve accuracy.
- Take measurements from your presentation visuals and drag in guides from the top and side to set margins, columns and gutters, header and footer and page fold measurements.
- Use the rules at top and left of your screen to position the guides accurately.

Adding a second page

When you produce a two-sided document, you need to add a second page to your master page. This is normally carried out with a tab at the at the bottom of the screen.

If you are producing a folded document with folds that are not symmetrical, you will need to set different guides for each side. Use your presentation visual to find the correct dimensions.

Printing a test copy

Before you spend too much time designing pages, it is useful to print a test copy to make sure all your guidelines are in the correct positions.

- Activate the **snap to guideline** function.
- Add **text frames** to the page and give the frames a **solid outline** so they will show when printed.
- Add lines to **identify folds**.
- Print a **hard copy** and check the position of frames and folds.
- **Modify** as required.

Once you have printed a copy with the folds and columns in the correct positions, you have established your master page. Other elements, such as the text and graphics can now be added.

Adding text and graphics

Once you have set up your master page, you can import text and graphics. The processes will be similar regardless of the DTP software you are using.

Using layers

You can build up your document in **layers**. In this example, there are three layers:
- Layer 1 holds headers and footers.
- Layer 2 holds headings and sub-headings.
- Layer 3 holds body copy.

More layers can be added for other elements. Structuring your work in this way can make it easier to edit later. You can switch layers on and off, which can make pages far less complicated to view and work on.

Your teacher may want to guide you through how to use layers.

Adding body copy

- **Body copy** can now be added in text frames. You can write your own copy, or you can use material from researched sources, but if you copy something from any published source, including the internet, you must acknowledge the source with the correct copyright line.
- Use the empty space on the screen to store your graphics while you prepare your text. Having the graphics onscreen while you are adding your text can help you visualise the final page layout. (You can use text and graphics downloaded from the internet, but remember to acknowledge the sources of any copyright material.)

Adding graphics

- Plan carefully where you are going to use your graphics. Consider **alignment** and try to create sharp vertical and horizontal lines.
- **Zoom in** and use **snap to gridlines** to ensure your alignment is accurate.
- **Text wrap** can be effective and is easy to do. It connects the graphic to the related text and creates visual interest.

Adding colour

- Your colour combinations should be selected to appeal to your target market.
- Colour bars and tabs create balance and contrast to make the finished brochure visually exciting.

Assessment

Your completed brochure is valued at 10 marks. The table below and the notes on the next two pages show how the **design principles** and **elements** have been used to create a visually exciting layout and explain how full marks would be awarded. Use this information to guide your decision making when designing your own DTP document.

Promotional graphics: DTP text and layout	Marks
The promotional DTP work must relate to the preliminary graphics produced earlier and include imported and manipulated graphics and creative use of text styles, including: • columns, margins and gutters • headers and footers • captions, boxes and borders • reverses and page orientation.	6
Promotional graphics: DTP technical layout complexity and quality	
DTP work must show technical quality and complexity, including: • careful alignment of text and graphics • correct use of text wrap and other features • complex structure • accurate layout to ensure correct positioning of fold lines.	4
Total	**10**

The outside of the brochure

Text and layout
Coloured tabs around the headers and footers helps to unify the layout. The tabs bleed off the page and create a modern feel.

Technical quality/complexity
Drop capitals emphasise the start of a new page and topic.

Text and layout
Margins and **gutters** are consistent and accurate.

Technical quality/complexity
The **vertical text** adds contrast. The sans serif font is modern and stylish.

Technical quality/complexity
The use of **reverse** text in **headers**, **footers** and **headings** creates **contrast** and gives the brochure a modern feel.

Technical quality/complexity
The bullet list creates visual interest and **rhythm**.

Text and layout
Hairlines sharpen up the layout and are used on all the promotional materials.

Text and layout
The title of the brochure uses the company name. A large font is used for **emphasis**. The product name is also prominent when it is folded.

Technical quality/complexity
This fun font style **contrasts** with the formal font style used in the company name LSU.

Technical quality/complexity
Most of the pictures in the layout are rectangular. The **cropped CAD illustrations** are the only elements on the pages that are not vertical or horizontal. This creates visual interest.

Technical quality/complexity
A range of colours is easily shown when 3D CAD software is used to produce the illustrations. In this example, **contrast** and **unity** have been introduced through colour selection.

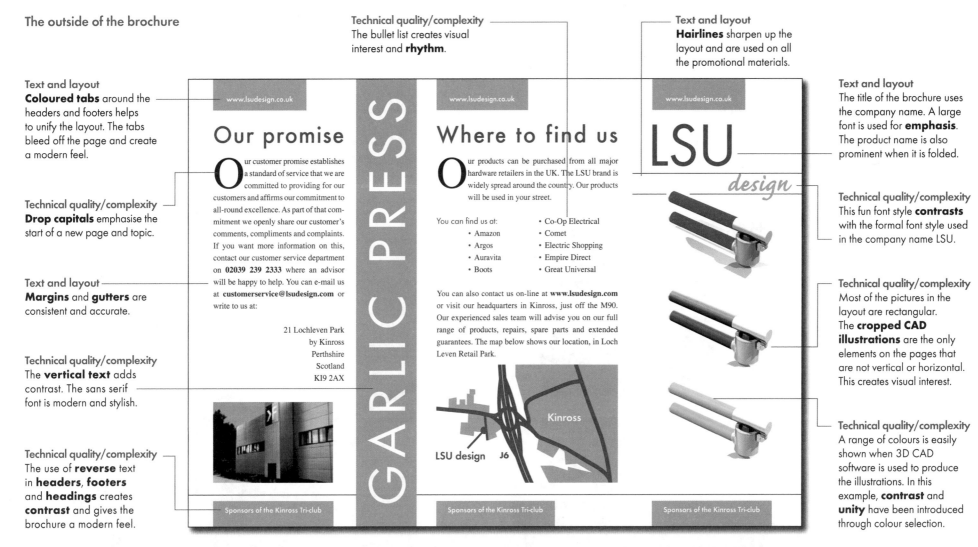

Our promise

Our customer promise establishes a standard of service that we are committed to providing for our customers and affirms our commitment to all-round excellence. As part of that commitment we openly share our customer's comments, compliments and complaints. If you want more information on this, contact our customer service department on **02039 239 2333** where an advisor will be happy to help. You can e-mail us at **customerservice@lsudesign.com** or write to us at:

21 Lochleven Park
by Kinross
Perthshire
Scotland
KI9 2AX

www.lsudesign.co.uk

Where to find us

Our products can be purchased from all major hardware retailers in the UK. The LSU brand is widely spread around the country. Our products will be used in your street.

You can find us at:
- Amazon
- Argos
- Auravita
- Boots
- Co-Op Electrical
- Comet
- Electric Shopping
- Empire Direct
- Great Universal

You can also contact us on-line at **www.lsudesign.com** or visit our headquarters in Kinross, just off the M90. Our experienced sales team will advise you on our full range of products, repairs, spare parts and extended guarantees. The map below shows our location, in Loch Leven Retail Park.

www.lsudesign.co.uk

Kinross

LSU design J6

Sponsors of the Kinross Tri-club

GARLIC PRESS

LSU *design*

www.lsudesign.co.uk

Assessment checklist

The promotional DTP work must relate to the preliminary graphics produced earlier and include imported and manipulated graphics and creative use of text styles, including:
- columns, margins and gutters
- headers and footers
- captions, boxes and borders
- reverses and page orientation.

DTP work must show technical quality and complexity, including:
- careful alignment of text and graphics
- correct use of text wrap and other features
- complex structure
- accurate layout to ensure correct positioning of fold lines.

The inside of the brochure

Text and layout
Clean vertical and horizontal lines are **aligned** throughout to give a sharp, organised feel to the layout.

Text and layout
Imported graphics demonstrate your use of hardware and software.

Technical quality/complexity
Text wrap connects the graphics with the text and adds visual interest.

Text and layout
The clearly defined and accurate **column structure** makes the brochure easy to follow.

Technical quality/complexity
The format of the brochure is complex. The panels are different sizes making an accurate back-to-back layout difficult to achieve. It **folds** accurately along the centre of the gutters.

Text and layout
Original graphics should be used creatively. 3D modelling software lets you **manipulate graphics** and show technical details, ideal for showing the product in a variety of positions.

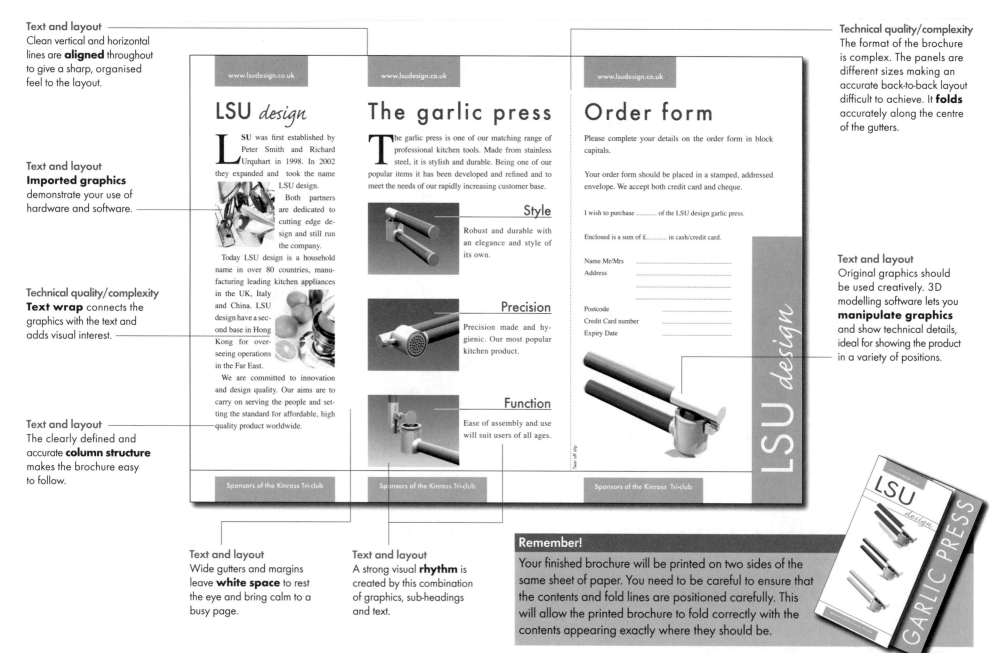

LSU *design*

LSU was first established by Peter Smith and Richard Urquhart in 1998. In 2002 they expanded and took the name LSU design. Both partners are dedicated to cutting edge design and still run the company.

Today LSU design is a household name in over 80 countries, manufacturing leading kitchen appliances in the UK, Italy and China. LSU design have a second base in Hong Kong for overseeing operations in the Far East.

We are committed to innovation and design quality. Our aims are to carry on serving the people and setting the standard for affordable, high quality product worldwide.

The garlic press

The garlic press is one of our matching range of professional kitchen tools. Made from stainless steel, it is stylish and durable. Being one of our popular items it has been developed and refined and to meet the needs of our rapidly increasing customer base.

Style
Robust and durable with an elegance and style of its own.

Precision
Precision made and hygienic. Our most popular kitchen product.

Function
Ease of assembly and use will suit users of all ages.

Order form

Please complete your details on the order form in block capitals.

Your order form should be placed in a stamped, addressed envelope. We accept both credit card and cheque.

I wish to purchase of the LSU design garlic press.

Enclosed is a sum of £............ in cash/credit card.

Name Mr/Mrs ..
Address ..
..
..
Postcode ..
Credit Card number ..
Expiry Date ..

Tear off slip

www.lsudesign.co.uk

Sponsors of the Kinross Tri-club

Text and layout
Wide gutters and margins leave **white space** to rest the eye and bring calm to a busy page.

Text and layout
A strong visual **rhythm** is created by this combination of graphics, sub-headings and text.

Remember!
Your finished brochure will be printed on two sides of the same sheet of paper. You need to be careful to ensure that the contents and fold lines are positioned carefully. This will allow the printed brochure to fold correctly with the contents appearing exactly where they should be.

LSU *design*
GARLIC PRESS

Promotional graphics: additional promotional graphics

In addition to the multi-page document you will design a range of three or four additional promotional items. Try to keep these in a single page format (you probably won't have time to include another multi-page document). The examples here are a poster, letterhead, compliments slip and a business card. You could also consider a magazine cover, CD cover, flyer and many others.

Problem-solving tips

Research existing promotional graphics. Find out what a business card or a letterhead should contain.

The design and layout of your multi-page document will guide you, but for all items, you should:
- use the same **colour scheme** and **layout elements**
- use the same **fonts**
- develop a **corporate identity** by **repetition**
- use your **logo**
- use your **CAG illustration**.

Don't over-complicate the layouts – keep them simple.

Promotional graphics: additional graphics	Marks
Visual impact and quality of the presentation, including: • creative use of text • creative use of colour • creative layout • creation of a visual identity • creative use of design elements • creative use of design principles	4

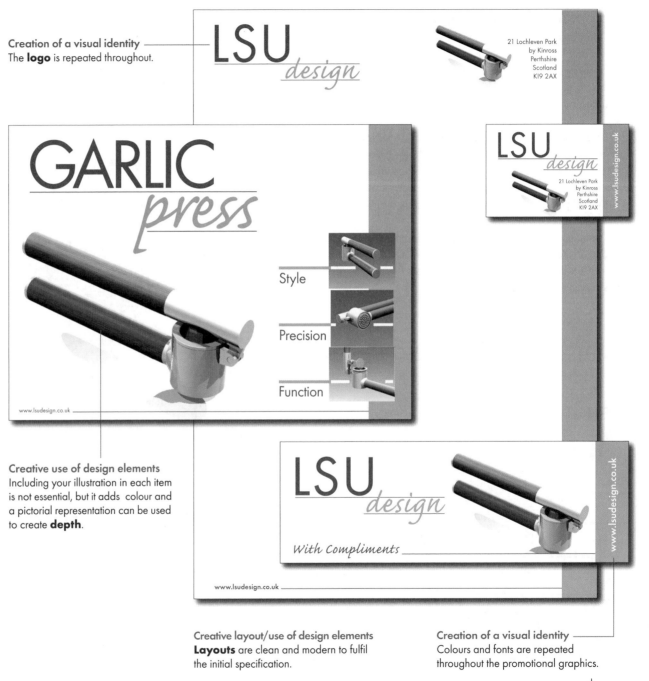

Creation of a visual identity
The **logo** is repeated throughout.

Creative use of design elements
Including your illustration in each item is not essential, but it adds colour and a pictorial representation can be used to create **depth**.

Creative layout/use of design elements
Layouts are clean and modern to fulfil the initial specification.

Creation of a visual identity
Colours and fonts are repeated throughout the promotional graphics.

Computer Graphics unit assessment

The Computer Graphics unit is the third unit in the course. Assessment for this unit requires you to complete a portfolio of computer graphic work and pass a National Assessment Bank (NAB) test. If you choose your Thematic Presentation work carefully, you should be able to use this material for your Computer Graphics assessment without having to produce any additional portfolio material.

The assessment sets Performance Criteria (PC) for four outcomes:
1 Use of a CAD package to produce orthographic and pictorial drawings
2 Use of an illustration package to produce computer-rendered drawings for promotional purposes
3 Use of a DTP package to plan and produce single- and double-page layouts
4 Knowledge of terminology and hardware associated with computer graphics.

For outcomes 1 to 3, you are required to complete a piece of work with printed evidence of completion. Your teacher will keep a checklist to show your achievement at each stage. This checklist should be updated as you progress through the Thematic Presentation. Outcome 4 is assessed with a written test.

Production drawings

Your Thematic Presentation **production drawings** can be used to deliver **Outcome 1**. The PCs allow you to select from a range of features. However, it is always worth trying to include all of the features. This approach should help you pick up more marks when your Thematic Presentation is assessed.

Use the checklist codes in the table below to identify each feature on the drawings, and use this as a guide when completing your own drawings.

Outcome 1: Produce orthographic and pictorial drawings using a CAD package		
CAD production drawings	**Assessment features**	**Check**
PC A **Orthographic drawings**	3rd angle projection symbol	a
PC A **Orthographic drawings** (minimum of two views, to include any two from this list)	Fillets	b
	Arcs	c
	Tangents	d
	Hatching	e
PC A **Line types** (any two from this list)	Dashed (hidden)	f
	Chain (centre lines)	g
	Continuous thick (visible outline)	h
	Continuous thin (dimensioning, hatching)	i
	Chain thin, thick at ends (cutting planes)	j
PC C **Dimensions** (any two from this list)	Lengths	k
	Diameters	l
	Radii	m
	Angles	n
PC B **Pictorial drawings**	Appropriate projection	o
	Sufficient detail to represent the item	p
	Drawings in correct proportion	q

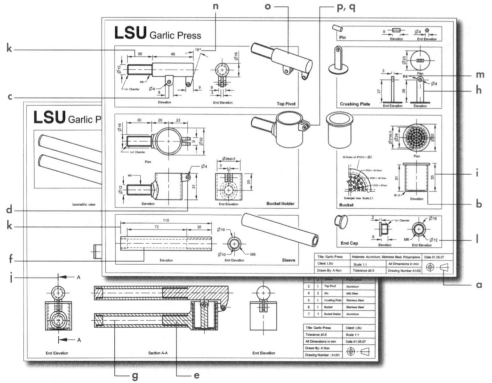

Promotional graphics

Your Thematic Presentation **promotional graphics** can be used to deliver **Outcome 2**. The main focus in this outcome is an illustration which is used in a graphic display. Ensure you combine your illustration with text and a backdrop and use an effective colour scheme and layout that creates visual impact.

Use the checklist codes in the table below to identify each feature on the drawings, and use this as a guide when completing your own drawings.

Outcome 2: Produce computer-rendered drawings for promotional purposes using an illustration package		
CAG illustration	**Assessment features**	**Check**
PCs A & B **Rendered drawings** (any two from this list)	Use of colour gradients	a
	Use of highlights	b
	Use of lettering	c
	Importing CAD files	d
	Visual impact	e

Preliminary graphics for DTP

Your Thematic Presentation **preliminary graphics** can be used to deliver the research and planning elements of **Outcome 3**.

Use the checklist codes in the table below to identify each feature on the drawings, and use this as a guide when completing your own drawings.

Outcome 3: Plan and produce single- and double-page layouts using a desktop publishing package		
Preliminary graphics	**Assessment features**	**Check**
PC A **Planning for DTP** (any two from this list)	Research into client requirements, purpose and content of document	a
	Sketches of different layouts	b
Thumbnails and visuals to consider	Page orientation	c
	Position of text and graphics	d
	Headers and footers	e
	Columns and margins	f

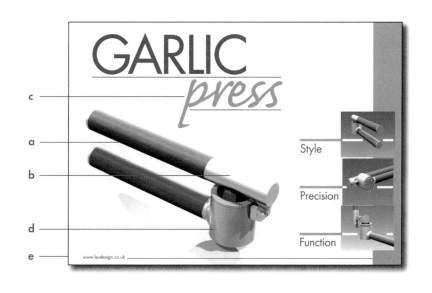

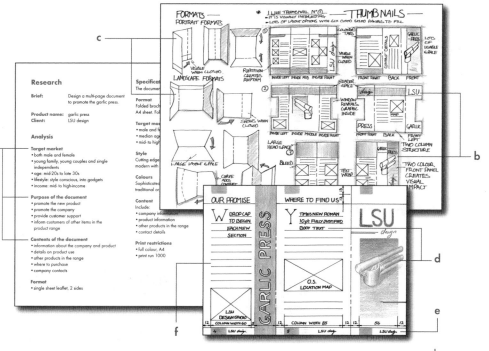

Promotional graphics

Your Thematic Presentation **promotional graphics** can be used to deliver the DTP elements of **Outcome 3**. The assessment here comes from a range of promotional documents, one of which must be a multi-page document.

Use the checklist codes in the table below to identify each feature on the drawings, and use this as a guide when completing your own drawings.

Outcome 3: Plan and produce single and double page layouts using a desktop publishing package		
Promotional graphics	**Assessment features**	**Check**
PC B **DTP document** (single- and double-page layouts)	Mix of text and graphics	a
	Imported and manipulated graphics	b
	Creative use of text style	c

National Assessment Bank tests

In addition to the portfolio assessment, the Computer Graphics unit is assessed with a **National Assessment Bank** (**NAB**) test. This is a pass/fail test which you will sit in class. The Graphic Design and Computers in Industry sections in this book will help you prepare for these tests. (A second NAB test, **Graphics in Industry**, assesses your knowledge of how graphics are used in industry.)

Outcome 4: NAB test (written paper)		
Computer graphics	**Assessments features**	
PC A **Common terms**	Common CAG terms	
PC B **Hardware**	Computer hardware	

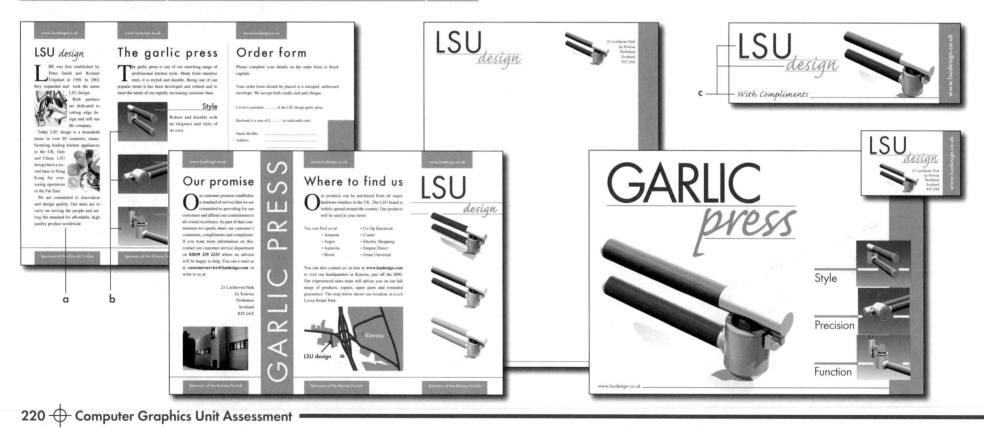

Dimensioning and tolerancing solutions (page 16)

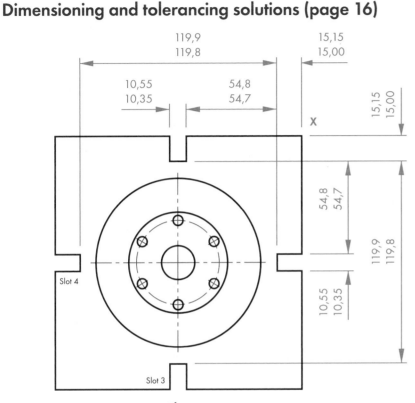

Plan

The soap dish is symmetrical about the two centre lines, so the dimensions of slots 3 and 4 are the same.

To calculate the maximum depth of slots 3 and 4

Find the minimum distance between the right-hand edge of the soap dish (defined by corner X) and the inside edge of slot 4:

119,8mm + 15mm = 134,8mm

Subtract this from the maximum overall size:

150,25mm – 134,8mm = 15,45mm

To calculate the minimum depth of slots 3 and 4

Find the maximum distance between the right-hand edge of the soap dish (defined by corner X) and the inside edge of slot 4:

119,9mm + 15,15mm = 135,05mm

Subtract this from the minimum overall size:

149,75mm – 135,05mm = 14,7mm

Ellipses solutions (page 48)

Concentric circle method

Trammel method

Building symbol solutions (page 124)

a = insulation

b = sawn timber

c = brickwork

d = concrete

Glossary

2D: two-dimensional drawing of an object where only two of the dimensions can be viewed; most commonly seen as orthographic drawings in 1st and 3rd angle projection

2½ D: two-and-a-half-dimensional drawing (isometric, planometric or oblique) where three sides of the object can be seen on the same view

3D: three-dimensional drawing or model where the object can be viewed or manipulated from any angle

alignment: 1. positioning of text in a column or on a page. Text can be aligned left, aligned right, aligned centre or justified. **2.** Lining up elements on a page to create a clean, organised layout

application software: software used for a specific task (such as 3D modelling, word processing, spreadsheet and DTP)

artwork/graphic: original illustration produced for use in a publication

ascender: the part of lowercase letters such as b, d, f, h, k, l and t that rises above the **x-height**

attach: CAG command where the cursor 'snaps' to a predetermined location (often a point on the grid), the end of a line or the intersection of two lines

auto-dimension: command for automatically adding dimension lines to CAD drawings

back up: duplicate files created in case the originals are corrupted or lost

banner: main headline across the top of a page

baseline: invisible line on which letters sit

bleed: extension of graphic or block of colour beyond the trimmed edge of a page

body copy/body text/body type: main block of text, typically 10–12 point in size

bold type: thicker, blacker text

box: rectangular outline around text or a graphic

bullet: a symbol, usually a dot, used for emphasis; often used in lists

CAD: **C**omputer-**a**ided **D**esign/**D**rawing/**D**raughting; design carried out on computers

CAE: **C**omputer-**a**ided **E**ngineering; engineering controlled by computers

CAG: **C**omputer-**a**ided **G**raphics; a broad term which covers CAD, 3D modelling, illustration and DTP

CAM: **C**omputer-**a**ided **M**anufacture; mass production controlled by computers

camera-ready copy: pre-printed layout that is finished and ready to photograph prior to printing

caps: see **uppercase**

caption: title or brief description that accompanies a photograph, illustration or table

centre-spread: two adjacent pages in the middle of a magazine; often designed as a double page layout

clip-art: ready-made graphics and photos stored in a clip-art gallery

column: vertical box into which text is placed. Columns help give structure to a page.

column guides: non-printing boxes or lines pre-set to position columns accurately

column rules: vertical lines between columns

column width: horizontal width of a column

compatibility: property of graphic and text files which allows them to be moved (exported and imported) between software packages. For example, a DTP application can use files from compatible illustration and word processing packages.

copy/hard copy: any documents printed on paper

CPU: **c**entral **p**rocessing **u**nit; the microchip that controls all computer operations

crop: trimming excess material from a photograph or graphic

crop marks: almost-intersecting corner lines used on oversized paper to indicate the edges of the printing area. This allows the printer to trim the printed paper accurately to its final page size.

cut-off rule: horizontal line (rule) separating different items

database: a means of organising and storing information on a computer so that it can be retrieved quickly and easily

descender: the part of lowercase letters such as g, j, p, q and y that drops below the baseline

digitiser: see **graphics tablet**

disc: magnetic storage device used to save and transport computer files. Computers use hard discs to store vast amounts of data.

display type: large type used in headlines

DPI: **d**ots **p**er **i**nch; a measure of the resolution of an output device. The higher the resolution the better the quality of the output.

drop capital: a capital letter which is larger than accompanying text and which drops below the base line of text; used at the start of sections and paragraphs

drum plotter: plotting device used to create line drawings where a pen-like device is moved across a drum which also moves the paper back and forth. Commonly used for large scale drawings.

DTP: **D**esktop **P**ublishing; the creation of a complete publication from start to finish using a computer. This process removes the need for manual typesetting, cutting, pasting and layout of graphics.

dump: transfer of data of files from computer memory to a printer or external storage device

DXF: **D**rawing E**x**change **F**ormat; a file format used to transfer data between different CAG systems

extrude: CAD command that allows a 2D shape to be extruded along its Z-axis, giving a 3D form

facing pages: two pages which are seen next to each other in a publication

file: collection of data that makes up either a drawing or piece of text, saved on a disc or other storage device so that it can be retrieved and used later

flat bed plotter: plotting device used to create line drawings where a pen-like device is moved in the X and Y planes across a stationary sheet of paper

folio: page number